50
digital ideas
you really need to know

Tom Chatfield

Quercus

Contents

Introduction

What do we mean by 'digital'? In one sense, we simply mean something whose ultimate existence is a string of ones and zeroes. A digital object, unlike the analogue stuff of the world or even of early computing, is a binary pattern.

Out of this simple fact have come some of the most transforming cultural forces of the second half of the 20th century and, now, the first half of the 21st. For perhaps the most remarkable property of digital objects – whether their ones and zeroes encode words, music, images, applications, web browsers, or databases containing much of the store of human knowledge – is their compatibility with each other.

For the first time in human history, it is possible almost endlessly to copy and distribute words, sounds, images, ideas; and it is possible to access, adapt and create all of these on the same devices.

The history of digital ideas goes back to well before the 20th century. It is in part the millennia-old story of mathematics, as well as the story of centuries of ingenious mechanical design preceding the last century's developments in the fields of electronics and computing.

I have chosen here, however, to focus on the more recent past – and on those aspects of the digital present that seem most powerfully to be shaping our future. As a result, this is overwhelmingly a book written about and around the internet.

As I write these words, in 2011, around two billion people – almost one third of humanity and one half of the planet's adult population – have some form of access to the internet. Thanks to the spread of mobile internet access, this figure will continue to soar over the coming decade, as will the use of those online services steadily reshaping much of what it means to be a member of a modern society.

The news is not all good: growth, amelioration and freedom are not to be taken for granted, and indeed are not enjoyed by many of the world's digital citizens. The internet is as powerful a force in the hands of many of the world's repressive and censorious regimes as it is in the hands of those using it to liberate, educate, connect and delight.

Similarly, it is a breeding ground for the best and the worst of humanity alike: the scammers and the selfless; the entertainers and the mockers; the entrepreneurs and the predators. But this only makes understanding its history, structures, potentials and possible futures all the more vital.

01 The internet

The internet is best thought of not so much as a technology as an infrastructure: a mass of interlinked hardware and software – from deep sea cables and telephone wires to desktop computers and mobile phones – connecting an increasingly large proportion of the world's computing devices. Many services operate via the internet – including, perhaps most famously, the world wide web – but the internet itself predates these. It is the vast, physical network within which much of modern digital culture exists.

The history of the internet dates back to the Cold War and the communications networks developed by America in the wake of Russia's launch of the satellite Sputnik – the first man-made object ever to orbit the earth – in 1957. Shocked by its rival's achievement, America poured resources into developing new communications technologies. In particular, the aim was to develop communications networks able to function even if a disaster destroyed large parts of the network itself.

This early research culminated in a 1968 report entitled 'Resource Sharing Computer Networks', which laid the foundations for the first computer network based on a system known as 'packet switching' – where all data transmitted between machines is broken down into small blocks or packets. The first computer network built using this technology was called the ARPANET (Advanced Research Projects Agency Network), and began operations in 1969, initially connecting four sites at the University of California in Los Angeles, the Stanford Research Institute, the University of California in Santa Barbara and the University of Utah.

timeline

1969	1974	1982
US Department of Defense creates ARPANET	Word 'internet' is used for the first time	ARPANET switches to Transmission Control Protocol (TCP) and Internet Protocol (IP)

ARPANET grew rapidly. By 1970 it had reached the east coast of America. The first ever piece of electronic mail was sent across it in 1971. By September 1973, 40 machines across America were connected to the network, and the first method for transferring computer files between them – known simply as 'File Transfer Protocol' or FTP – had been implemented. In December 1974, the word 'internet' itself was used for the first time in a paper by Vinton Cerf, Yogen Dalal and Carl Sunshine, as an abbreviation for the term 'internetworking'. It referred to what was becoming a revolutionary idea: a global communications meta-network, itself formed by combining multiple networks of machines that used the same protocol for sharing packets of information. This 'network of networks' idea is perhaps the core idea behind the modern internet.

> **'The internet is becoming the town square for the global village of tomorrow.'**
>
> **Bill Gates**

Protocols Cerf, Dalal and Sunshine's 1974 paper formulated two ideas that would be central to the future of the internet: 'Internet Protocol' (IP) and 'Transmission Control Protocol' (TCP). Between them, these

IPv6

Since 1981, every computing device attached to the internet has had a unique numerical address allocation to it via the fourth version of the Internet Protocol system on which the net is based: IPv4 for short. Today, however, the phenomenal growth in internet-based resources means that IPv4 is running out of numbers. IPv4 is able to support 'only' 4,294,967,296 unique internet addresses – the maximum size of a 32-digit binary number. The newest, sixth version of Internet Protocol is based on 128-digit binary numbers, allowing more than a billion times as many addresses again as version four. Switching the internet over to a new protocol is a huge challenge, especially for older physical hardware, and it is being performed and tested in several stages. But it is an increasingly urgent task, with 'address exhaustion' for IPv4 dated for some regions to mid-2011.

1985	1990	1991
US National Science Foundation commissions its network	First dial-up commercial internet access	World wide web is invented

> **❝The Internet is the first thing that humanity has built that humanity doesn't understand, the largest experiment in anarchy that we have ever had.❞**
>
> **Eric Schmidt**

protocols explained the precise way in which data should be broken down into packets and sent between computers. Any computer that used these methods – usually abbreviated to TCP/IP – should, in theory, be able to communicate with any other computer also using them. Internet protocol defined the route that the data should travel along to connect computers at particular locations – or 'IP addresses' as they would come to be known – while transmission control protocol ensured that the packets of data were sent in a reliable, ordered manner.

Over the next decade, much work was done ensuring that it was possible for as many different types of computer as possible to connect successfully to each other using TCP/IP. This culminated in 1983 with the switch of all the computers on the ARPANET system to TCP/IP rather than the older packet-switching system they had previously used. In 1985, America's National Science Foundation commissioned its own network of computers, designed to run in American universities using TCP/IP, and in 1988 this network was opened up, allowing other emerging computer networks to connect to it. The TCP/IP protocol made it easy for different kinds of machine and network to link together, and the end of the 1980s saw the launch of the first commercial Internet Service Providers (or ISPs), offering network access to companies and individuals.

Growth By the early 1990s, large parts of the world – led by universities and research institutions – had independently begun to use computer networks based on TCP/IP protocols, something that made it extremely easy for these networks to connect to each other, share files and data, and send electronic mail. It was only, however, with the invention of the 'world wide web' in 1989 by Tim Berners-Lee that the tools it was possible to use via the internet began to become genuinely accessible to ordinary computer users as well as academics and researchers. Through the 1990s, the number of people connected by the internet more than doubled each

Net governance

Set up in America in 1998, the Internet Corporation for Assigned Names and Numbers (ICANN) is the single most important organization for regulating the future of the internet. Its primary responsibility is managing Internet Protocol address spaces: that is, ensuring the allocation and management of a unique address for every site and service using the internet. It also allocates blocks of addresses and what are known as 'top-level domains' to different parts of the world: for example, allocating websites that end in 'uk' to British-based websites, in 'au' to Australian websites, in 'com' to commercial operations, and so on. ICANN is a charitable organization and must balance the needs of different parts of the globe while attempting to preserve a coherent, cohesive internet structure: a considerable challenge due to the net's increasingly international nature.

year on average, a rate that only slightly lessened through the next decade. It is estimated that, at the end of 2010, approximately two billion people, almost one third of humanity, were connected.

The world wide web is explained in more detail in the next chapter. With it is arrival, and the rapid spread of websites and browser technology, the internet began to play the role that most people would recognize today: a truly global network, connecting individuals and nations through an increasingly vast proliferation of computing devices. But its future cannot be taken for granted. The internet relies on continued cooperation between nations and individuals; and also on the continued construction and upgrading of hardware – that is, cables and computer servers – capable of handling the increasingly vast amounts of information being exchanged online, in the form of not only words, but videos, images, sounds and complex applications.

the condensed idea
the internet connects everything

02 The world wide web

Although many people treat them as synonymous, the world wide web is not the same thing as the internet. The web is just one of a number of services that use the internet. Others include everything from file sharing and online games to video chat or email. The web is, however, perhaps the single most important service within modern digital culture, for the world wide web is founded on the principle that anyone with an internet connection should be able to move freely between websites, and create their own if they wish. In this sense, it's as much a set of principles as a technology.

The idea for the web was born in 1989, in a research paper by the British engineer and computer scientist Tim Berners-Lee. In it, Berners-Lee outlined his concept for a 'universal linked information system' that would 'allow a place to be found for any information or reference which one felt was important'. This system would operate via the established structure of the internet – but the key words in Berners-Lee's scheme were 'universal' and 'linked'. Anyone had to be able to create sources of information on his system, and these sources had to be created in such a way that it was possible for everyone to find them, use them and move seamlessly between them.

By December 1990, Berners-Lee had – with the help of his Belgian colleague, Robert Cailliau – assembled all the components necessary for a fully functional realization of his proposal at their place of work, the physics research institute CERN in Geneva, Switzerland. Three essential components were involved: the world's first 'page' of digital information (so

timeline

1989	1990
Tim Berners-Lee first proposes the web	First working version of the web

that there was something to look at); the first 'browsing' program, which allowed people to view the information on this page from their own computer terminals; and the first web server, the computer on which the web page was 'hosted'. The host computer would function a little like a digital noticeboard: the page of information was posted on it and then anyone with a browser program could simply connect to this host computer and view the page on the noticeboard. And as many people as had browser programs could look at the same time: the page itself simply remained on the host, displayed to all.

Today, even conservative estimates put the number of web pages in existence at over a trillion, a large proportion of which it is now almost impossible to locate – despite the immense power of modern search engines – yet billions of sites are in use and accessible to anyone with a computer and a web browser. It's an astonishing testament to the power of Berners-Lee's original vision and to the determined efforts of the company he set up in 1994, the World Wide Web Consortium, in order to maintain common and open standards for the whole of the web.

The first website

The old joke about who the owner of the first telephone was going to talk to doesn't quite apply to the web, but it comes close. Fittingly enough, then, the first ever website – created in December 1990 by Tim Berners-Lee – was simply a few pages of linked text describing what the 'world wide web' was all about. And it had what was also the world's first web address: http://nxoc01.cern.ch/hypertext/www/theproject.html. The world wide web, it explained, is something that 'merges the techniques of information retrieval and hypertext to make an easy but powerful global information system'. And you can still view a version of the original site online today via the World Wide Web Consortium's current site, www.w3.org.

Hypertext HTML or, to give it its full name, HyperText Markup Language, is the set of rules that underpins every page on the world wide web. As the name suggests, it's like a 'hyper' or enhanced version of ordinary writing. This is why every web address today begins with the letters http: they stand for HyperText Transfer Protocol, and refer to the system that allows information in the form of hypertext to be exchanged between computers. The words printed on the pages of a book are text in

1991
Web becomes publicly
available via the internet

1994
World Wide Web
Consortium is founded

Tim Berners-Lee: a digital life

Sir Tim Berners-Lee – knighted in 2004 for his achievements – is revered today as 'the father of the web'. Perhaps still more remarkable than his ingenuity, however, is his guardianship of the principles of universality of freedom embodied in his creation. Born in London in June 1955, he studied physics at Oxford before working in telecoms, software engineering and technical design, becoming a fellow at CERN in Switzerland in 1984, where in 1989 he first conceived of the web. Once his brainchild had launched, rather than profit from restricting its use, in 1994 Berners-Lee founded the World Wide Web Consortium: an organization devoted to ensuring the web's continued openness and the maintenance of its universal standards. He remains one of the world's leading advocates of the open, transparent use of data, and an advocate of maintaining the web's evolution through the 21st century as a still more potent force for linking and creating knowledge.

the ordinary sense: mere words on paper. They become a hypertext when this ordinary text is 'marked up' by the simple addition of a small number of 'tags' embedded in the electronic version of the text. Each tag contains a special, additional piece of information about a piece of text, telling any web browsing programme how it should be presented, what other pages elsewhere on the web it should connect to and so on.

In the first version of HTML, there were just 20 basic ways in which information on a page could be tagged. Perhaps the most crucial idea of all was that each page was to be given its own unique 'base address', and that it would then be possible to specify the addresses of other pages in a form 'relative to the address of the current document'. What this meant in practice was that a simple tag could be used to connect any one page to any other, by telling a web browser to create a link between the unique address of one page and another page. Most people using the web today will never see a single line of actual HTML: but in its latest version it remains the underpinning of every website that's out there.

Web browsers Browsers are the dedicated programs through which users access the web. Today, a host of different browsers are available, including such famous brands as Internet Explorer, Firefox, Chrome and Safari. Part of the genius of the web is that any browser should be able to grant any user access to pretty much every website there is.

Browsers allow users to navigate their way between different websites and web pages, either by following links between them or by entering a specific address. The very first browser was initially called WorldWideWeb – and later renamed Nexus – and allowed users to do little more than view different web pages and move between them. Over the years, a host of more sophisticated functions have been built into browsers, allowing for more and more complicated effects to be achieved through websites: from the use of complicated style sheets to, today, streaming sounds and video within web pages and even running complicated interactive applications such as games entirely within the windows of a web browser.

> **'Anyone who has lost track of time when using a computer knows the propensity to dream, the urge to make dreams come true and the tendency to miss lunch.'**
> **Tim Berners-Lee**

Web servers Web pages can be viewed by anyone with an internet connection and a web browser, but the code that they are made up of needs to be actually stored on a computer somewhere for it to work. The computers on which websites are run are known as web servers and are responsible for delivering the content of a website over the internet to anyone who wishes to access it through a browser.

What this means is that a web server literally 'serves' a copy of a web page to every user whose browser is set to that page's unique address. If two people do this at the same time, each is simply given a copy of the page to view in their browser; and the same is true for a hundred, a thousand or even millions of people. Provided, of course, the server is powerful enough to keep up with the demand. The more complicated a page or the more people who want to view it, the more powerful the server hosting it needs to be. In the case of the world's most visited websites, such as Google's homepage, the servers required to grant everyone access to the site and process the queries they type in run to thousands upon thousands of machines, serving hundreds of millions of user requests.

the condensed idea
the web is open and universal

03 Internet service provision

Internet Service Providers, or ISPs, are the backbone of digital culture providing individuals or companies with internet access in return for a fee. In the early days of the internet, before the world wide web, it was ISPs who brought to the general public a technology that was still new and daunting to access. Even after the far more accessible world wide web took off, ISPs remained a dominant force, controlling the email and online experiences of millions of internet users. Today, their role is less visible, but they remain an integral part of much of the world's access to online services – and powerful players in any debate over the future direction of the net.

The first Internet Service Providers began to appear in the late 1980s but they did not offer access to what we think of today as the 'internet' or even its full early incarnation. The direct ancestors of the modern internet – NSFNET and ARPANET – were at this time reserved for use by higher educational institutions and defence contractors. And so US-based companies such as UUNET (founded 1987) and Netcom (founded 1988) began to offer paying customers access to systems based on the more informal UUCP, or Unix-to-Unix Copy, network: a system that allowed networked machines to call each other individually and exchange information, such as news and mail.

The world wide web did not even exist at this point, meaning that paying for internet access principally allowed users to send and receive emails and to take part in discussion forums such as Usenet, an influential early

timeline

1987	1992
Limited public paid access to internet	First full paid-for net access

community of digital words and ideas. Until this point, digital culture outside of major institutions had relied on individuals with computers accessing so-called Bulletin Board Systems (BBSs) by dialling them directly with modems over ordinary phone lines. BBSs continued to grow their user numbers until the mid-1990s, when a combination of widening internet access and the growth of the world wide web finally overtook them.

Offering commercial access to the UUNET in the late 1980s proved a useful source of revenue for expanding network systems and capacities, but much debate continued to surround the commercial opening up of the NSFNET and ARPANET systems. Finally, in 1992, Congress voted to allow commercial operations to begin on the NSFNET. This signalled the beginning of commercial access to the 'true' infant internet, which until then had been largely a non-profit scholarly tool.

How fast?

One of the most confusing and potentially controversial areas in internet access is speed: how fast will the connection provided by an ISP download and upload data; and how well will it cope with the increase in online traffic during hours of peak demand? In Britain, for example, ADSL broadband – provided over the phone network – has a theoretical maximum download rate of 8 Mbps. But this is rarely achieved, with rates ranging from 4 to as low as 1 Mbps more common. Some countries, such as South Korea, have invested heavily in dedicated cables providing a far faster national broadband network than others. ISPs there are able to offer an average of around 12 Mbps, compared to Japan's 8 Mbps and Britain's average of just under 4 Mbps. Speeds are expected to increase dramatically over the coming decade but so are the amounts of data transferred by the average internet user, thanks to the increasing quantity and quality of video streamed online. To meet demand and maintain speeds, many ISPs believe that substantial government investment across the world is required in parallel to the commercial sector's efforts to keep up.

1996

Term 'broadband' is coined

2002

AOL subscribers peak

America Online

America Online or AOL was one of the most impressive success stories of the early days of the commercial internet. From the late 1980s, AOL offered one of the first and most appealing of the early 'walled garden' internet services. For an hourly charge – which became a monthly fee in 1996 – users gained access to chatrooms, games, email on the company's own network, an instant messenger service and other proprietary content. The service was extremely user friendly and well marketed, and gained a huge number of users through the 1990s, reaching around 35 million subscribers by 2002. But the model of safe, controlled internet service provision fell apart in the 2000s in the face of the ongoing expansion of the web and the proliferation of free online services. By early 2011, AOL had only around four million subscribers remaining – and was busily reinventing itself as a content-based business, with purchases including the world's most-read blog, the Huffington Post, for over $300 million.

First full access From 1992, ISPs were able to sell 'dial-up' access to the full internet as it then existed. Dial-up access is so called because – much as with Bulletin Board Systems – it involves a computer connecting to the internet via an ordinary phone line, attached at one end to the computer's modem, and at the other to a receiving modem attached to the computer belonging to the ISP.

The first company to offer a full dial-up internet service was The World, which did so from August 1992, having offered dial-up access to the UUNET since 1989. Other companies followed in quick succession, and with the launch in 1993 of the first graphical browser for the world wide web, global online growth began to take off.

In 1996, internet service provision saw the emergence of a new term, 'broadband', which appeared prominently in an advertising campaign for American ISP MediaOne. The term has no precise technical meeting, but was used to show the fast internet access rates MediaOne was able to offer via its cable modem service: modems that operated not through ordinary telephone wires, but along the cable television infrastructure, allowing far faster access speeds. Cable modems had been in limited use since the early 1990s, but it was not until the second half of the decade that the notion of broadband access began to take off and constitute a major market sector for ISPs.

ADSL arrives Towards the end of the 1990s, a second broadband technology began to become an affordable option for domestic users: an Asymmetric Digital Subscriber Line or ADSL. The technology had existed since the end of the 1980s but had been extremely expensive as it involved using a complex form of digital signal processing to send information along an ordinary telephone wire at a far higher rate than was possible via an ordinary dial-up connection.

All of this has meant a gradual transition in pricing models for internet access from paying by the minute for dial-up to paying a flat monthly fee for broadband access that was always on. ISPs themselves pay for the internet access they pass on to their customers – usually from a larger ISP, with access to larger sectors of the internet. Ultimately, this money goes to funding the structure of the internet itself, spread between the numerous private companies that maintain the high-capacity lines sometimes referred to as the 'backbones' of the internet, as well as the regional networks, consortia and connections that form the vast modern spread of the internet.

> **❛Access to the internet itself has become a human right.❜**
> **Michael L. Best**

Today, both more varied and more powerful ways of connecting to the internet are becoming widespread: from high-speed cables to more advanced forms of ADSL-style encoding, as well as high-speed wireless access. For ISPs, tasked with maintaining reliable access to the internet for a rapidly growing number of users who are also each using increasingly data-intensive services, the future holds a number of challenges to do with maintaining both profits and service quality in the face of this growth. New business models supported by advertising are being attempted by some, while others are attempting to make money by charging to prioritize certain kinds of traffic – a key issue in the 'net neutrality' debate.

the condensed idea
Those controlling internet access wield great power

04 Email

Electronic mail – the sending of text-based messages between computers – is one of the first and most fundamental of all digital ideas. In fact, it predates the existence of both the internet and the world wide web, dating back to almost the earliest occasions on which one computer was linked to another. For almost as soon as the idea of connecting computer terminals was possible, people set out to do something that has for millennia driven civilization forwards: communicate with each other.

In the early days of computing, machines were huge and extremely expensive, and it was usual for one 'mainframe' to have a number of terminals linked to it through which many people could use the single, central computer. From 1961, an early mainframe computer known as an IBM 7090 was in use at Massachusetts Institute of Technology (MIT). This computer had what was then a radical operating system, which allowed several users to log into the computer from different terminals and transfer files they were using onto the computer's central disk.

It gradually became clear that this ability to transfer files onto a central disk meant that this operating system could in effect be used like a mail box. You could, for example, write a message in a file and then upload it to the computer's central disk with a filename like 'FOR TOM'. This was like posting a letter addressed to a particular person. I would then log onto a different terminal, search the computer's central disk, see the 'FOR TOM' file and thanks to its name would open it to read the message that had been left in it for me.

timeline

1965	1971
'Mail' command is first introduced	@ sign is first used

By 1965, this system was being sufficiently widely used that a specific 'mail' command was created on the operating system. This effectively automated the established mailing process, meaning that any user could now send a message to any other specific user, and the file containing this message would be placed in a specific 'mailbox' location on the main disk. All you had to know was the unique numbers identifying a particular user and you could send a message to them. This would be indicated the next time they logged on to a terminal by the message 'you have mailbox'.

Introducing @ The next significant developments in email came with the creation of the Advanced Research Projects Agency Network (ARPANET) in 1969 at MIT – the precursor to the internet. The rapid expansion of this network hugely increased the use of electronic mail and began to generate further innovations in the mailing process. In 1971 the now-standard '@' sign – usually referred to as the 'at' sign – was used for the first time to denote the particular location that someone sending or receiving mail was 'at', an innovation that formed part of a new email system implemented by programmer Ray Tomlinson. Tomlinson's system was the first to allow messages to be sent between different host computers, rather than simply between different users on the same mainframe computer. In the modern sense, it marked the first true email system.

The next year, 1972, one of the founding fathers of the internet – Larry Roberts, who had led the development of the ARPANET,

@ around the world

Until its first use in emails in 1971, the @ symbol was an obscure accounting symbol used to indicate pricing levels in accounting. Since then, it has become one of the world's most widely used symbols and has gathered a bewildering and colourful variety of different descriptions in different languages. While in English it is simply called the 'at sign', others are more poetic. In Italian, it is *chiocciola*, 'the snail', thanks to its shape, while the Finnish language thinks it looks more like a curled-up cat (*miukumauku*). Russian leans towards a dog (*sobaka*) and the Chinese sometimes call it *xiao laoshu* or 'little mouse'. But perhaps most colourful of all is the German interpretation: *Klammeraffe* or 'spider-monkey'.

1972
First email software

1995
First webmail

Email apparatus

A host of options are now considered essential for any email program. Top of many lists is the ability to send and receive files – documents, photographs, databases and so on – as 'attachments' to an email. Address Book functions for managing contact details are also almost universal, as is the ability to send a 'carbon copy' (cc) or 'blind carbon copy' (bcc) of a message to other recipients, and to forward (fw) messages on to others. Many people also use email signatures, automatically putting their business or personal details at the bottom of each email.

Newer email systems like Google's Gmail have also introduced the idea of 'threaded' email exchanges, grouping together emails sent backwards and forwards with particular people for ease of reading. And tagging and filing systems for keeping track of past emails are increasingly important given the many thousands of messages an average user can expect to build up over their lifetime – not to mention filtering and priority systems for ensuring that important messages get read, and trivial ones automatically set aside for casual browsing.

designed the first fully operational email management program, able automatically to read, respond to, file and manage emails. Numerous other email management programs quickly followed but every one remains essentially the same in the core functions it performs.

Email software When an email is sent, it arrives not at an individual's computer but at the online mail server providing your particular email service. If you're using a piece of software that can process emails – such as Microsoft's Outlook – this software will log into the mail server via the internet to look for new messages, downloading a copy of any new messages to your computer.

Many people now use 'webmail' rather than a software 'client' on their computers, meaning that they access their mail server through a web browser. Webmail programs were first demonstrated in 1995, and offer the convenience of being able to send, receive and read mail wherever there is access to the internet and a web browser. Popular webmail providers today include Google's Gmail, Microsoft's Hotmail and Yahoo!'s Mail.

> **‘Email never seemed big at the beginning because there weren't many computers. It was only as big as the network.’**
>
> Ray Tomlinson, Inventor of email

For both webmail and mail checked using a software client, there are two dominant modern protocols for getting messages off a mail server: Post Office Protocol (POP) and Internet Message Access Protocol (IMAP). POP is a simpler system, treating the server much like a post office: it tends to connect to a server, check for and download new messages, delete old messages, then disconnect. IMAP offers a more sophisticated process, connecting to the server for longer and allowing multiple pieces of client software on different computers to connect with the central server mailbox and synchronize the status of messages between them. In effect, it allows the remote management of the email mailbox on a server, rather than simply the download and sending of messages.

Overkill Given the sheer volume of email now sent and received around the world – even excluding the vast quantities of spam messages demanding ever more sophisticated filtering techniques on the part of email service providers – inbox management is a vital skill in many modern businesses. Popular techniques for managing emails range from 'inbox zero' (no messages allowed to linger in the inbox) to 'batching' (setting aside time for dealing with large amounts of email in one intense session). The world's most-used communication method is at once simple and an ever-shifting art.

the condensed idea
Sending words digitally is its own revolution

05 Personal computing

The earliest computers were anything but personal: vast, expensive machines within the reach only of elite academic institutions, major corporations or governments. The gradual democratization of computing power has been one of the most fundamental of all digital transitions, and something that's summarized in the very idea of 'personal computing' – a device in every home. It has also created a culture based on a historically unprecedented intimacy between people and machines.

The word 'computer' itself began as a term for a person who performed calculations. It was first used to refer to a calculating device in the 19th century, and to an electronic calculating device in 1946. These early machines used vacuum tubes to perform calculations, a bulky and energy-intensive system that filled entire rooms. The first fully programmable electronic computing machine, named Colossus, was built in Britain in 1943 and was in operation in 1944 decoding German messages during the Second World War.

From 1955, electronic transistors began to replace valve systems in computers, leading to the development of the first mainframe computers; in the 1970s, integrated circuits and then microchips replaced these transistors, and for the first time it became possible to think about computing systems whose size, costs, simplicity and energy requirements put them in the range of domestic consumers.

timeline

1970	1974	1981
First personal computer	First commercial microchip	First IBM PC

The microprocessor revolution The phrase 'personal computer' itself was featured in several advertisements in the 1960s, but the first machine truly to deserve the title was designed in 1970 by the Kenbak Corporation. Called the Kenbak-1, it cost $750 in 1971 – the equivalent of around six times that amount today. Less than 50 machines were built.

The Kenbak-1 did not have a microprocessor – just a combination of transistor-based circuits. In 1974, however, the American company Intel produced what's often thought of as the first commercially viable microprocessor, the Intel 8080. Around 500 times faster than the Kenbak-1's integrated circuits, this 8-bit chip was the basis of a 1975 computer, the Altair 8800 – manufactured by the young US company Micro Instrumentation and Telemetry Systems (MITS) – that would help transform the public perception of digital technology for good.

> **❝Ready to slash through long routines and come up with answers in milliseconds. The new Hewlett-Packard 9100A personal computer.❞**
>
> **1968 advert in Science magazine**

Touch-screen tablets

The newest addition to the personal computing family is the 'tablet' – a slim, portable device that's primarily controlled by a touch screen rather than a keyboard. Microsoft first demonstrated a tablet PC in 2001; but it was the release of Apple's iPad in 2010 that fundamentally shifted the idea of what a personal mobile computer could mean. Running a streamlined mobile operating system derived from that used on Apple's 2007-released iPhone, the iPad suggested a new kind of ease and intimacy in the use of mobile computing devices, and their emergence as platforms not simply for work and functionality, as laptops have traditionally tended to be used, but as fully-fledged media centres, for browsing, reading, watching, listening and playing. Computing is continuing to get considerably more personal.

1985	1991	2010
Microsoft Windows is launched	First Apple PowerBook laptop	Apple launches the iPad

> **If the automobile had followed the same development cycle as the computer, a Rolls-Royce would today cost $100, get a million miles per gallon, and explode once a year.**
>
> Robert X. Cringely

Priced at $439 in kit form – or $621 assembled – over a thousand Altair 8800s were ordered within a month of launch, and thousands more over the course of the year. A culture of modification and accessory-building rapidly sprang up around them. But it was on the software side that the Altair 8800 had perhaps the greatest effect, thanks to the release for it of a programming language called Altair BASIC – the very first product of a new company then called Micro-Soft which two friends, Paul Allen and Bill Gates, founded in response to the computer's release.

The Altair 8800 had helped to prove something that surprised almost everyone at the time: computers were not simply of interest to academics and experts; they had the capacity to ignite passions across the human spectrum. Building on this success, 1977 saw three other companies release some of the very first mass-produced machines that would go on to sell millions of units and help to establish digital thinking as part and parcel of daily life: the Apple II, Commodore PET 2001 and Tandy TRS-80.

Towards the present By the mid-1980s, the global personal computer market was worth billions of dollars, boosted by steadily improving hardware and software, and the gradual move towards Graphical User Interfaces (GUIs), such as Mac OS (released 1984) and Microsoft's Windows (released 1985). These were operating systems that allowed people to interact with their computers via coloured, interactive graphics rather than having to type in commands on a blank screen.

IBM released its first personal computer, the IBM PC, in 1981, and its success profoundly affected the personal computer market by moving it rapidly towards a common standard. Previously, software and hardware had been particular to different models and manufacturers, creating a fragmented market, but the huge success of IBM's machine led to a rash of 'IBM-compatible PCs' being released, and eventually to the acronym

How fast?

The world's first personal computer, the Kenbak-1, was capable of performing fewer than 1,000 operations per second on its release in 1971. Four years later, an Altair 8800 could perform 500,000. But this was barely the beginning. By 1982, Intel's new 80286 chip could operate at 2,660,000 operations per second, while the computers it was installed in had over 100 times more memory for running programs in than the Altair. By 1990, personal computer chips were operating at over 40 million operations per second; by 2000, this had risen to over 3.5 billion; and by 2010 to over 140 billion. And these chips were installed in home computers costing less than 10 per cent of the price of a 1980s machine, with around 10,000 times the memory capacity. This continuing story of getting more and more for less is one of the most important ongoing drivers of change – and waste – in digital culture.

'PC' itself coming to mean an IBM-compatible machine rather than any personal computer. The 1980s also saw the emergence of a new kind of portable computer, first marketed in 1981 but with little commercial impact until the late 1980s: the laptop.

Apple continued to operate its own software and hardware lines, but IBM-compatible machines dominated. They gradually gained a host of accessories that made domestic computing ever more powerful and universal: dedicated and increasingly powerful graphics and sound cards, CD-ROM drives from the early 1990s, larger and higher performance monitors and, in due course, internet connections.

By the year 2000, more than 100 million personal computers were being purchased a year; and by 2002 more than half a billion were in use worldwide, rising to a billion by 2008. Today, however, personal computers' dominance of the digital marketplace is shrinking, as they become simply one increasingly commoditized device among many – no longer many people's sole window into a new technological world.

the condensed idea
Computers are for everyone

06 Servers

Almost every action taken online involves at least one 'server' computer. In the simplest sense, a server is simply a system on a network that can provide services to other systems on that network. Today, thanks to the client/server model that underpins the entire structure of the internet, tens of millions of servers exist around the world – clustered, in the case of the biggest web services, within data centres holding thousands of units. This physical infrastructure consumes immense amounts of resources and gives the virtual world a substantial (and potentially vulnerable) real-world footprint.

In a typical client/server relationship online, the client is an individual computer or program such as a web browser, while the server, also sometimes known as a 'host', is the source of the information or service that the client wishes to use. All internet resources run according to the client/server model, meaning that there are a host of different server types: email servers that people connect to in order to use mail, web servers that operate websites, games servers hosting online video games, and so on. Servers also perform many of the higher level functions that keep the basic infrastructure of the internet itself operating.

One such high-level function is performed by servers that deal with the names of different websites, ensuring that the unique numbered addresses of every site on the web are successfully mapped into the addresses that people are accustomed to reading in their web browsers: www.bbc.co.uk and so on. This mapping function is performed across the web by Domain Name System (DNS) servers, which ensure that internet users can type in a web address into a browser and be successfully directed towards the right site.

timeline

1970s

First racked servers begin to be used

Serving by proxy

Using a proxy server introduces an additional link into the client/server chain: a 'proxy' machine sits between a user's computer and the service they are using. This has a range of uses, the most common of which is speeding up internet access: the proxy server caches information that is being used frequently by the client (that is, it keeps copies of it) meaning that not everything has to be sent from the actual server. Proxy servers are widely used by Internet Service Providers and data hubs to speed up traffic. But they can also be used to circumvent filtering or censorship. It may be impossible to access a particular website or online resource because its server details are blocked on a particular network, but using a proxy server as a go-between circumvents this. Proxy servers can also allow people to browse the internet anonymously by concealing their unique IP address, effectively acting as a mask between an internet user and anyone wanting to observe and trace their actions online. Chains of proxy servers can make the original source of web traffic almost impossible to trace.

Among DNS servers, 'root name servers' – those that operate the most fundamental part of the hierarchy of the domain name system, its 'root' zone – are especially important. These are, in effect, the nodes that ensure the functioning of the internet. Just 13 different root name servers exist around the world, named from A to M in the alphabet – although there are in fact multiple copies of each for security and stability reasons, with a total of around 250 root name server machines operating worldwide.

Server chains Simply accessing a page on the world wide web can involve numerous servers, as requests are rooted from a web browser on your computer through your domestic router or internet connection, then through different levels of domain name servers implementing the protocols governing web addresses to the server or servers on which the website itself is hosted.

> ❛If you hack the Vatican server, have you tampered in God's domain?❜
>
> **Aaron Allston**

If the website or service you're using is not on the same local network as your computer, your local DNS server will need to get its information from another DNS server – and will have to contact the root name server to find out which primary and secondary name servers have the relevant information about the web address you entered. Only once the actual numerical address of the website you're trying to visit has been relayed back to your computer can your web browser then contact the site directly and begin to display it on your screen.

Building a server Servers are physically specialized computers that function very differently to office or domestic machines. Their defining characteristic is that they should almost never need to be turned off: a server needs to be able to respond to requests at all times, and is expected to be operational well over 99% of the time (in the case of many businesses, this expectation can rise up to 99.995%). Reliability is thus a key concern, together with security of power supply and the ability to maintain a safe operating temperature. This often means installing backup and failsafe systems.

Who has the most?

The amount of computing power needed to operate the world's largest websites and internet companies is staggering. Hard numbers are difficult to come by, and are constantly changing, but in 2010 by some estimates Google was thought to operate more than a million servers in order to process the billions of requests that its websites receive. This might on its own represent around two per cent of all the web servers in the world, concentrated into purpose-built data centres at key global locations and consuming millions of dollars worth of power. By comparison, the world's largest computer chip manufacturer, Intel, had around 100,000 dedicated servers in 2010; and Facebook may also be approaching that number thanks to the enormous speed of its growth. Meanwhile, online retailer Amazon – with tens of thousands of servers of capacity, installed in part to ensure its site never crashes even during peak times of sales fever – is leading the world in renting out its server power to paying customers (see Chapter 41 on Cloud computing where this is addressed in more detail).

> **Today in our data centers we have literally hundreds of thousands of servers. In the future, we'll have many millions of those servers.**
>
> ### Bill Gates

These factors coupled with the need of most major digital services for a large number of servers mean that it makes sense to operate them in large groups, sometimes referred to as 'server farms' or 'data centres'. These can contain hundreds or even thousands of machines, physically arranged in racks: high metal cabinets that can traditionally store up to 42 servers stacked up vertically. These servers are machines stripped down to only basic components; a still more pared-down type of server, known as a 'blade' due to its extremely thin profile, has taken this still further, with up to 128 blade machines theoretically fitting into each server rack.

Server farms consume large amounts of electricity – more in eventual running costs than the purchase cost of the computers themselves – and generate large amounts of heat, meaning that keeping them cool and allowing air flow around the racks is crucial. This has traditionally meant expenditure on air conditioning, fans and raised construction to ensure air flow, but, with the potential energy savings running to millions of dollars, large companies are increasingly experimenting with basing their servers in locations with cold climates, using advanced ecologically friendly air circulation techniques, and even sea rather than land-based centres.

The energy consumption of servers is an increasingly significant environmental issue. Around two per cent of America's total electricity consumption is already spent on information technology, and with the steady global growth of the internet and online companies, the internet itself is becoming one of the world's fastest growing sources of emissions, thanks in large part to the massive energy consumption of the servers required to keep it running.

the condensed idea
Servers are the engines of the digital world

07 Browsers

Web browsers were invented at the same time as the world wide web and are an integral part of its architecture – the software tools through which users access an increasingly vast array of online applications, media, information, programs and social tools. The development of browsers from simple tools to arguably the world's most versatile and important software suites is a central part of the story of digital culture – and of the internet's increasingly seamless integration into daily life.

As explained in Chapter 2, the very first browser was created by Tim Berners-Lee in December 1990. Browsers are necessary for converting the markup languages in which the web is written into usable, coherent pages. If you were to attempt to view a web page within a simple text editor, you would see its 'source code' in raw form, encoding a series of instructions on appearance and performance that a browser would display as a fully functional web page.

Tim Berners-Lee may have released the first browser but it was a program called Mosaic, released in 1993, that first brought the web to a non-expert public. Mosaic boasted a number of firsts. Designed by a team at America's National Center for Supercomputing Applications (NCSA) and released for free, it displayed web images alongside text rather than in a separate window, featured an elegant graphical interface and, crucially, was soon usable on machines running Microsoft's Windows operating system rather than simply on the more specialized Unix operating system previous browsers had been designed for.

timeline

1991	1993	1995
World's first web browser	Mosaic browser, the web's first 'killer app', is released	Microsoft's Internet Explorer is released

The end of operating systems?

As web-based languages and applications become increasingly advanced, everything that a computer user does is increasingly taking place within the windows of a web browser rather than on separate, dedicated applications. One company that has taken this further than most is Google, whose own browser, Chrome – publicly released in 2008 – was designed from the beginning as a first step towards a future computer operating system that would function entirely on the basis of web-based applications rather than as a program installed on an individual computer. Chrome OS is due for release by the end of 2011, and is just one among a number of developments in operating an increasing number of core computing services via the internet rather than on local machines.

Transforming perceptions The arrival of web browsers as attractive, accessible graphical experiences was the beginning of a sea change in the way the internet was used. Until this point, accessible online services for non-expert computer users had largely been restricted to the services offered by ISPs like AOL, which offered proprietary email, news, chat, games and other services within the limits of their own private networks. Suddenly, though, the open spaces of the world wide web had begun to look like a genuinely mass phenomenon.

The next step in browsing came in 1994 with the release of Netscape Navigator, which was based on Mosaic and also available for free. Improvements on Mosaic included the ability to see the contents of web pages while they loaded, rather than watching a blank screen until all

2003
Apple's Safari is released

2008
Google's Chrome is released

> **❝Long-frustrated dreams of computer liberation – of a universal library, of instantaneous self-publishing, of electronic documents smart enough to answer a reader's questions – are taking advantage of [the Mosaic browser] to batter once more at the gates of popular consciousness.❞**

<div align="center">

Gary Wolfe, 1994

</div>

the data had been transferred. Other innovations that arrived via various updates to Netscape during the 1990s included the capacity for websites to store nuggets of information, known as 'cookies', on a user's computer for use by their browser to offer an enhanced or customized service; and the first scripting language for a browser, JavaScript, which allowed a number of dynamic functions to be embedded in web pages – from images that changed when a mouse passed over them to interactive forms and menus.

Corporate rivalries By 1996, Netscape overwhelmingly dominated the expanding browser market. At this point, however, Microsoft began automatically including a copy of its browser, Internet Explorer, with the Windows operating systems installed on new computers. The strategy was a resounding success: so much so that Microsoft would later find itself facing antitrust litigation based on competition law. By 2002, Internet Explorer had risen to dominate the browser market, being used by around 95% of web users.

Since then, however, fuelled by continued innovation in web applications and the ever-growing community of web users, the market has opened up considerably. The open-source successor to Netscape, Mozilla's Firefox browser, is now the choice of almost a third of web users, still behind Internet Explorer's total of over 40%. Meanwhile, Apple's browser Safari, first released in 2003, dominates among Mac users and holds around 6% of the overall browsing market. The other major player, Google, launched its browser Chrome in 2008 and currently holds a rapidly rising 12% of the global market.

Plugging in As the uses of the web have expanded, browsers' native capacity to display increasingly complex web pages has been complemented by the growth of 'plug-ins' – additional downloadable

How well does it score?

Rendering every element of a modern webpage correctly can be a difficult task for a browser, given the complexity of the elements that go into creating the most advanced online services – and it can be equally hard for a user to know whether their preferred browser meets the best current standards. The web page Acid3 was designed with this in mind. Simply visit the address http://**acid3**.acidtests.org and your browser will attempt correctly to render a page that tests its conformity to the Web Standards Project's current criteria, broken down into 16 subtests of everything from scripting to rendering. The result will be a test image and a score out of 100. At the time of its initial release in 2008, every available browser failed to get full marks, although some – such as Chrome – can now manage this.

pieces of software that allow a browser to display media developed to run on third-party programs like Adobe's Flash (for animations, games, video and interactive media) or Apple's iTunes and QuickTime.

Such tools substantially increase the versatility and power of browsers – although not all are compatible. For example, versions of Apple's Safari browser designed for use on mobile and tablet devices like its iPhone and iPad are not compatible with Adobe's Flash – making large amounts of online multimedia content impossible to use through these devices. As such omissions suggest, browsers remain a vital battleground for digital technologies, determining much of what it is possible for businesses and services to achieve – or fail to achieve – online.

the condensed idea
Browsers bring the web alive

08 Markup languages

Markup languages are the encoded sets of directions that tell a web browser exactly how every web page should look and behave. The most fundamental of these languages is HyperText Markup Language, or HTML, which defines the basic format of web documents and enables them to be viewed through browsers and linked together. But there are also several other important languages and language protocols that collectively allow the modern web to deliver sophisticated interactive functions we now take for granted.

The first important extension to HTML itself was called Dynamic HTML, or DHTML for short. The 'dynamic' label signified that, for the first time, web pages were being written in a language that allowed them to display content that could change and function interactively – as opposed to the original HTML, which simply instructed browsers on how to display a static page. With the early web pages based entirely on the first versions of HTML, any kind of change or response from a web page meant that it had to be downloaded all over again from the server. By contrast, a page written using DHTML can react to a web user's actions without having to contact a server and re-load every time something happens.

DHTML Unlike HTML, DHTML is not a single language: the term refers to a combination of three core technologies that between them allow web pages to perform dynamically. First is the Document Object Model (DOM), a tool able to define every single object on a web page. Because a page using DOM can be treated as composed of actual 'objects' rather than simply an undifferentiated quantity of information, it becomes possible for

timeline

individual objects within the page to change or interact with a user without all the information on the page needing to be sent out over the internet again.

The second aspect of DHTML is Cascading Style Sheets (CSS), a series of templates able to define how everything from font size to colour, spacing and image sizes should be applied to everything on a web page. Like a DOM, CSS provides a general set of rules for a web page, rather than fixed information about every individual part of it, allowing for far greater flexibility and scope. Anything labelled as a 'headline', for example, can automatically be assigned to appear in large, bold, underlined type – allowing elements of the page to change automatically simply by shifting the style being applied to them.

Third and most important of all in DHTML is 'scripting languages'. These are effectively a miniature programming language that download a series of instructions to be run from the 'client' side – that is, within an individual's web browser – rather than the server side of the web. These instructions allow a web browser to offer a far more complex experience to a user than would be possible if every single action and event had to be determined by querying the server.

> ❛‘We need to put tools for language growth in the hands of the users.❜
>
> **Guy Steele**

Keeping up standards

A language is only as powerful as the number of people who speak it – and a great deal of effort is similarly expended ensuring that a common standard is defined for all of the languages and protocols that underpin both the web and digital technology in general. Several organizations are involved in this process. The World Wide Web Consortium (W3C) is the web's leading international standards organization, updating and maintaining standards for most of the major public protocols and languages used online: from CSS style sheets to XML and HTML. The International Organization for Standardization (ISO) is another important international body. Headquartered in Geneva and founded in 1947, it oversees many of the world's most fundamental digital standards, from programming languages to graphics, data formats, networking and hardware.

1998
XML is first defined

2005
Term AJAX is coined

JavaScript The most popular and important of these client-side scripting languages is JavaScript. Released in 1995 as part of the Netscape web browser – having originally been developed under the name Mocha – it had nothing to do with the programming language called Java. JavaScript rapidly became extremely popular, enabling web developers to provide far richer online experiences than had been possible simply through early HTML. Microsoft rapidly released their own compatible scripting language, JScript, for their own rival web browser in 1996. JavaScript and JScript enabled web developers to devise programming functions that could be applied to 'objects' defined by the Document Object Model on a web page, allowing the first versions of much of what we take for granted on the modern web: dropdown menus, interactive forms to fill out, words and images that change colour or size when a mouse moves over them and so on.

> **The purpose of JavaScript is to give potentially millions of people who are not programmers the ability to modify and embellish web pages.**
>
> Brendan Eich, 1996

XML Another key stage in the evolution not just of the modern web but of digital culture in general was the release in 1998 of Extensible Markup Language, or XML. XML was based not on HTML, but on a pre-internet set of general principles for defining the style of documents. It had originated in the 1960s as a means of making electronic documents readable according to a single standard practice across many types of device.

XML applied this principle of standardization to the web, addressing a key issue with its continuing growth – the importance of websites being able to be correctly 'read' and displayed by many different kinds of device and browser. Before XML, developers effectively needed to maintain several versions of a website, each with unique code, in order for it to function correctly across different browsers and devices. XML, however, defined a series of rules for encoding information in a standard format readable by all kinds of machines and programs, such as web browsers but also many other programs.

In this sense, XML functioned not as a single language but as a set of rules for devising compatible languages: today, hundreds of languages based on the principles of XML are used across web browsers, office and professional tools, databases and many other fields. Thanks to the common standard defined – and regularly updated – in XML, all these developments are able to remain compatible on a fundamental level.

A history in print

Both the word 'markup' itself and many of the most common terms in online markup languages date back not to the first days of digital technology, but to a far earlier technological transformation: the birth of printing. Printing with movable type first appeared in Europe in the 15th century and was a laborious process that usually involved handwritten manuscripts being 'marked up' with instructions to the printer as to how they should be presented on the page: which words should be in bold, italics, headings, underlined, or set out separately. Several printer's terms survive to this day in online markup languages: from the abbreviation 'em' signalling 'emphasis' (type in italics) to the use of the tag 'strong' to signal bold type.

Beyond XML The most advanced websites today are highly interactive and increasingly function more like computer programs in their own right. One of the most powerful ways of achieving this is through a technique known as AJAX (or Asynchronous JavaScript and XML). Like DHTML, AJAX is not a single language, but a group of technologies that collectively allow for the existence of highly interactive websites, such as email programs or many shopping or entertainment sites.

The term AJAX was itself coined in 2005, although the kind of technologies it involves had been in use for some time. Most importantly, it allows web pages to retrieve data and operate independently while a user is viewing and using a page – hence the 'asynchronous' description in its name, describing the fact that all of these processes can occur independently at different times. Further details on how complex, interactive content is delivered online can be found in Chapter 17.

the condensed idea
Digital technologies demand common digital languages

09 Search

Without the ability to search the increasingly vast amounts of information it contains, the internet would be of limited use. As early as 2005, Eric Schmidt, the CEO of Google, estimated that there were around five million terabytes of data online: approximately 1,000,000,000,000 bytes of information. Of that, Google – the world's largest search engine – had indexed just 200 terabytes, about 0.004%. The amount of data on the internet has grown many times larger since then; and searching the most important parts of it remains one of the greatest challenges of a digital culture.

Google was founded in 1998 and is the most famous company to have built a business out of searching through the information that's on the internet. But there are and have been many others devoted to the same task. The first internet search engine was built eight years before Google even existed, in 1990, by a student at McGill University in Montreal. It was known as Archie – derived from the word 'archive' with the 'v' removed – and was the first program to perform a simple but crucial function: it automatically downloaded a list of all the files available on every public internet site it could find. Users could then search through this list of file names, to see if they matched particular words or abbreviations.

The next stage in search development came in 1993. By this stage, the world wide web had begun to take off, meaning that the internet didn't just consist of files stored on connected computers. There were also an increasing number of actual web pages out there, being hosted on computers that acted as actual web servers rather than simply places where files could be stored. Another student, this time at MIT, created

timeline

1990	1993	1995
First internet search engine	First web search engine	Yahoo! Web directory launched

something he called the World Wide Web Wanderer – a program able not just to record the names of files on machines connected to the internet but actually to crawl around finding websites and recording their exact locations. This 'wanderer' was the first example of what's called a web 'robot', as it could function automatically. Over several years, it built up an index, giving some indication of the ever-growing size of the early world wide web.

Full indexing The next great leap came in 1994, with a program called WebCrawler. This was the first search engine that built up an index not just of the names and locations of different websites, but also of every single word within the pages it visited. This allowed users for the first time to search through the actual contents of websites via a search engine, rather than having to find a page that looked interesting and then go and visit it in order to see whether it was actually of interest to them.

global rivals

Google is the dominant search engine in almost every country in the world, a remarkable feat for an American company in so thoroughly international a zone as the internet. Today, Google operates in over 60 global regions and in a similar number of different languages. But there are a handful of countries in which it does not dominate. In China, the native Chinese search engine Baidu – which follows government censorship rules – had in late 2010 over 70 per cent of the search market compared to Google's less than 25 per cent. In Russia, the Russian company Yandex controls over 60 per cent of search, while in the Czech Republic and in South Korea local companies also dominate. Overall, though, these are exceptional cases: Google in late 2010 boasted over three-quarters of all global searches, followed by Yahoo!, Microsoft's Bing search engine and Baidu, all at under ten per cent.

1998
Google founded

2000
Baidu founded

2009
Microsoft launches Bing

Trying to cheat

Almost as soon as there were search engines, there were people trying to take advantage of them by pushing their own websites up the rankings of results: a process that has meant search companies have, in turn, had to refine their methods to stay one step ahead of the cheaters. In the crudest cases, people may try to generate a huge number of links to their own website by posting these all over other people's sites, or they may attempt to pack their site with the kinds of words that a lot of people tend to search for, such as 'sex' or 'money' or the names of celebrities. There can be a fine line between 'search engine optimization', as it's called when you try to make your website as popular as possible in search traffic, and outright cheating. And one reason that the exact details of search engine's algorithms tend to be closely guarded secrets is that they aim to make it as difficult as possible for people to rig results and shortcut their way towards potentially valuable high levels of attention online.

By this stage, the commercial possibilities of the web were becoming clear and search was beginning to look like a valuable business opportunity. Between 1994 and 1996, a host of rival search engines launched, taking advantage of the essentially open structure of the web to compile their own indexes of sites and attempt to win over users. These engines included Lycos, Magellan, Excite, Infoseek and AltaVista, and between them rapidly drove innovation in a field that was all about winning users' attention by attempting to provide more powerful, and more useful, tools than anyone else.

Usefulness The idea simply of matching search terms to websites and other resources is only a small part of the story of search. Just as important, and far more difficult to ensure, is the idea that searching for something should display not only accurate and comprehensive results but also useful ones. There are three main ways of trying to ensure useful results, all of which are vital for successful modern search engines: having as comprehensive an index of websites as possible; giving users as many

> **❝Some say Google is God. Others say Google is Satan. But if they think Google is too powerful, remember that . . . all it takes is a single click to go to another search engine.❞**
>
> **Sergey Brin**

tools as possible to help them search; and – trickiest of all – trying to learn from people's behaviour and from websites themselves what is and isn't considered useful information by people looking for something.

Through the mid-1990s, innovations in these fields proliferated. Lycos, for example, were the first to allow users to look for two words found close to each other within a website, while AltaVista offered the ability to search for media, like images and videos. It was, however, a research project begun at Stanford University in January 1996 by students Sergey Brin and Larry Page that would come up with the most powerful innovation in the field: an algorithm they called PageRank.

PageRank was a way of measuring the importance of any particular website, by automatically looking at the number of other sites that connected to it, and it formed the basis of Brin and Page's experimental search engine, Google. In 1998, Google was incorporated as a company, and it has continued to refine its PageRank algorithm ever since, in the process coming to dominate around three-quarters of the world internet search market. Rival search engines remain active around the world, however, and for all of the companies active in the field, attempting to offer good-quality search results in the face of an ever-expanding internet demands a huge amount of time, effort and innovation.

the condensed idea
Data is only useful if you can find it

10 Web 2.0

A few years after the dotcom crash of 2001 soured many digital dreams, the idea that the web was entering a 'second phase' began to gain ground. What the term used to describe it – Web 2.0 – referred to was not so much a technological advance as a general shift in why and how people interacted online. In its first decade, the web was seen primarily as a tool for finding and sharing information. Web 2.0 described both an increasingly active and an increasingly ubiquitous digital culture: a place where the tools for collaborating, socializing, sharing and creating were accessible to all.

The very earliest days of the internet had, before the existence of the world wide web, been shaped by a computer-literate minority, and this balance of power continued through the early days of the web, with early adopters often being highly computer literate. Many 'ordinary' users, drawn by the web's ease of use, tended to browse and consume content rather than create it themselves.

This gradually changed thanks to the steady evolution of more powerful and accessible web-based tools that allowed every web user to become an active participant in the online world. This was something that Berners-Lee had from the beginning designed the web to be, but that needed to achieve a certain critical mass of accessibility before it could become a reality.

This came about through the gradual evolution of a combination of technologies and attitudes that were perhaps most influentially embodied in the form of technologist Tim O'Reilly's inaugural Web 2.0 Conference,

timeline

1999	2001	2003
RSS feeds are introduced	Wikipedia is founded	Term 'social bookmarking' is coined

> **If your target audience isn't listening,
> it's not their fault, it's yours.**
>
> Seth Godin, *Small is the New Big*

held in San Francisco in 2004, which set out to explore 'how the Web has developed into a robust platform for innovation across many media and devices – from mobile to television, telephone to search'. The answer was a user-centric one: revolving around the power to search, create, collate and share and categorize content, interconnect these activities, and to do all of this in an increasingly rich online environment.

Collective creation One of the core creative technologies at the heart of Web 2.0 is the 'weblog' or 'blog' – a platform for everyone and anyone to publish their words online, but also a platform for comment and dialogue and for an increasingly active culture of following and responding to others' actions online. This is facilitated by connecting applications like 'readers', which collate updates from a web user's personal selection of favourite sites in one place.

This culture of facilitation around blogging is significant, as it was the emergence of these tools – tags for indicating the content of blog posts, comments for feedback and sharing, feeds that allowed easy syndication, third-party programs designed to collate favourite blogs – that stimulated an online culture of mass participation.

Tagging the world

Tagging is one of the simplest forms of digital classification: words or phrases are associated with a page or piece of information, and these 'tags' are then used to help others understand what that information is about. This process lies at the heart of many innovations associated with Web 2.0, as it allows millions of internet users collectively to generate a picture of what the key themes are in everything from blogs to books to news and links: a structure that can then be searched, aggregated, compared, shared and used to build up a global picture of the ways in which different websites and pieces of user-generated content relate to each other and the world.

2004
First Web 2.0 conference

2005
Video-sharing site YouTube is founded

> **'An essential part of Web 2.0 is harnessing collective intelligence, turning the web into a kind of global brain.'**
>
> **Tim O'Reilly, 2005**

Perhaps the single most influential example of such participation was launched in 2001: the online encyclopedia Wikipedia, begun with the stated aim of being a universal reference source created and maintained entirely through the efforts of volunteers, and open to anyone who wished to contribute. The idea of a 'wiki', or online database that anyone could add entries and information to, is itself one fundamentally connected to that of Web 2.0: derived from the Hawaiian word for 'quick', the first one was started in 1995.

In the decade since its founding, Wikipedia has become an emblem of the collaborative potential of the web – of, in Tim O'Reilly's phrase, 'harnessing collective intelligence'. It's a trend that extends broadly across almost every major success story associated with Web 2.0: from Google's ability to measure the link structure of the web in order to optimize its search results to Amazon's integration of user reviews, comments and recommendations into the basic structure of its site.

Really Simple Syndication

Really Simple Syndication, or RSS for short, was born in 1999 and is one of the most popular kind of web feed – a way of automatically making available content and information from a website for other sites to syndicate. The simple principle of allowing material automatically to be extracted for everything from blogs to news and media sites was an important part of the Web 2.0 process of collaboration and synthesis. Feeds made it easy to follow and distribute content from numerous other sites, and to automate the process of checking for and classifying updates. Armed with syndication technology, the amount of sites any web user could regularly monitor increased by an order of magnitude.

The social side Another mantra of Web 2.0 is the power of viral spread – that is, the diffusion of an idea not thanks to a marketing push by its originators, as in the old media world, but thanks to active distribution via its audience. Central to this process online has been the development of numerous connected social tools and platforms: from 'social bookmarking' sites like Digg (launched in 2004), where users post links to stories and vote on how interesting they find them, to fully fledged social networking sites, which began to flourish with the founding of Friendster in 2002 and have since come to dominate much of the web thanks to the staggering success of Facebook – founded in 2004, and featuring over 600 million users as of early 2011.

Whether all of these forces mark a transformation over the first decade of the web that actually merits the 2.0 label is a matter for dispute – Tim Berners-Lee for one dislikes the phrase – but they unquestionably mark a hugely increased leveraging of the power of web users as active participants in digital culture; an idea enshrined in the 'long tail' theory, which argues that the majority of a market is filled not by a few major successes, but by a huge number of niche products and ideas.

As social media and a proliferation of networked devices begin to take the web to its next stage, the legacy of Web 2.0 is evident perhaps above all in a shift of assumptions so fundamental it is now taken for granted: that everyone online has a voice, and an active role to play – for better or for worse – in shaping digital culture.

the condensed idea
Interaction and collaboration are a new global standard

11 Netiquette

How should you treat other people you encounter online? Inevitably, different rules and conventions apply to interacting with other people via the internet rather than in person. Perhaps above all, we are freer in our behaviour when we don't have to deal with someone else face-to-face: more able to be rude, dismissive or silly but also more able to be altruistic, collaborative or helpful. As the internet and digital culture has grown, the idea of encouraging positive behaviour online has grown with it; something summarized in the idea of an unwritten etiquette of behaviours on the net, or 'netiquette'.

Codes of user behaviour existed on the internet well before the world wide web. Early internet interactions centred around email, discussion forums and news; the word 'netiquette' was in use for much of the 1980s as a tongue-in-cheek description, playing its part in popular 'net behaviour' guides that reflected ironically on early antisocial net habits such as signing posts with overlong and over-elaborate signatures, sending out hundreds of copies of an email, writing sloppily and using unhelpful subject lines to describe your work.

The first document to use the word 'netiquette' explicitly as an attempt to enshrine what good behaviour meant on the young internet appeared in 1995. Released by Intel corporation, it was aimed at informing the rapidly growing community of new internet users of some of the protocols and conventions that had been established over the earliest years of the internet's growth. In particular, it broke down internet usage into three main categories – one-to-one communication, one-to-many communication and internet services – and set out a number of

timeline

1983	1992	1995
First reference to a 'netiquette document'	First description of 'trolling' on internet	Intel publishes its Netiquette Guidelines

Privacy and plagiarism

Precisely because copying most material is trivially easy online, plagiarism and the failure to acknowledge others' work – whether by passing off entire copied websites as your own work or simply failing to give credit for an idea or quotation – are two of the most common and serious breaches of netiquette. Similarly, given how public an arena much of the internet is, a failure to respect others' online privacy can be a serious breach of trust: publishing a private email address and correspondence, for example, or just openly copying large numbers of strangers into a correspondence. More trivially, emails intended for one recipient only but accidently forwarded to others are one of the most common – and potentially embarrassing – breaches of netiquette in the digital world.

both general ('Be conservative in what you send and liberal in what you receive') and particular ('Use mixed case. UPPER CASE LOOKS AS IF YOU'RE SHOUTING.') pieces of advice based on the norms established by early internet users.

Over time, as the internet and then the web expanded by many orders of magnitude, these guidelines gave way to something at once vaguer and more important: the notion that the positive potential of cyberspace could only be realized if certain norms of ethical conduct were observed, centred not only on courteous conventions to do with communication, but on a more general willingness not to abuse perhaps the two most central features of online interactions: anonymity and multiplicity (that is, the ease of reproduction and distribution).

Flames, griefers and trolls One of the earliest phrases related to online conduct that's still in use today is 'flaming' – the posting of deliberately inflammatory content, originally on one of the internet's early discussion forums. Trying to incite flaming by publishing something that invites extreme comment is known as flame-baiting and can lead to a 'flame war' in response between other members of the discussion.

2007
Bloggers' Code of Conduct

2008
California passes anti-cyber-bullying law

Such behaviour has translated predictably enough from discussion forums to live chat, social networks, video games and most online spaces within which people gather. Today, the generic term 'griefers' is applied to those who enter online spaces – and online games in particular – with the particular intention of disrupting things for others. One particular and persistent subset of griefing is known as 'trolling' – where someone pretends to be a naive ordinary participant in an online conversation in order to gain the trust of – and then inconvenience – others.

Sock puppets and astroturfing One increasingly common breach of netiquette is the self-serving brand of dishonesty of using 'sock puppets' – other, fictional online identities that allow people to create the false impression that other people endorse them or their work. A typical modern use of sock puppets might involve an author posting several favourable reviews of their own works on Amazon under fictional identities; or, more seriously, the creation of multiple fictional identities on political blogs in order to advance a particular view, or undermine opposing views.

Precisely because of the ease with which it can be perpetrated, this kind of deception is a severe breach of one of the most basic underlying principles of netiquette – a commitment to open and honest debate. A

cyber-bullying

Many breaches of netiquette can be gathered together under the single heading of cyber-bullying: online behaviour that singles out particular individuals and subjects them to abuse, and that may also involve 'cyber-stalking' them across different sites and forums. A combination of anonymity and the increasing universality of internet-enabled devices like smartphones can make cyber-bullying both more common and more difficult to escape than real-world bullying, especially among younger web users. As awareness of the potential severity of such behaviour increases, legislation is being passed making online threats and persecution illegal in many countries. Publishing false and defamatory information about others online, another severe breach of internet ethics, is also increasingly being taken seriously and prosecuted as a serious offence in an increasingly digital society.

related practice to the use of sock puppets is 'astroturfing' – something not restricted to the digital world, but especially prevalent within it, where a false impression of a 'grass roots' movement in support of something is created by disguising pre-planned advertising or publicity campaigns as spontaneous. From commercial products to politics, spontaneity can be all too easy to simulate.

> **❛No matter how well you know the rules of netiquette, you will eventually offend someone who doesn't.❜**
> **Don Rittner**

Codes of conduct One of the first positive codes of conduct to achieve wider influence on the modern web was the so-called 'bloggers' code of conduct' first proposed by Tim O'Reilly in 2007 as a reaction against the insincerity, incivility and dishonesty undermining honest and productive discourse on many blogs – and indeed the wider web as a whole. O'Reilly's code was aimed at bloggers but in its seven proposals encapsulates most of the basic principles of online integrity.

These are: taking responsibility for both your own words and the words of others that you allow on your site; indicating your tolerance for abusive comments, so that you can avoid content likely to offend you; not automatically tolerating anonymous comments, as these may encourage abuse; ignoring rather than 'feeding' trolls and other provokers; taking the conversation offline if cyber-bullying becomes a serious issue; confronting people you know to be behaving badly online; and not saying anything digitally that you wouldn't be prepared to say in person.

This last point is perhaps the most telling of all and the neatest single-sentence summary of netiquette around: if you wish to be part of a civilized digital culture, treat it as you would any other civilized realm, and maintain the same standards that govern decent interactions between people – who, whether the space they are interacting within is virtual or physical, themselves remain equally real.

the condensed idea
A healthy online culture is an ethical culture

12 Blogging

The idea that anyone who wants to could write a 'weblog', or 'blog' for short, was one of the central aspects of the radicalism of the early internet. Publication had historically been something achieved only by specially selected writers, while in the early days of the web, building a website was a skill possessed by only a minority of users. The culture of the blog changed this, putting into the hands of every web user a simple way of publishing their own words and ideas online. For the first time in history, everyone was an author.

The word 'weblog' first appeared in 1997, followed two years later by the word 'blog' itself. The ideas behind blogging, however, evolved alongside the early internet throughout the 1990s. Before 1990, the standard way of sharing ideas on the early internet was via newsgroups, which essentially functioned as moderated forums for discussion: members could post comments and ideas, which would then be shared with members of the group if they were approved. As the world wide web gained users, however, the idea of keeping online diaries began to develop: people started to set aside one part of their website for posting regularly updated content about what was going on in their lives. One such pioneering diarist was a student at Swarthmore College in Pennsylvania, Justin Hall, who began a website called 'Justin's Links from the Underground' in 1994 and increasingly devoted space on this to telling visitors about what was going on in his life.

Regularly updated personal websites in the 'diary' style had a deep appeal both to readers and writers and became increasingly popular towards the end of the 1990s – a development reflected by the emergence of the first dedicated blogging tools. In October 1998, the service Open Diary

timeline

1994	1997	1999
First online journals appear	Word 'weblog' is first used	LiveJournal is founded

was launched, allowing users to blog without themselves owning or maintaining a website. Shortly after launch, Open Diary introduced one of the facilities that would become a central part of blogging culture: readers were able to post comments responding to a particular blog post, allowing a conversation to be carried on in public view in response to someone's writing, and allowing blog writers to see for the first time what kind of response their words were generating.

New roles The development of blogging as an open, accessible tool was driven by the launch of services like LiveJournal in March 1999 and blogger.com in August that year. As blogging began to break into popular consciousness, distinct genres began to develop in addition to simple personal diary formats. Political blogs were some of the first to gain wide notice, and 2000 and 2001 saw the founding among others of former editor of The New Republic Andrew Sullivan's blog, The Daily Dish, and law professor Glenn Reynolds's 'Instapundit'. Unlike print media, 'live

> **❝A blog is in many ways a continuing conversation.❞**
> **Andrew Sullivan**

The power of blogs

In the last five years, some blogs have risen in profile and influence to a similar level to the largest newspapers and broadcasters – not to mention taking on many of the features of a professionally run media outlet themselves. The world's most-read blog, progressive political site The Huffington Post, now employs around 60 staff, with four regional versions across the USA. Engadget, the world's top technology blog, operates in nine different languages globally and is arguably the world's single most influential technology news outlet – closely followed by the TechCrunch network. Meanwhile, news and celebrity gossip blog TMZ broke some of the biggest stories of recent years, from Mel Gibson's arrest to Michael Jackson's death.

2003	2005
Google buys blogger.com	Huffington Post is founded

> **❝Where the internet is about availability of information, blogging is about making information creation available to anyone.❞**
> **George Siemens, 2002**

blogging' allowed for almost instant political commentary on key events, while the very structure of blogs encouraged a newly integrated level of political comment, quotation, debate and reference to online materials between bloggers.

Cultural, gossip, technology and special interest blogs soon proliferated, and often found themselves able to out-compete traditional media in terms of speed, frankness and specialist attention to detail. Blogs grew in influence in parallel with their audience, a process catalysed by the Web 2.0 structures and conventions around commenting, tagging, syndication feeds and 'blog rolls' – the habit of listing on your own blog a selection of your own favourite bloggers.

In 2004, 'blog' was selected as word of the year by Merriam-Webster's dictionary. By this stage, blogging was established as something approaching a medium of its own – ranging from those who simply blogged as a diary, or as a marketing strategy, to those who treated it as a serious form of art or comment. Perhaps inevitably too the art of posting inflammatory comments on blogs – 'trolling' – had firmly established itself as a parallel digital art.

By the mid-2000s, passionate communities of interest were also building up around popular blogs – or even generating blogs communally, as in the case of tech news website Slashdot, whose stories are submitted and voted on by readers – while blogging was increasingly becoming a method for cultural and political figures alike to communicate directly with their audience. British author Neil Gaiman began blogging in 2001, gathering a huge following; British MP Tom Watson began blogging in 2003, one of the first figures in British politics to do so.

More than words As the content of the web has grown richer, blogs too have moved away from being based simply in words. Art and photography are now common subjects – as are blogs that take advantage

Micro-blogging

The world's most famous micro-blogging site, Twitter, neatly embodies the concept: instead of posting detailed posts in the form of an online diary, micro-blogging invites users to post extremely brief (140 characters is the maximum length in the case of Twitter) updates about their status that are published instantly, forming a real-time stream of words and links. Given the maturity of blogging as a medium, some commentators look to micro-blogging as an image of its future: it integrates seamlessly with social networks, is suitable for short attention spans and mobile devices, and offers an immediacy that can make even daily blogging seem slow.

of the essentially limitless space offered by online publication to cover a specialist topic in exhaustive detail through words, images, sounds and videos. Major product reviews on modern technology blogs often incorporate all these media and can run to thousands of words – and thousands of comments.

Audio blogging – in the form of downloadable audio files, often referred to as 'podcasts' – is another way of finding a particular audience: an important art, given that well over a hundred million blogs are now active across the world in the English language alone. The influence of blogging has been so powerful, in fact, that it can be increasingly hard to draw a line between blogs and the online presence of traditional media outlets – almost all of which now feature not only blogs, but also most of the innovations that blogs helped to popularize, from comments to syndicated feeds.

the condensed idea
Now anyone can be an author

13 Aggregation

In an age where information is increasingly available to all in overwhelming quantities, filtering and making such information useful is a hugely important task. To aggregate simply means to gather together into a single place and, alongside the ability to search data, aggregation has become one of the most fundamental of all digital ideas. It can also be controversial, with some arguing that the ease of simply gathering rather than creating information online is helping to drive original content creators such as newspapers out of business.

The practice of aggregating information long predates digital culture. Publications like *Reader's Digest* could be seen as an aggregation of written ideas and content, while the ancient tradition of publishing almanacs, miscellanies and annuals testifies to the self-evident utility of accumulating information in one place. As so often, what the digital version of aggregation has brought with it is an exponential increase in the complexity and scale of this process, together with the potential for its increasing automation.

There are two fundamental types of digital aggregation: customized aggregation, taken from sources of information chosen by individual users; and centralized aggregation, which individual users themselves do not control, but that is chosen either by a particular individual, individuals or an automated process.

Customized aggregation Well before the web existed, internet users were able to access a very early form of aggregation in the form of 'message reading' services such as GNUS – a simple piece of software

timeline

developed in 1988 that in addition to checking a user's email account could also subscribe them to news groups of their choice, meaning they would automatically receive news updates in a separate folder to incoming emails.

Services like GNUS functioned rather like a modern mailing list: once you had signed up, messages would be sent to you until you ended the subscription. Towards the end of the first decade of the web's existence, however, things had begun to get more complicated, with basic news-reading software integrating increasingly poorly with much of the content being generated online: blogs, specialist interest and news sites that were generating complex, frequent output, including images, links, sounds and new levels of metadata classifying them by type and topic.

The key response to this arrived in 1999 in the form of a specification called Really Simple Syndication, or RSS (outlined briefly in Chapter 10). RSS was able to take the content of a website and produce a page of code in XML format, complete with a title, description and link to the original content. This XML code could now be taken and displayed on a separate website for which the term 'aggregator' was coined. Users created an account for free on an aggregation site, and then – as the popularity of the RSS specification rapidly took off – subscribed to receive a regularly updated feed of content from the blogs, news and other sites of their choice.

News controversies

In April 2010, media magnate Rupert Murdoch launched a vituperative public attack on search engines and others offering new aggregation services, accusing them of 'taking stories for nothing' and tapping for free into a 'river of gold' online. Later that year, a number of Murdoch's newspaper titles put up paywalls around their websites, preventing any search, viewing or use of their content online without a subscription. Murdoch's strategy may or may not prove a commercial success but his concerns echo those of many in traditional content-production businesses, who worry that the ease of online aggregation and the lure of leading aggregation sites and services mean that expensively generated original content is re-used outside of its original context, leaving little opportunity for its creators to gain either profit or credit.

2003	2006	2010
NewsGator is launched	BuzzFeed is founded	Rupert Murdoch introduces paywalls around his newspapers

Social trends

The idea of 'digital curation' – where individuals or editorial teams exercise their taste in selecting interesting daily links – has gained a new force thanks to the rise of social media, and in particular thanks to Facebook and Twitter, which make following and sharing an individual's recommendations extremely easy. Social media have also, however, superseded many of the roles that customized aggregation services once played in helping internet users keep track of everything of interest to them online. Talk of aggregators, today, is more likely to describe a form of automatic data-gathering or analysis service than it is an old-fashioned tool for reading blog feeds. There are, however, more aggregation tools appearing by the month to help social media users manage these services: from lists of most retweeted items to the most-shared links, the trending topics or just a summary of everything that everyone else has been saying about you.

By 2003, RSS-based aggregators were a mainstream phenomenon and part of the vanguard of Web 2.0. In August that year, an article in Wired magazine announced that 'maniacally wired netizens' were starting to turn 'to a new breed of software, called newsreaders or aggregators, to help them manage information overload'.

Popular early RSS aggregation services included NewsGator and SharpReader, both launched in 2003. Today, the ability to display feeds from both RSS and its main rival format, Atom, are integrated as standard into most web browsers and email clients. The modern aggregation market has consolidated considerably, with the Google Reader service – first launched in 2005 – dominating the market, with Bloglines in second place.

Aggregation websites Not all web users will have used or even encountered personalized aggregation services. Far more people, however, will have experienced aggregation websites and services based on the selective compiling of content for users simply to view rather than to choose for themselves.

One of the first websites to make an impact by aggregating news was the Drudge Report, which originated in 1996 as a gossipy newsletter service, but developed the next year into a website onto which the newsletter's editor,

> **Human wisdom is the aggregate of all human experience, constantly accumulating, selecting, and reorganizing its own materials.**
>
> **Joseph Story**

Matt Drudge, would post a daily selection of headlines and links to items around the world that had caught his attention.

Numerous other successful aggregation websites have been founded on the basis of regularly updated links reflecting an individual's or editorial team's taste – from popular cultural hubs like Arts & Letters Daily, founded by philosopher Denis Dutton in 1998, to BuzzFeed, a site founded in 2006 whose team of editors specialize in capturing the current cutting edge of viral media.

Automation and expansion Aggregation sites with links chosen by dedicated editors continue to be a popular online service. But by far the greatest growth in the field has come from automated and socially driven services, based on keywords, algorithms and social trends.

Google's news service, for example, is an aggregator entirely based on automated search and analysis of trends across thousands of news outlets at any particular moment. 'Social news' sites like Digg and reddit, meanwhile, aggregate links that are gathered – and then voted on – by readers. Other sites, known as 'scrapers', automatically search particular types of websites hundreds or thousands of times a day, and post the results in one place for users to compare: a service that has led to the growth of hundreds of specialist scraping sites, dedicated to everything from shopping price comparisons to betting odds, travel deals or car prices. There are even aggregations of aggregators, such as Popurls, a site that lists the hottest links on other major aggregation services.

the condensed idea
Bringing a world of information into one place

14 Chat

Real-time communication with other people may seem one of the most self-evident uses of the internet – and one of the areas in which technology has little significant role to play in transforming such a fundamental activity. Yet live online conversations have both developed a number of important subcultures and contributed to the nature of digital culture as a whole.

Before the internet even existed, real-time messages were being sent between users on early institutional computer systems in the 1960s. Perhaps the most noteworthy feature of the conversations hosted on such machines is also the most obvious: the fact that, for the first time in history, conversations were being conducted in real time via the written word rather than speech.

The earliest forms of real-time communication via computer had their limits. Talk began to be included as a standard command on the PDP (Programmed Data Processor) series of computers in the 1970s – at that time the world's most widely used mid-range computer hardware – but only for different users logged into a single machine, and without differentiating between people: characters simply appeared as typed, at a maximum rate of 11 per second, meaning that overlapping sentences would mingle on screen.

> **On the internet, nobody knows you're a dog.**
> Peter Steiner,
> cartoon caption,1993

Internet Relay Chat As the 'talk' command developed, it began to incorporate users on different machines, while early dedicated chat programs like ntalk and ytalk allowed conversations to include more than two people. It was in 1988, however, that one of the programs set to shape conversation online arrived. This was Internet Relay Chat, or IRC for short.

timeline

1988	1996	1997
Internet Relay Chat is invented	ICQ is launched	AOL Instant Messenger is launched

Brave new words

The limitations and possibilities of computer-mediated conversation have – together with the linked field of SMS (Short Message Service) messaging – birthed numerous new words and conventions, many of which are space-saving acronyms: from the infamous (LOL for 'laughing out loud') to the functional (BRB for 'be right back') and the wittily obscure (DAMHIKIJKOK for 'don't ask me how I know, I just know ok'). Also part of online diction are common typos that have become words in their own right ('pwn' for 'own', meaning to win at a game or in an argument) and formulations that started out in the 1980s as a deliberate means of avoiding censorship but that have since taken on a life of their own – from 'n00b' meaning a 'newbie' or inexperienced person to 'l33t' meaning someone 'elite' who actually knows what on earth is going on and being said.

IRC was based on a server/client model, meaning that anyone wishing to use it needed to install an IRC client on their computer and then use this to connect to an IRC server on the internet. Rather than working on the basis of individual conversations, IRC primarily worked through the idea of 'channels'. Each channel on a server would tend to focus on a particular topic; connecting your IRC client to a server meant choosing to join a particular channel, at which point you would be able to watch and take part in live text-based chat between all the people logged into that particular channel.

IRC also allowed individual asides to be 'whispered' between just two people, but it was its channel-based structure combined with the openness of the protocol – thanks to which thousands of people could independently set up servers hosting channels all around the world – that made it one of the most powerful and popular early demonstrations of the potential of the internet.

Before the world wide web even existed, thousands of people across the globe were talking in shared online spaces and sharing their knowledge. IRC channels offered one of the few glimpses many US citizens had, for example,

2004
AOL introduces video chat

2005
Google Talk is launched

2009
Chatroulette goes online

Playing chatroulette

One of the most recent evolutions of online chat is the Russian-based website Chatroulette. Launched in 2009 and running entirely from within a web browser, it connects users at random to each other, using a webcam (assuming people have a webcam and allow the site to access it) to set up a live video-conference between two people at a time. Users can disconnect from each chat and 'spin' again at any time to find themselves in another random conversation. From a few hundred users in its first month, the site had well over a million within a year of launch and – for all the controversy generated by some of the less savoury antics of those logging on – had demonstrated once again the internet's capacity for fuelling that most fundamental of human interests: reaching out and encountering other people.

into life in communist Russia. Even today, IRC remains popular across the world, with its own network of utilities, search, nuisance bots and drones, conventions and communities.

Instant Messaging Unlike IRC, instant messaging systems are based on private communications, usually between two people or a small group of invited people. Like email, they tend to operate on the basis of personal lists of friends and contacts, running in the background behind other computer utilities and informing you as friends come online and are available to chat.

Very early real-time messaging systems in the 1960s and 1970s can be thought of as a form of instant messaging. But it was after the launch of the web, in the mid-1990s, that these systems began to become a dominant form of online communication, thanks to the release of a number of attractive and user-friendly systems offering a more accessible vision of online talk than the comparatively austere text-based world of IRC.

The first instant messaging service to span the internet was launched in 1996. Called ICQ (pronounced 'I seek you') it was distributed for free online and, in addition to chat, offered services including file transfers, text messaging to mobile phones, games and a directory of users. ICQ was followed in 1997 by AOL's program Instant Messenger – known as AIM – and it was AOL's program that proved the tipping point for instant messaging as a mass-market service. A boom had begun, with AIM being swiftly followed in 1998 by Yahoo!'s own messaging service and in 1999 by Microsoft's.

Talking elsewhere As messaging services became increasingly popular over the second half of the 1990s, the opportunity to chat online increasingly became expected in other contexts. Video games were arguably

the most significant and culturally rich of these locations, having been among the very first computer technologies to allow people to interact in real time with each other online – as early as the 1980s in the case of text-based virtual worlds.

By the end of the 1990s, game chat was a thriving online activity in its own right, with many gamers running dedicated IRC or other talk services in parallel to play in order to maintain control of conversations. 'Chatrooms' dedicated to particular topics or themes were also proliferating online, sometimes adding graphics to create physical contexts for interactions, although these were increasingly overtaken by the growth of fully fledged virtual worlds and multiplayer games involving thousands or even millions of players through the first decade of the 21st century.

Audio and video With the increasing power of computers and bandwidth of internet connections, it was inevitable that instant messaging would begin to incorporate audio and video services. AOL introduced video chats to its messenger service in 2004; Microsoft did so in 2005, by which stage both video and audio were becoming standard expectations for chat services, together with integration into email and other online services.

Today, live chat is assumed as a basic facility within everything from social networking services to project management tools and online document editors, while video and audio conferencing facilities are easily available either through messaging services or dedicated applications such as Skype. The bulk of online communication remains typed, however – and continues to bear the unique stamp of the history of online chat.

❝**The internet: transforming society and shaping the future through chat.**❞
Dave Barry

the condensed idea
A new medium demands new ways of talking

15 File sharing

The practice of internet users sharing files came most prominently to public attention in the late 1990s and early 2000s with the widespread adoption of software for sharing music – something that precipitated profound changes to an entire industry. File sharing between internet users is, however, an older and broader business than this, and forms one of the most fundamental ways in which digital information is shared and distributed – as well as a continuing challenge to older models of distribution, copyright and ownership.

Files have been shared between computer users as long as there have been such things as computers and files – and attempts by the producers of particular software or media to prevent copies of their work being distributed have been matched for just as long by a culture of cracking, distributing and circumventing digital forms of copyright and protection. As the world wide web gained users over the 1990s, however, the number of people around the world with internet connections, the speed of those connections and the power of the computers attached to them steadily increased. As millions of people around the world began to store an increasing number of media files in digital formats on their computers, a critical mass of files and computing capacity gradually accrued – and the result was the emergence of software specifically designed to enable people to share files directly with each other from anywhere in the world.

Peer-to-peer This software was known as 'peer-to-peer' because, rather than making everyone access content from a single central location, it allowed them to locate another user or users who had the file they were looking for and then connect directly to them.

timeline

1998	1999
USA passes Digital Millennium Copyright Act	Napster is founded

Perhaps the most famous early peer-to-peer service was launched in June 1999 by a student in Boston. Called Napster, it operated until July 2001 – when it was closed by court order, thanks to the immense number of copyright violations that it had facilitated between users. At its peak, Napster had allowed 25 million users to share over 80 million files. Today, the brand operates as a legal music download service.

How exactly did the software underpinning Napster operate? First, the Napster software itself needed to be downloaded and installed on a computer. Running this software would then connect your computer to a central Napster server, which contained a central index of all the other computers running Napster that were connected to the internet at that time. You typed in the details of the song you were looking for, and the Napster server provided the details of any other Napster users whose computers had that particular song. Having selected the file you wanted, Napster would then set up a direct connection between your computer and the computer with that file on, and you downloaded it.

Unwelcome downloads

One of the main dangers of participating in peer-to-peer file sharing is the risk that unwelcome files and programs may come attached to seemingly innocent downloads and services. As well as general difficulties with assuring the legitimacy of files downloaded via unofficial peer-to-peer services, some popular file-sharing services have historically been accused of installing 'spyware' on the computers of those using them, in order to uncover personal data about users. One such system, Kazaa, installed a range of tools on users' computers that tracked internet browsing habits and displayed various kinds of advertising. Founded in 2001, Kazaa was shut down as a file-sharing service in 2006 after agreeing to pay around $100 million in damages to the recording industry – and operates today as a legal music service.

2001	**2003**	**2010**
BitTorrent is created	The Pirate Bay is founded	UK passes Digital Economy Act

❛Illegal music file sharing collapses the music creation cycle and has the potential to damage cultural output worldwide.❜

Osamu Sato

As part of the process, Napster would also index all the music files on your computer within a designated directory for sharing music, and would then allow other users to connect to you and download them when you were connected to the internet. Because of its use of central search servers, Napster was not a pure peer-to-peer service – but its success illustrated the power of such networks, and set a precedent for other such services devoted to sharing all manner of files: from music and video to applications and games.

BitTorrent Created in 2001, BitTorrent is an open-source protocol for file sharing that has had a still more profound effect on digital culture than early systems such as Napster, thanks to its power and flexibility. Where Napster restricted its users to sharing MP3 files, various forms of BitTorrent are, today, the preferred system for the sharing of almost all large files online, from movies to software packages – and may today account for as much as a quarter of all internet traffic.

Like Napster, BitTorrent first requires a user to download a piece of 'client' software onto their computer. Then, they must find online a link to the file that they wish to download. Rather than a central server connecting them to a single other internet user who has a copy of the file they need, however, instead they will download a small 'torrent' file that contains detailed information about many different computers connected to the internet that each have a copy of the actual file the user wants.

This enables the user to download different pieces of the single large file they are looking for from different computers at the same time – something that makes the download process far faster and more robust than simply copying the file from one other computer, and that also puts far less strain on the networks connecting users.

The group of computers that the file is being downloaded from are collectively known as a 'swarm' – and while pieces of the file are being downloaded from the swarm, they may also simultaneously be being uploaded to other users elsewhere. To encourage sharing, someone who uses BitTorrent

Legal issues

File sharing between peers can be legitimate, but is often a violation of copyright – depending on the nature of the service used, the files themselves and the countries within which sharing takes place. One issue is who is legally liable for breaches of copyright when a file is shared: the individuals doing the sharing or the service allowing them to share. This can in turn depend on whether the file-sharing service has a centralized index of available files through which it connects people or is a decentralized system. In Europe, for example, individuals sharing copyright material online risk losing access to the internet. It can, however, be both difficult and controversial to identify internet users from their online activity. In the USA, thousands of cases have been launched in recent years against individuals thought to have been involved in file sharing in breach of copyright – but a binding national legal position has yet to be reached at the highest level.

frequently and provides a large number of uploads for other users will tend to be given priority over other users. Perhaps the most famous BitTorrent-based site of all, The Pirate Bay, was founded in Sweden in 2003.

Future sharing File sharing through mechanisms such as BitTorrent is almost impossible to prevent, as it is de-centralized, simple and extremely popular. Perhaps the most effective way of resisting it is by creating legal methods of online distribution for products, which offer a similar level of convenience, but charge a small amount in exchange for reliability, legality, guaranteed quality and integration with other services.

There are also plenty of entirely legal and official uses made of powerful file-sharing technologies, and BitTorrent in particular, to distribute software and updates online: notable users range from the British government to Facebook, Twitter and Blizzard Entertainment – the publishers of World of Warcraft – for whom this form of distribution is a powerful way of reducing load on networks and servers.

the condensed idea
Sharing is only ever a click away

16 Streaming media

Sharing and downloading files is a powerful way of distributing content digitally. But even with the rapidly expanding capacities of computers and mobile devices, it's something that takes up considerable time and space. This is where streaming comes in: the ability to listen to or watch media online without having to wait for the entire file to download. Streaming services effectively allow a powerful, flexible form of broadcasting via the internet – and one that offers content providers and broadcasters a powerful alternative to file sharing.

Music was the first medium to demonstrate the potential of streaming services, thanks to the relatively small size of music files compared to other media content, and the spread of the compact MP3 music file format from 1993 onwards. In the case of music, one of the earliest services used for streaming files was called RealPlayer. Launched in 1995, a basic version could be downloaded for free; once this had been installed on a user's computer, its integration with web browsers meant that they were free to stream music from anyone offering a service compatible with RealPlayer.

All streaming services are essentially alike. A user clicks on a link in their web browser: instead of starting the download of a complete media file, the browser contacts a web server and downloads what's known as a 'metafile'. This small metafile contains instructions to the browser to launch the media player service required to play the file, as well as information about the online location of the file that is going to be streamed.

timeline

1995	2005	2007
RealPlayer is released	YouTube is launched	Full launch of BBC iPlayer

Once the browser has been given the location of the media file to be streamed, it begins the process of 'buffering' – sending packets of data to be stored in a certain amount of memory set aside for receiving media content. This takes a small amount of time, depending on the speed of the internet connection, but ensures that play is not continually interrupted by the need to download data: it has been 'buffered' against this happening by the download of part of the file in advance.

The most watched forms of streamed media on the modern internet come via video sites like YouTube, which offer a powerful and rapid means of integrating media into web usage. Clips on YouTube can be watched on the main site itself or can be 'embedded' into other sites – meaning that the video content can be integrated into a blog or other website and watched there without having to visit YouTube itself.

Streamed games

Launched in 2010 in America, OnLive proposed to stream not just sounds and images to its users over the internet but complete interactive video games. The service – based on a series of powerful data centres and advanced video compression technology – has pushed back the limits of what many commentators thought possible in terms of streaming technology. As well as being extremely complex graphically, games can require hundreds of interactions between players and a virtual environment every minute. To achieve this across the internet – with the game itself running not in a player's living room but on a computer in a data centre hundreds of miles away – demonstrates what may be a new level of sophistication for the notion of remote streaming replacing people actually owning and running their own copies of software on their own machines. As with films, such 'on demand' games services may ultimately allow users to choose between tens of thousands of titles through a monthly subscription – although the technical demands of maintaining a high quality of service remain considerable.

2008	2011
Spotify is launched	YouView due to launch in UK

Recording streamed media

Many pieces of software allow users to record streamed media via a simple recording process – effectively turning streaming into a download process as well as a broadcast. Because of the copyright implications and the loss of control (and thus potential revenues from advertising and viewers) this represents, most streaming websites expend considerable effort trying to block recording software. This protection usually involves digital rights management (DRM) techniques, such as encoding the media stream, or methods to conceal the location from which a stream is originating. It is extremely difficult, however, to prevent someone determined to record streamed media from making a copy of what appears on their computer through techniques such as screen capture software, which simply makes a record of everything happening from moment to moment on screen.

The future of broadcasting Streaming video occupies far more bandwidth than streaming audio files, meaning it has only relatively recently become a widespread possibility – a good-quality broadband connection is required for ordinary television, and an extremely fast connection for high-definition content. As such connections become common, however, almost every conventional form of broadcasting is moving towards the internet and streamed services.

Perhaps the most famous example of television streamed via the internet is the BBC's iPlayer, the first full version of which was released in 2007, which allows web users to stream audio and video content to 'catch up' with recent broadcasts. Today, the iPlayer handles well over 100 million program requests each month; while its success has helped to highlight many of the potential issues around streaming media over the internet as a distribution model. The sheer popularity of the iPlayer has caused criticism from some Internet Service Providers, thanks to the amount of bandwith it takes up. Because the BBC is funded by a licence fee paid only by British citizens, its content is only available online to internet users with an IP address within Britain. It is not, however, necessary to have paid a television licence in order to watch iPlayer content within Britain. Rights are also a complex issue, with many programs only being available for a limited time after broadcast, and some not at all, in order to comply with copyright. A paid-for international version of the iPlayer is set to launch in 2011, as is an advanced multi-channel internet television service in the UK, known as YouView.

The death of scheduling As well as 'catch up' streamed media, most major broadcasters are increasingly offering live streaming online – which effectively uses the internet as a parallel broadcasting platform to ordinary television, although it may only be accessible as part of a subscription package to a channel or as a separate, premium pay-per-view event. This move towards internet-based broadcasting has rapidly been accelerated in recent years by the release of video-streaming software not just on computers but on games consoles and other media devices, driven by the expectation that consumers increasingly expect to be able to access all forms of media through the internet – and to choose exactly what they view and when, rather than relying on the model of scheduled programmes on a particular channel.

> **We're living at a time when attention is the new currency.**
> Pete Cashmore, 2009

The increasing personalization of broadcasting applies not just to television, but to a general desire to customize media experiences. Music streaming services such as Spotify, for example, pose a challenge even to highly successful online stores such as iTunes by offering users the chance never to buy music, but simply to pay a monthly subscription for the ability to stream music from a selection of more than ten million tracks.

This transition from purchasing media like music and video to simply subscribing to a well-stocked streaming service marks part of a potentially vast shift in ideas of the ownership of media: with sufficient bandwidth and choice, many people may see little need actually to own a copy of any music or video when these can be streamed into the home. The flip side of this, of course, is evident enough: that using these media depends upon a reliable internet connection and the ability of the company at the other end to provide a service to all its users.

the condensed idea
The internet is becoming a universal broadcaster

17 Rich internet applications

Delivering 'rich' content online – animation, sounds, videos, interactivity – is one of the most central tasks for modern software developers. As an increasing amount of all digital activity takes place via the internet and demand for complex online applications grows ever larger, the battle to deliver more and to control the software through which the rich content of the future is delivered has become a heated one. A furious race for further innovation is on.

The move to delivering rich content online, rather than simply using the internet for email and communications or the web for delivering linked information, has been a central part of the transition to Web 2.0. In particular, a whole host of tasks – such as word processing, keeping an electronic diary or building spreadsheets – that used to require computer users physically to install software packages on their computers can now simply be performed through a web browser by using dedicated online services.

What does a 'rich' piece of online content look like? On the one hand, there are services like Google's Gmail or online Documents and Calendar systems, which offer most things that ten years ago would have meant paying for an expensive piece of desktop software: word processing, detailed address books linked to dynamic calendars and complete email records, and the ability to upload and convert document and database files across a variety of different formats. Microsoft's Office suite of applications has since 2010 offered a suite of Office Web Apps in response, recognizing the increasing move among many computer users to perform tasks via the internet that once required

timeline

1996	2005
Adobe Flash is launched	Term AJAX is coined

offline software to be purchased separately: the suite allows users to view and edit documents for free directly from a web browser.

At the other end of the spectrum is online entertainment. Delivering video and music on demand within a sophisticated interactive website – an increasingly important market for all broadcasters – is typical of modern rich content. However, the most sophisticated products of all in this space are games, which demand moment-by-moment interaction with players, and can have extremely high memory, graphical and processor requirements compared to most other online activities.

In the 1990s, almost any sophisticated computer game had to be played as an individually purchased piece of software. But the growing ability to deliver rich content online has fuelled a boom in delivering complex play through web browsers – from emulations of classic board and puzzle games to flourishing independent communities of developers delivering titles of comparable quality to those released on the dedicated games consoles of a decade ago.

A lack of support

As of early 2011, neither Flash, Silverlight nor Java were natively supported by devices running Apple's iOS operating system: iPods, iPhones and iPads. Performance concerns may be one factor in this but some critics have argued that another issue is also involved: control. Independently operated web platforms potentially allow developers to circumvent the high level of control Apple enjoys over the media and applications used on its devices, as they would allow third parties to make such materials available through the web. Given the rising importance of web applications, it's probably only a matter of time before almost all browsing experiences are compatible with all the major development platforms – unless one or two clear winners emerge to dominate the field and claim the rewards. When it comes to rich content, control may prove the most crucial concern of all.

2007

Microsoft Silverlight is launched

2008

First draft of HTML5 is released

Three-dimensional worlds

While Flash, Silverlight and Java are the world's dominant platforms for developing rich internet applications, other more specialized ones also exist with powerful particular uses. One recent example is the Unity Web Player, designed for use in online gaming. Once downloaded, it enables the rendering of immersive three-dimensional worlds within web browsers – something that until relatively recently was only possible within individually purchased (and elaborately designed) games. Tools such as Unity show just how central web browsers now are to the digital experience on computers, and how services delivered within them are increasingly able to function not only as complex interactive services but as carefully realized interactive environments. Tools such as Unity, moreover, put the capability of designing such environments within the budgets and skills of an increasing number of people, as the production of digital software and content continues to shift from a minority activity to something within reach of almost every single user.

Popular platforms One of the first decisions a web developer has to make when developing 'rich' content to be used online is what software it will operate on. Will it run within the existing capabilities of a web browser, or will it require users first to install an external software framework which can then be run as a browser 'plug-in'? Installing such software to the hard drive of a computer can give it access to a number of options and functions beyond the capabilities of a web browser: but also risks a lack of compatibility with systems that are unable to use it, or platforms that will not allow a user to download and install additional software.

Three downloadable platforms overwhelmingly dominate the global market for creating Rich Internet Applications (sometimes simply called RIAs): Adobe's Flash, Microsoft's Silverlight and Oracle Corporation's Java. Once the latest version of each of these has been downloaded – something that has already been done on many freshly bought new computers – online content that uses their capabilities can then simply be run without the need for further installation.

Flash is the most widely installed of all these platforms, and comes as standard in most newly purchased modern computers. Especially popular for developing online games, thanks to its relative ease of use and suitability for animation and interaction, Flash was first introduced

> **While the Web's origin was around static documents, it is obviously becoming a platform for rich and social applications.**
>
> **Louis Gray**

in 1996 as a way of introducing animation to online content, such as advertising, and has since grown into a powerful multimedia platform.

First released in 2007, Microsoft's Silverlight set out to challenge Flash's dominance, offering similar services and – like Flash – working on a proprietary rather than open-source basis, something that some advocates of a free and open web have cited concerns about. Java, by contrast, was launched as a programming language in 1995 and is available under a free software licence – although the platform JavaFX, released in 2010 specifically for building RIAs, has not yet been released on a public licence.

HTML5 and AJAX There also exist several ways of generating rich, interactive content online without having to 'plug in' platforms like Java, Silverlight or Flash to a web browser. The most popular of these is AJAX or Asynchronous JavaScript and XML, a term describing a group of technologies that collectively allow the development of rich web content based on standard functionalities that are integrated into the capabilities of almost every modern web browser, and that are based on entirely open standards rather than involving proprietary software. Sites such as Gmail and Google Maps are built using AJAX.

Another open standard also seems likely to provide a tempting tool for many web designers: HTML5, the most recent version of the HyperText Markup Language that underpins the world wide web. HTML5 currently remains in draft form, with its final specifications yet to be fully determined, but it goes far further than any previous version of HTML in allowing developers to generate sophisticated, interactive and multimedia content within web browsers without relying on external plug-ins.

the condensed idea
Web applications are
defining software's future

18 Wireless

The first phases of digital culture played out through the development of a physical infrastructure that still forms the basis of the modern internet: a massive global network of cables connecting nations and continents. Today, however, a second phase of unwired connections is proving as transforming again and allowing whole new parts of the world, as well as many new kinds of device, to join the internet, and move us from a culture of physically interconnected desktop machines to one of numerous, ubiquitous networked devices.

The most common form of wireless connection to the internet is known as Wi-Fi – a term that covers a group of technologies, many of which are based on a series of technical standards called 802.11. The term Wi-Fi itself is a trademark and was first used in 1999. A multitude of devices – including desktop and laptop computers, smartphones, tablets, games consoles and media players – are today sold with Wi-Fi enabled, meaning that they contain a wireless network card.

The key to using Wi-Fi is not so much having a Wi-Fi-enabled device as connecting to a network. This means connecting to a wireless access point – also known as a router – which serves as a bridge between Wi-Fi devices and the internet. A router is itself connected, usually physically, to the internet, and then uses a radio transmitter and receiver to allow Wi-Fi devices in range (typically around 30 metres indoors) to locate and communicate with it. Depending on the sophistication of the router, many different Wi-Fi devices can all connect to the same wireless network and gain internet access through it – or simply access other devices on the same network.

timeline

1994	1996
Bluetooth is created	First commercial internet access via mobile phones

As well as domestic and office routers, public Wi-Fi 'hot spots' are increasingly common, offering people with Wi-Fi-enabled devices internet access as long as they are in range. Some networks may require payment to be made first via a login system, or may be provided nationwide by a mobile phone provider as part of a subscription service. Many public spaces also have free, open Wi-Fi.

Vulnerabilities Wireless networks are potentially vulnerable to hacking or malicious use, especially if they are 'open' – meaning the name of the network is broadcast openly by a router, and any device can join it. A higher level of security is provided by requiring a password for network access or by making it invisible to those who don't already know the name and details.

The power of Bluetooth

Named after a 12th-century Scandinavian king who united warring tribes under his rule, Bluetooth is an open wireless networking technology – created in 1994 by the Swedish company Ericsson – used for creating secure networks between devices at short range. Most phones, laptops and computers sold today are Bluetooth enabled, as are an increasing number of cars, Global Positioning Systems (GPSs) and other devices a user might wish to connect without wires in close proximity. Each device has a Bluetooth profile coded into its hardware, containing information about what it is used for; when another Bluetooth device comes into range, they examine each others' profiles to determine if they can work together. If they are compatible, a 'piconet' is established – a network that can connect up to eight active devices. Piconets can link to other piconets, and devices can belong to more than one of them, making Bluetooth a convenient and powerful way of transferring information or combining the functions of personal devices: running mobile telephone calls through a car stereo, for instance, while playing music from an MP3 player through the same system.

1999

Term Wi-Fi is first used

Welcome to WiMAX

Short for Worldwide Interoperability for Microwave Access, WiMAX is a similar system to Wi-Fi but without its range limitations, as its antennae can broadcast over entire towns or cities. Although not yet widely deployed compared to other services, this may prove one of the most powerful wireless technologies in the future history of the internet, as it has the potential to cover large populated areas with high-speed wireless networks with ease. Individual devices can connect directly to WiMAX networks if they have the correct hardware installed. Another possibility in increasingly common use, however, is the use of WiMAX broadcasts to connect to WiMAX subscriber units within individual homes or offices. These subscriber units then act as routers, providing local Wi-Fi networks for all devices within the home or office.

By default, many wireless networks are also operated without any encryption, leaving them vulnerable to hacking via the 'wardriving' technique, which involves hackers travelling around using software that automatically attempts to locate and connect to unencrypted wireless networks in order to steal data from them. Encrypted and password-protected networks are safer from this technique, although the most common encryption technique for Wi-Fi networks – a standard known as Wired Equivalent Privacy (WEP) is known to be vulnerable to some hacking approaches. The more recent standard, Wi-Fi Protected Access (WPA), is more secure.

Mobile access Still more significant than Wi-Fi globally is access to the internet via mobile phones – something rapidly having a transforming effect in parts of the world, such as Africa and Asia, where physical telecommunications infrastructure is patchy and too expensive to construct in many areas, but where mobile access via telephone masts can rapidly be rolled out to offer coverage in almost every part of a country. For millions of citizens in the developing world, this means that the first experience of the internet comes not via a computer or a wired connection but through a mobile phone.

A host of different data standards and formats exist across global mobile phone networks. Internet access was first offered commercially via mobile phones in Finland in 1996, while full internet browsing via mobile

> **❛In the next few years, more than a billion people will get mobile phones who have never had a mechanism of communication outside of their village.❜**
>
> **Erich Schmidt, 2010**

devices did not appear until 1999 in Japan, via the i-mode mobile phone service. Mobile phone standards are generational, ranging from first generation or 1G standards to the current widely used third generation or 3G standard, which allows relatively rapid internet data transfer rates of at least 200 kbits/s, comparable to moderate wired broadband speeds. Fourth generation mobile standards will include far more secure and rapid internet access, with several mobile phone providers now offering 'pre-4G' services operating far faster and more powerfully than ordinary 3G. Many parts of the world, however, still operate predominantly on various 2G networks, which offer limited data transfer rates.

Hundreds of millions of people now access the internet via mobile phones, but both the variety and the limitations of devices and networks make for a more fragmented experience than the wired world wide web. While those using modern smartphones and fast networks can browse the web with almost the same freedom as they might on a personal computer, older phones and slower networks severely limit internet use, as do incompatibilities between operating systems designed by different manufacturers. Apple's iOS and Google's Android are the two dominant operating systems for smartphones; but these continue for the moment to be used by a minority of global mobile internet users.

the condensed idea
Wherever you are, you can go online

19 Smartphones

A smartphone integrates the functions of a telephone with more advanced computing functions and in particular the ability to access internet services, ranging from basic email to full browsing. Smartphones only make up around a fifth of modern mobile phone sales but this sector is steadily transforming the way in which millions of people relate to and access digital resources, from email and the world wide web to media, leisure and productivity software, commercial services and the world of business.

The word 'smartphone' was first used in 1997 by the Swedish company Ericsson to describe a device that was never actually released on the market: the GS88 Communicator, part of the company's 'Penelope' project. Central to the 'smart' side of this device was not so much its hardware – powerful though this was for the time – as its software: a prototype version of the first dedicated operating system for mobile devices to offer anything approaching the power and flexibility of a computer.

The operating system was called Symbian and had been developed in collaboration with Psion, Nokia and Motorola, and the first commercial mobile phone to use the Symbian operating system duly appeared on the market in 2000: Ericsson's R380. Internet-based services such as email were already available on some other phones, but their functionality as mobile computing devices had been severely limited.

Ericsson's device was not hamstrung by the problems that had until that point crippled almost all efforts to build serious software for mobile phones: inadequate computing power, but above all the absence of multitasking,

timeline

1997	2001	2002
First smartphone is demonstrated	First 3G network	First third-party software for smartphones

memory and coding capabilities that were demanded if powerful applications were to be built. The R380 itself was fixed in its software – it was not possible for other companies to develop applications for it – but by 2002 a recent collaborative corporate venture between two electronics giants, Sony Ericsson, had rectified this with the introduction of an expansion to the Symbian operating system that for the first time allowed third parties to develop applications for it.

The demand for data 2002 was also the year in which upgrades to the BlackBerry series of wireless pagers announced its arrival as a competitor in the smartphone space. By this stage, with phone displays and software growing more sophisticated, the demand for transferring data across mobile phone networks was growing more intense, and the so-called second generation of mobile networks (2G) began to give way to the third (3G), complete with a hugely enhanced ability to transfer data.

The transforming force of apps

For almost the first decade of their existence, smartphones lacked something the mainstream computer market had long taken for granted: a vigorous software marketplace. The proliferation of different devices and, above all, extreme difficulty of marketing to smartphone owners and persuading them to spend money on additional software meant that high-quality products were scarce. Apple's iPhone and Google's Android marketplace transformed this entirely. For the first time, independent developers could actually hope to profit by developing appealing, high-quality software and selling it directly to the owners of smartphone hardware – as had been common practice for decades with home computers. Moreover, digital distribution offered instant scalability: the potential to reach every single user of a smartphone without going through retailers other than Apple or Google. Almost overnight, the 'app economy' became one of the digital world's most dynamic places to do business.

2007
iPhone is launched

2008
Android phones are launched

❝The app is the new 99-cent single – for kids, it's the new currency.❞

Tim Westergren

The first fully operational 3G mobile network was launched in Japan in late 2001, followed by South Korea the next year. As these higher capacity networks began to spread across the world, the possibilities for smartphones increased – from sophisticated pre-installed software and interfaces towards genuine online services, software marketplaces and internet content more complex than just words, email and static images.

Enter iPhones The turning point was 2007, when Apple's CEO Steve Jobs ended years of speculation by announcing his company's new product: an integration of the company's hugely successful iPod (launched in 2001) with a mobile phone and a new species of internet-browsing device, complete with a fully functional mobile version of Apple's desktop web browsing software.

It was a year until anything else comparable to the iPhone arrived on the market – a year during which perceptions of what a smartphone meant changed fundamentally. The iPhone combined a large high-quality display fit for watching video with a web-browsing experience comparable with that offered by 'proper' computers. From July 2008, it also offered access to the world's first truly successful digital marketplace for smartphone software: the App Store, which would go on to see ten billion downloads by January 2011, from a selection of over 400,000 different apps.

The first true rival to the iPhone arrived in 2008 with the launch of the first smartphone based on Google's new mobile operating system, Android: the HTC Dream, also known as the G1. This was to be just the first of many devices running Google's open-source operating system: as of early 2011, over 50 Android-based smartphones were available, complete with a digital Android Market similar to Apple's App Store with over 200,000 apps available.

Pocket computing power Smartphones, today, continue to grow steadily in power, just as the data networks supporting them begin to make the transition towards a fourth generation of high-speed access. Although smartphones will not represent the majority of mobile phone sales for many years yet, the presence of such computing power in hundreds of millions of pockets around the world is already having a profound effect on digital culture.

Performance test

As smartphones have grown more advanced, the race to add and improve features has veered, at times, close to parody. With cameras, high-resolution video, motion sensitivity, multi-touch screens, internet access and GPSs now becoming standard, many areas are running out of room for improvement. Apple's iPhone 4, released in June 2010, boasts a 'retina display' – showing 300 pixels per inch on its screen, said to be as high a level of detail as the human eye is able to appreciate from an average viewing distance. Meanwhile, Nokia's N8 phone, released in September 2010, offers a camera able to take 12 megapixel images: around six times the level of detail displayed by a full-HD television. All these features require power, of course – one of the reasons why battery life, which still struggles to reach a full 24 hours of heavy use for any smartphone, is almost the only figure associated with mobile phones to have gone down over the last decade.

Specifically, smartphones have fed into a tremendous and growing demand for social networking, gaming and working on the move – as well as applications that can base their services on knowing exactly where users are, thanks to the integrated GPS in most smartphones. Media consumption through smartphones is increasingly simple and universal but they have also fuelled the rise of a 'two screen' culture, in which the experience of watching a broadcast or live event is augmented by the parallel use of a smartphone to comment via social media, share links and reactions with friends, and follow the global stream of responses to the action in real time.

As surveys of teenage media habits have observed, a smartphone is often the first object a modern owner touches when they wake up in the morning and the last thing they use before going to bed: an intimacy with digital technology and a level of integration into the daily stuff of both work and leisure that was hard to imagine even a decade ago.

the condensed idea
Computing power for everyone, everywhere

20 Malware

Malware, a contraction of the phrase 'malicious software', means exactly what its name suggests: software that does something bad rather than good. It's also a huge and ever-expanding field that has gone hand in hand with the growth of computing and the internet. From viruses to Trojan horses and from worms to data theft, the ecology of malicious software is every bit as varied and ingenious as the rest of the online world.

Malware is defined by malicious – and sometimes criminal – intent on the part of its creators, usually for one of two general purposes: obtaining information from unwitting users, or hijacking computers so that these can covertly be used to spread further malware or conduct other illicit activities.

As online activity has increased, the possibilities for malicious software have increased hugely. At the same time, the line between legitimate and illegitimate types of software has been increasingly blurred by the desire of many companies providing an online service to find out as much as possible about their users.

❝An inefficient virus kills its host. A clever virus stays with it.❞
James Lovelock

In particular, the field of 'spyware' – programs designed to record and transmit information about internet habits and computer use – has proliferated as part and parcel of some commonly used programs. Alongside this is the growth of 'junk' software that is not so much actively malicious as unnecessary, and which can come surreptitiously bundled with other programs in an effort to lead someone towards particular websites or services.

timeline

1971	1986
First self-replicating program, Creeper	First Trojan Horse program, PC-Write

Viruses and worms The most famous and perhaps the oldest
type of malware is a computer virus. Viruses are hidden, self-replicating
programs, and the earliest examples were more often written for fun or as
experiments by programmers than for genuinely malicious ends. Before
connection to the internet was commonplace, such viruses were largely
spread via infected files on floppy disks. By the 1980s, infection via early
internet links and email became more common, alongside opportunities to
profit through the use of viruses as tools.

As the name suggests, a true computer virus 'infects' particular files, and
these files must then be activated by a user for the virus to deliver its
'payload' – that is, the hidden actions determined by its creator. These
may range from deleting crucial files on a hard drive to the more subtle
installation of hidden programs allowing a computer to be controlled
remotely or its user's actions monitored.

The great worm

The first and most famous internet worm in
history was created in November 1988 by a
Cornell University student, Robert Morris, after
whom it is named. A self-replicating piece of
software that exploited known vulnerabilities
in email commands on the operating system
of the computers comprising the early internet,
Morris claimed that it was an innocent project
to attempt to measure the size of the net.
Unfortunately, the decision to introduce a one
in seven chance of self-replication every time
it encountered a networked computer meant
that it spread with enormous speed, and then
continued to overload the limited bandwidth
between networked computers, infecting the
same machines many times over. Estimates at
the time suggested that it infected around 10
per cent of all machines then connected to the
internet – around 6,000 out of a total of 60,000
– and caused over $10 million of damage in
terms of repairs, labour and lost time. Morris,
who is today a computing professor at MIT,
became the first person to be convicted under
America's 1986 Computer Fraud and Abuse
Act, while his worm prompted the founding
of the world's first Computer Emergency
Response Team for dealing with future
such events.

1988

First internet worm, the
Morris Worm

2004

Mydoom worm briefly slows
global internet by 10%

By contrast to a virus, a 'worm' is a malicious program that is able actively to spread itself across a network, without the need for someone unwittingly to activate it. While viruses tend to target files on a particular computer, the self-replicating capacity of worms mean they can cause severe damage to networks themselves, consuming bandwidth and preventing legitimate traffic from getting through.

Trojan horses In Virgil's *Aeneid*, the ancient Greeks gained entry to the besieged city of Troy by hiding inside a giant wooden horse presented as a gift to the Trojans. Trojan horse pieces of software – often simply referred to as Trojans – similarly appear desirable, but contain malicious hidden code.

Trojans span a multitude of possibilities, ranging from the concealment of a virus or worm designed to hijack a user's computer to less damaging impositions, such as installing a sponsored toolbar within a web browser or displaying advertising during web browsing. One of the most dangerous pieces of software a Trojan can potentially install is a 'key logger', which records and then transmits to its creator a record of every single piece of keyboard input on the machine.

> **The only truly secure system is one that is powered off, cast in a block of concrete and sealed in a lead-lined room with armed guards.**
>
> Gene Spafford

Trojans may also install pieces of 'adware' and 'spyware'. These force unwanted advertising and sponsored links on computer users, and transmit data and potentially personal details to third parties without a user's consent. This kind of malware has traditionally been a problem on both peer-to-peer file-sharing networks and in the more disreputable kinds of free online software. Some software occupies what many consider to be a grey area over its status as spyware, sending data to a central server about a user's viewing history. This is only done with explicit user consent, which clearly differentiates such programs from 'true' malware.

Prevention The malware-prevention industry is a major modern business, but the most important aspect to prevention is simply ensuring that a computer's operating system and software are fully up to date, as manufacturers will regularly release new versions of software that remove known vulnerabilities exploited by malware. The second aspect of prevention is also a form of common sense: not executing any programs or opening any messages that do not come from trusted sources.

Zombies for hire

One of potentially the most lucrative uses for computer viruses or worms involves creating a covert network of infected computers – sometimes known as zombies. Collectively, a network of zombie machines is known as a 'botnet'. Such networks can consist of thousands of machines or more under the covert control of a controller who is then able to hire out the network: usually either for sending huge quantities of spam email, for gathering data or for launching coordinated attacks on a particular website, where huge numbers of zombie machines will be made repeatedly to access it, potentially causing it to crash due to the huge increase in traffic. This is known as a Denial-of-Service or DoS.

The biggest botnets in the world are thought to contain 30 million or more infected machines, and have the capacity to send billions of spam emails each day or bring down all but the biggest and best-protected of websites. Such services are an increasingly valuable part of the black internet economy.

Beyond this, most modern computers now come automatically equipped with some form of 'firewall' – software that prevents unauthorized network access to a computer. Anti-malware programs are also widely used, with free and paid-for versions available for download and incorporated with new machines; regular updates help these to identify the latest threats.

Most modern operating systems and browsers are well equipped with security warnings and doublechecks on potentially dangerous activities. Increasingly, however, modern computer users are most vulnerable not when running programs on their own machines, but when using internet-based services – whose valuable databases and user accounts provide rich temptations for the world's growing number of professional digital criminals.

the condensed idea
Every digital technology has its parasites

21 Spam

Build something and there will always be people who try to exploit it. Build something that's free to use – like email and the web – and the opportunities for exploitation will be almost limitless. Unsolicited electronic mail has for years been a painful fixture of digital life. And yet the billions of junk messages sent every day are just the tip of an iceberg of junk links, websites, blogs and schemes that together pose one of the most significant threats there is to the future of the internet itself.

'Spam' first came to public attention in the early 1990s, as email and the internet began to be opened up to the general public. Because the cost of sending an email was effectively nothing, it was possible to use computers automatically to send out vast amounts of unsolicited emails to millions of addresses, in an effort to get unsuspecting email users to visit a particular website or to do something that might generate income for the 'spammer'.

This basic pattern remains true today: it's cheap and easy to send out millions of electronic messages, it's difficult to track down the people doing this, and it only needs a tiny percentage of people to reply to the messages to generate enough income to make the process worthwhile.

Word origins The word 'spam' itself originates from a 1970 sketch entitled 'Spam' in the British television comedy series Monty Python's Flying Circus: the sketch depicted a café where almost every single dish served involved the canned meat product Spam (a brandname itself introduced in 1937 as a catchy abbreviation for the phrase 'Hormel Spiced Ham'). The sketch – which culminated in a song about Spam drowning

timeline

1978	1994	2000
First known spam email	First significant commercial email spamming	Term SpaSMS coined to describe mobile phone spam

out all the other lines – caught the public imagination, and began to be referenced in computing in the 1980s to describe antisocial users in early chatrooms who would deliberately fill up screens with large amounts of nonsense text (including the word 'spam' itself) in order to drown out other users' conversations. This has also led to the practice of desirable emails being called 'ham' by some computer users.

Today, even conservative estimates suggest that spam comprises over three-quarters of all emails sent, and the techniques used by those sending it have become increasingly sophisticated in response to the increasing sophistication of their audience. Rather than use their own computer systems to send out messages, spammers deploy 'zombie' networks of other machines that they have hijacked from unwitting users through the use of viruses. The automatic 'harvesting' of email addresses from websites and address books – and the subsequent sale of address databases – has also

Phishing and scamming

A term first coined in 1996, 'phishing' describes a frequent tactic by which spam emails and malicious websites attempt to obtain personal details from unsuspecting users, ranging from email and online account logins to banking and credit card details. Scamming, meanwhile, is the more general process by which spammers try to get money out of victims – a practice associated with 'classic' spamming tricks such as emails asking the recipient to help a supposed third party get a large amount of money out of a foreign country in exchange for a cut. Phishing scams are more sophisticated, and involve 'fishing' for information by pretending to offer some kind of legitimate service or query which requires personal information. Emails may appear to come from tax services, banks, insurance companies and major web outlets – and techniques of link manipulation can make it appear that they connect to a legitimate rather than a bogus website. As well as fake websites, telephone numbers can be used, and even texts or instant messages: one popular scam asked people to phone a 'free' number if they wished to query a fictional delivery, something that in fact entailed spending hugely expensive time on hold to a foreign premium rate number.

2003
First automated
blog spamming

2011
Around seven trillion
spam emails due to be
sent this year

Talking to robots

The quantities involved in the production and dissemination of spam mean that it is a highly automated business. But automation is not restricted simply to sending out millions of identical emails. Sophisticated 'spambots' are used for tasks ranging from trawling online forums in order to find email addresses to posting bogus comments and circumventing safeguards designed to ensure that only humans are able to post or use particular sites. Some spambots are also used to trawl chatrooms, IRC channels and anywhere that people might be engaged in conversation online, churning out simple formulae in an effort to get users to click on malicious links or reveal details about themselves. A chat robot might, for instance, pretend to be someone linking through to pornographic material, a site offering bargain discounts, or just an interesting sounding personal site. Inevitably, such robots also feature today on services like Twitter and Facebook – although security routines are frequently updated and spam accounts deleted in an effort to keep disruption to a minimum.

become increasingly common, as have collaborations between different kinds of spammers, and people specializing in different kinds of digital deception. There have been several attempts to make spamming illegal and to punish the people sending it, but spammers simply tend to move their operations from country to country to avoid prosecution.

Spam sites Email is the most famous kind of spam, but the idea of automatically generating millions of deceptive messages for profit is predictably widespread in digital culture. From instant messaging services to text messages on mobile phones, from online discussion forums to groups on social networks, electronic spam is universal. Spam comments are also a major hazard on blogs, usually consisting of automatically generated comments that contain links to spammers' websites in an effort to generate both increased traffic to these sites and an increased number of results for them on search engines.

Beyond this lies the increasingly common practice of automatically generating entire blogs or websites that serve no purpose other than to drive traffic towards spammers' websites and products. A spam blog – sometimes abbreviated simply to 'splog' – tends to consist of text that is either stolen from other sites or automatically generated, together with huge numbers of links to a spammer's own website. By some estimates, as many as 20 per cent

of blogs consist of this kind of spam, while around a million automatically generated web pages full of spam content are created every single hour. When it comes to popular topics for spam, such as medical treatments, the sheer quantity of spam blogs and websites can make it extremely difficult to find legitimate sites and information through search engines, especially given the increasingly professional appearance of many spam sites.

> 'Nothing in the Constitution compels us to listen to or view any unwanted communication, whatever its merit.'
>
> **US Supreme Court judgement**

Clogging the net The mounting quantity and sophistication of spam poses real problems to the internet in terms of the space and bandwidth it occupies, as well as the damage it does to search results and the time it can take legitimate web users to deal with the amount of spam appearing in their email and on their own websites. Anti-spam filters are a major business, and one that is constantly developing in parallel with spamming techniques. This has led some people towards a view of the web where they tend to use only particular, trusted sites rather than risk open-ended exploration.

The prevalence of spam has also led to a demand for services like the search engine blekko, which launched in 2010 and allows users to search only for websites that have been actively labelled by other people as trusted, useful sites, rather than simply located by a search engine that has found particular words on a page. This is also one advantage of using the web via things like mobile phone applications rather than simply searching – because these tend to require approval from companies, allowing an element of quality control and human discernment into the process.

The overall cost of spam to the world is extremely difficult to estimate, but it runs into tens of billions of dollars in wasted time, wasted space and bandwidth, and expenditure on the programs and devices needed to control it.

the condensed idea
Cost-free communication means a rising tide of junk

22 Privacy

The internet is a new kind of public space: a network of interconnected sites, services and resources that contains an increasingly large and valuable amount of information about both the world and individual people. Inevitably, the issue of privacy has become one of the digital age's most controversial and complex debates. How much information should we be able to learn about others, or reveal about ourselves, online?

Privacy can be broadly divided into two fields. First, there are matters that aim to be entirely private and secure against any outside attempts to access them, from using online banking and shopping services to accessing an email or social networking account. Second, there are areas of relative privacy – in which the question becomes not only the basic security of a system, but also what information and activities should be accessible to third parties, and which third parties these should be. This covers everything from profile information on social networking sites to online information about the author of a blog, a contributor to a web forum, the subject or author of an online article, or even simply a social networking status update.

Online identification For most users, the internet itself is not an arena in which absolute privacy can be guaranteed. There are several basic ways in which any computing device attached to the internet tends to be identified. Most important is the Internet Protocol address, or IP address, which tends to be expressed in the form of a four-part number separated by decimal points and which provides a unique numerical address for each computer in a network.

timeline

1998	2007
UK passes Data Protection Act	Google Street View launches

Data leaks

Some of the most controversial breaches of online privacy in recent years have happened thanks to vulnerabilities in the systems run by online services. One of the most severe of recent breaches was the hacking of the Gawker network of blogs, which in late 2010 revealed that a hacker group had broken into their servers and obtained the details of 1.3 million user accounts. The passwords were encrypted, but simple passwords were vulnerable to a 'brute force' approach – and many users who had replicated account login details across different online services found that their Twitter accounts were being used to transmit spam after the hack. The Gawker hack highlighted the importance of using different login details for different online services, as well as complex passwords not easily susceptible to brute force decryption or guesswork based on lists of common passwords. The most common hacked passwords from the Gawker incident were: 123456, password, 12345678, qwerty, abc123 and 12345.

IP addresses often, but not always, allow the location of someone using the internet to be determined, and are also important when an organization or individual wishes to prevent access to or from sites on a blacklist. Internet Service Providers are in a position to monitor not only general information about the location of their users, but also the specifics of data sent to and from individual computers – something that they are legally banned from doing in any depth under normal circumstances, but that they may be requested by government authorities to do in exceptional circumstances. For this reason, some people use 'anonymizer services', which aim to conceal the details of online actions from an Internet Service Provider.

Secure connections The most crucial single component of online privacy for the majority of important transactions is encryption (also discussed in Chapter 30 on E-commerce). Normally, a web address begins with the letters 'http', standing for HyperText Transfer Protocol. Sometimes, however, a web address will begin with the

> **❝Just because something is publicly accessible doesn't mean people want it to be publicized.❞**
> **Danah Boyd**

letters 'https', indicating that the site is using a 'secure' connection – also usually indicated by the presence of an icon representing a lock in the window of a web browser.

Clicking on this lock icon reveals details about the security a particular website is using. A number of conditions must be met for a connection to be genuinely private and secure. First, the web browser itself must be fully functioning and not compromised by malicious software. Second, the secure site being visited must have a valid electronic 'certificate' backed by a valid certificating authority. Once a trusted connection has been made, data can then be transferred between a user and a website in encrypted form, meaning that only the intended recipient can read it, thanks to a complex mathematical algorithm that can only be decoded by a unique 'key'. For this to be fully secure, the encryption must be impossible for anyone intercepting web traffic to decode.

Cookies Encryption and certification are the basis of most sensitive online interactions. For most ordinary online activity, however, the most common potential breaches of privacy centre on 'cookies' – nuggets of information that are automatically stored on a web user's computer in order to permit websites to do anything from remembering a user's preferences to offering a complex interface. Most cookies are benign and an essential part of web browsing but their semi-invisible nature means that some can be used to monitor more about someone's online behaviour than they may realize. In particular, 'tracking cookies' installed by third parties in some web pages can allow advertisers to build up a picture of someone's web history. All modern web browsers allow users to enable or disable cookies in general, and third-party cookies in particular – although some sites require them in order to work correctly.

Sharing information Aside from hacking or the use of malicious software, by far the greatest dangers to privacy on the modern internet come from an insufficient awareness on the part of web users about privacy and sharing settings on a variety of online services, and how some information can be gathered and exploited by everyone from marketing agencies to identity stealers. Much of the problem is that the default settings for privacy on many sites that encourage users to submit personal details, can allow more sharing and visibility of data than users might assume. Reviewing and altering such settings if necessary should be one of the first things

What does the web know about you?

In January 2011, the British edition of *Wired* magazine printed a limited number of 'ultra-personalized' covers as a demonstration of how much can be found out about individuals online. Sent to selected readers, the covers relied entirely on open online sources, including the edited electoral register, Companies House, the Land Registry, public data on social networks, and updates and materials relating to friends and family, all cross-referenced. Some of the individually addressed covers included details such as mobile phone number, birthday, address, recent sightings, recent purchases, details of spouse and children, and recent events attended. As the editor himself put it, 'recipients need not worry about what happens now with that data: only they received a copy with their personal data, and we have since destroyed our database. But you do know that data will stay out there forever, don't you?'

anyone does after signing up for a service that uses personal information. It is vital to be aware of which personal information is eligible to be seen by anyone at all searching a site, which can be viewed by members of a shared network or group of some kind, and which can be viewed by people marked as direct 'friends' or contacts.

Legislation Perhaps above all, the future direction of online privacy lies in the hands of governments and corporations, and in legislation and negotiation over citizens' rights to privacy and companies' rights to profit by gathering and exchanging data on consumer habits. From the UK's 1998 Data Protection Act to California's Online Privacy Protection Act of 2003 and beyond, policy has been being formulated for over a decade now on these new challenges. But it will only be truly effective if matched to a population fully aware of the complex, shifting nature of digital privacy.

the condensed idea
Absolute privacy is a rare digital commodity

23 The deep web

The world wide web consists of many billions of websites, services and pieces of data. Yet this visible, accessible data by some estimates makes up less than one per cent of all the activity and information that actually exists online in some form. Much of the web's information lies beneath the surface layer that is searchable by ordinary web users – hence the term 'deep web' to describe a shadowy and shifting zone that is also sometimes known as the invisible or hidden web.

The 'deep' parts of the web are distinct from what is sometimes referred to as the 'dark' web. Dark sites are those that can no longer be accessed at all, and have thus gone 'dark', thanks to a breakdown in the processes through which traffic is directed. Deep sites exist but for a variety of reasons are not visible to search engines and the casual web user.

Perhaps the most common class of website belonging to the deep web is one that is dynamic: that is, its content and location are not fixed but are generated in response to particular queries or needs, making it impossible to pin down. Something as simple as the details of live train arrivals might be included in this, as the information is constantly shifting, preventing it from being permanently indexed or recorded.

Databases are another large category of potentially invisible site, as many large information resources are not simply listed on websites that can be indexed by search robots, but are stored on servers and only appear online as the result of queries by web users, which generate a web page with a couple of results on but leave the vast bulk of the database hidden.

timeline

1994

Phrase 'invisible web' is coined

Sites protected by passwords or with private content that is barred to search engines and casual browsers are also effectively hidden. This can also apply to much of the content of sites like social networks, which is not openly visible and requires an account and a certain level of privilege to view. On Facebook, for example, despite privacy concerns, it is not possible simply to browse all the information associated with every account: unless you are 'friends' with someone, all you can often find is their name, if that.

> **❝The vastness of the deep web . . . completely took my breath away. We kept turning over rocks and discovering things.❞**
>
> **Michael K. Bergman**

Finally, there is web content that exists in a format search engines cannot index. As search engines steadily improve, more of such content becomes accessible but the contents of many sites can remain opaque, such as PDF documents, the scanned texts of books, image archives that have not been tagged or even sites that have not been sufficiently well constructed according to the standard conventions of the web.

Hand delivered

In the shadowy world of private file transfers and attempts to access or transfer hard-to-obtain information, electronic file transfer is not the only or always the most effective technique. Trying to get hold of a pre-release copy of a film or album, for example, may involve trying to obtain a file from a secure system, in which case the easiest method may be to copy it physically onto a disk or flash drive, rather than attempting to use a network. Similarly, the original leak of the 2010 WikiLeaks diplomatic cables was achieved by copying files onto a flash drive from a secure system, not by electronic transfer. Using physical distribution for electronic files is sometimes referred to as using a 'sneakernet' – that is, a network relying on the use of a human courier (sneakily wearing sneakers). In the case of extremely large files, this can actually be faster than electronic transfer, as the time it takes to move a physical disk containing vast amounts of information can be shorter than the time taken to send that information across a network.

2002
Microsoft releases paper on file-sharing darknets

2003
WASTE application is developed

> **The more people do everything online, the more there's going to be bits of your life that you don't want to be part of your public online persona.**
>
> Danny O'Brien

The growing deep As suggested above, deep web exists in part due to the limitations of the procedures that search engines use to create indexes of websites and online resources. Search engines are continuing to improve yet the size of the deep web is also growing, to the concern of many who believe that the openness of the web is its most fundamental virtue.

The central reasons for the growth of invisible, 'deep' online content are the increasing complexity of web-based applications and the increasing amount of information that is stored in 'information silos' –closed systems that are unable to exchange information with other systems outside of them. Social networks are one example of this, as are most complex online services involving user profiles, such as online video-gaming sites, web applications for business and travel, banking systems, proprietary application stores and an increasing number of e-commerce sites that customize their experience for individual users.

In many of these cases, privacy is essential for personal details. But the larger issue is one of the proprietary – that is, the closed and sometimes paid-for – provision of online services, rather than the use of open formats. Apple is, for example, accused by some of creating vast information silos on the web thanks to the exclusivity of applications and operating systems for its mobile and tablet devices: users spend much of their time not on the open internet at all, but in a closed environment of Apple-only software and hardware. Similarly, with an increasing number of pay-for-access or membership-only systems being operated around online resources like newspapers, the open flow of information and opinion is interrupted, and whole parts of the web are effectively vanishing into 'deep' status.

Darknets In addition to invisible content, the internet also contains many private or hidden groups of a rather different kind. Sometimes referred to as 'darknets', these are structures used for closed communications and file sharing outside of the notice of ordinary net users, potentially for illegal or quasi-legal purposes. The term darknet was

first used well before the web, in the 1970s, to refer to computer networks that could interact with the ARPANET (the proto-internet) but which did not appear for security reasons on any lists or indexes, and were largely invisible to ordinary users.

Today, darknets usually centre on file-sharing networks that are based only on private, peer-to-peer interactions. Connections are only made between two people who know and trust each other – and may involve concealment of the locations of both participants. Such interactions do not require any use of the world wide web itself and are almost impossible to detect or shut down without actively infiltrating a network.

Software exists to facilitate such exchanges, such as the 2003-released program called WASTE, which takes its name from an underground postal system in Thomas Pynchon's novel *The Crying of Lot 49*. WASTE allows users to set up decentralized peer-to-peer networks, including facilities such as chat, messaging and file-sharing

How deep?

Estimating the size of the visible web is a difficult task, which makes estimating the size of the deep web still harder, but even conservative estimates put it at several hundred times the size of the visible web. Most of this hidden data is not shadowy or illegal but simply inaccessible. By some reckonings, the largest single 'deep' site on the web has historically been the databases of the USA's National Climatic Data Center (NCDC), which are public, but searchable by entering queries on the site rather than being indexed by search engines. The NCDC database is followed in the rankings by NASA, although with over 600 million users, the amount of data stored within the servers of Facebook is today likely to eclipse even these records.

protocols. It also offers a high level of encryption. Decentralized networks like these are effectively impossible to shut down, as there is no key link in them or way of measuring their extent. Typically, fewer than 100 people might constitute an individual network, sharing files and information among themselves. Such networks can be effective tools both for cyber-activism – as in the sharing of data such as the notorious WikiLeaks diplomatic cables released to the world in 2010 – or cyber-terrorism; or simply for the private exchange of legal, quasi-legal or illegally obtained files, ranging from films to photographs to text.

the condensed idea
Much of the digital world lies below the surface

24 Hacking

The word 'hacking' is most often used pejoratively today, to describe the process of breaking into a computer system, network or piece of software against its owners' wishes – either for the sake of the act itself, as some kind of message, or in order to profit through exploitation. The history and culture of hacking, however, is richer than this, and represents an ongoing digital underground that can be innovative and public-spirited, albeit avowedly libertarian in spirit.

The digital use of the word hacking is thought to date back to MIT in the 1960s, when students first began to take apart computer software and find ways around problems and obstacles that a program's original design could not overcome – or simply getting a program to do something outside its original specifications.

This sense of the word 'hack' survives today, when programmers talk about finding a 'quick hack' or an 'ugly hack', or perhaps a 'neat hack', which gets around a particular problem with software or hardware and allows it to be used successfully where it was previously failing. In very early computers, the memory for running programs was extremely limited and so a 'hack' often literally meant hacking a program down to a smaller size so that it was able successfully to run.

To be a 'hacker' at this time was a compliment: it implied being an expert, adventurous programmer. The word also had a wider sense outside of the digital world that survives to this day, meaning someone who was prepared to find unconventional ways of using any system and to disobey prescriptive rules if necessary; as one early alumnus of MIT described it,

timeline

1963	1971
First known use of 'hack' in a digital sense at MIT	*Esquire* prints article on phone phreaking

it meant above all 'to be playfully clever'. For some people, this positive sense of the word hacker remains its 'true' meaning.

Phone hacking By the 1970s, another form of technological hacking was gaining momentum in the form of 'phone phreaking' – hacking phone systems in order to gain free calls. This was done with a variety of techniques, usually involving users emulating the tones used in American phone exchanges to route long-distance calls, either by whistling or more frequently by using home-made machines.

Related tricks had been in use for decades but it was in the 1970s that it gained the status of an underground culture, with some 'pranks' passing into legend – such as a call put through to the Vatican purporting to come from Henry Kissinger, made by Steve Wozniak, who would go on to co-found Apple with another noted prankster, Steve Jobs.

Hackerspace

Although it may sound sinister to many ears, a 'hackerspace' is not a den of computer thievery but something more like an open public laboratory for those involved in a more unconventional kind of hacking – people interested in DIY technology, and the use and design of their own digital tools and projects. The subculture surrounding such DIY efforts is also known as 'maker' culture, referring to its emphasis on people actually being able to construct and understand the digital tools they use in an age when the inner workings of any electronic equipment are a mystery to most people. There are over 100 hackerspaces across America today, dedicated to sharing skills, equipment, advice and expertise – and celebrating the possibilities of non-corporate digital culture. Online, the blog Boing Boing is one popular outlet for the products of maker culture, and its co-founder the author Cory Doctorow is a vocal advocate of the virtues of thinking outside the intended constraints of modern hardware, software, business models and attitudes towards technology.

1983

Schoolboy hacker Neal Patrick features on cover of Newsweek

1999

15-year-old cracks US Department of Defense computers

Personal computing power While the hacking culture born at MIT in the 1960s continued to develop across the early internet and through the computer systems installed in academic institutions, it was the rise of the microprocessor and the subsequent home computing revolution of the 1980s that brought both technology and the notion of hacking within reach of millions more people.

> **A lot of hacking is playing with other people.**
> Steve Wozniak

Those who use computer 'hacks' to bypass digital security systems are also known as 'crackers', a term that many who identify hacking with the original, positive sense of the word feel should be used exclusively to describe such activity. It was in 1983 that cracking arrived for perhaps the first time in the public consciousness, thanks to both the release of the film *WarGames* – which imagined a teenage computer genius managing to start a nuclear war by hacking into the national defence computer system – and the real-life case of the hacking group the 414s, who were identified that year by the FBI as having broken into a number of secure computer systems across North America.

How to break in Most computer cracking either exploits known vulnerabilities in software such as operating systems in order to gain access to sensitive data, or attempts to infiltrate a system with malicious programs – malware – in order covertly to gain control over it or to set up a 'back door' method of access which only they know about. This is in addition, of course, to perhaps the most effective and hardest to prevent technique of all: corrupting the human side of things, and managing to obtain access codes or passwords or inside knowledge from someone working in connection with the system you wish to access.

As described at the start of this section in Chapter 20, there are many varieties of malware used to gain control of computers. Infection often takes place either via email or the downloading or copying of infected files. Common malware types include Trojan Horses, viruses and worms; computers may well be infected without their users' knowing, leaving a path open for both information theft and the use of a computer to send out further infections or mount attacks on other systems.

Other software used to help in cracking includes 'vulnerability scanners' and 'port scanners', which respectively explore whether networked computers exhibit any of a range of known weaknesses, and whether any

Hacker types

Many different kinds of people are involved in hacking and, as a result, a semi-official classification of different hacker types has developed in the online community, differentiating experts from amateurs, malicious groups from ideological ones and so on. The main groupings include 'black hats', who tend to be engaged in malicious activity for profit; 'white hats', who have benign reasons for hacking, such as testing security arrangements; 'hacktivists', who hack for particular ideological reasons and to draw attention to a cause; 'script kiddies', who lack expertise and conduct basic forms of hacking by running automated routines known as 'scripts' in order to break into computer systems (the term is a deliberately dismissive one); 'blue hats', who are working for an official computer or security firm attempting to identify and deal with potentially exploitable problems; and 'elite' hackers, who may belong to one of a number of shadowy and prestigious online collectives, and who are considered to be the most skilled operators of all and the usual inventors of new scripts, exploits and ways of breaking into the latest allegedly secure computer systems.

'ports' or data access points are potentially open to invasion. Data that is being transmitted across a network can also be potentially read by a 'sniffer' program if it is not sufficiently securely encrypted.

Far more sophisticated techniques than these abound, exploiting everything from particular knowledge about the 'overflow' points of memory within individual systems to the intricacies of 'root kits' designed to conceal all evidence that a computer's systems have been tampered with. One of the few certainties in all this is that the arms race between those seeking to break in and those hoping to keep them out is set to continue indefinitely – and that the skills of the best hacking minds are urgently required by the builders of new systems if they hope to keep the crackers and mischief-makers at bay.

the condensed idea
Someone is always going to break the rules

25 Cyberwar

As the name suggests, cyberwar is the digital version of war: one state attacking another, not with physical weapons but with virtual ones, aimed at damaging or compromising its digital infrastructure. With digital infrastructure playing an increasingly vital part in most nations' offensive and defensive capacities, the ability both to defend against and if necessary deploy 'cyber' techniques as part of warfare or espionage is a key modern concern for the military, and one involving elaborate drills, war games and technological innovations.

Like most other non-conventional forms of warfare, cyberwar involves far more than military targets. Digital attacks against a country can aim to damage its governing structures in general as well as its military technology in particular, its financial and economic structures and its infrastructure. In all of these cases, the divide between digital techniques and real-world consequences can be an extremely narrow one. Stock markets are essential digital entities but with profound real importance. Transportation networks – road, air, rail and sea – all rely to a greater or lesser degree on technology to operate, and can be profoundly disrupted by digital assaults.

Similarly, energy grids and telecoms grids, although run on more secure networks than the world wide web, can potentially be crippled by sufficiently advanced digital infiltration techniques. In fact, one of the most notable things about cyberwar is the relative difficulty and inconvenience of attacking specifically military targets, which tend to be operated by highly secure closed computer systems, compared to causing profound damage to a nation by attacking less secure governmental, commercial or civilian digital resources.

timeline

1999	2007
Serbian hackers attack NATO systems	Largest cyber-attack in history of USA

> **❝Our adversaries will find our weakest link and exploit it, whether it is public or privately owned and operated.❞**
>
> Keith Alexander

Techniques The techniques used in cyberwar can broadly be divided into those of espionage: gathering secret information to gain advantage; and sabotage: inflicting damage on an aspect of digital infrastructure. Of the two, various types of espionage are more common on the global stage, with nations having much to gain from covertly harvesting information about rival powers. Arguably, this does not fully constitute 'war' and most such acts would be unlikely to be treated as acts of war by a state. Sabotage and vandalism, meanwhile, are techniques more likely to be deployed by individuals or small groups, and potentially by those wishing to engage in 'cyber-terrorism' for whom causing maximum disruption is the highest priority.

The biggest assault

In 2007, America experienced what a former state department official described as 'our electronic Pearl Harbor' when a still-unknown foreign power broke into the computer systems of many of the countries high-tech and military agencies, including the Department of Defense, the Department of State, the Department of Commerce, and perhaps NASA as well. Several terabytes of data were copied – almost as much as the entire contents of Wikipedia. The massive security breach was achieved by a simple method: malicious code was placed on a portable flash drive that was then plugged into a military laptop in the Middle East, and once on the machine the malicious code was able to spread undetected through classified military networks. This was a breach of security orders of a magnitude more troubling than the high-profile release by the website WikiLeaks in 2010 of thousands of US embassy cables passed on to it by an American soldier who had downloaded the data while in Iraq.

2008	2010
NATO cyber-defence policy formed	USA appoints its first cyberwar general

Playing cyberwar games

Simulations are one of the most effective ways to train for and model the potential consequences of military actions – something that is especially true of virtual conflicts. In February 2010, one such simulation in America modelled what might happen if millions of phones and computers in America were compromised by malicious software, turning them into a massive 'botnet' able to be controlled remotely and launch attacks on websites and networks. The result, played out over four days with many former senior government officials involved, saw tens of millions of Americans cut off from the electricity grid and the stock markets shut down, thanks in part to the government's limited ability to control and to quarantine privately owned electronic equipment like mobile phones. Partly in response to such simulations, emergency legislation to be deployed in the case of cyber-emergencies is currently being debated in the USA and other nations; and in May 2010 America appointed its first general explicitly in command of cyber warfare, Keith Alexander.

Cyber counter-intelligence has become a substantial area of investment over the last decade, and in particular since a prominent cyber-assault of Russian origin on Estonia in 2007. In response, NATO established a Cyber Defense Center in Estonia's capital, Tallinn, and in 2008 formulated an official policy on cyber defence – one that was reiterated at its 2010 summit, where it was asserted that 'the rapid evolution and growing sophistication of cyber attacks make the protection of Allies' information and communications systems an urgent task of NATO on which its future security depends'.

DDoS The 2007 attacks on Estonia targeted commercial, government and media websites, and took the form of one of the most potent forms of assault: so-called DDoS or Distributed Denial of Service attacks. In these, websites are swamped by tens or even hundreds of thousands of visits, overwhelming the capacity of their servers to operate. Such attacks made global headlines once again in late 2010, when they were used both to target controversial website WikiLeaks and, subsequently, in a series of

'revenge' attacks orchestrated against corporate websites such as PayPal which were perceived to have colluded with WikiLeaks' opponents.

DDoS attacks are a highly visible form of online assault, yet it can be extremely difficult to trace those conducting them, as they are most often deployed using unwitting networks of 'zombie' machines controlled by a hacker using maliciously spread software.

Other cyberwar techniques include the interception and modification of digital information, and the breaking of encryption, either through infecting the target systems with malicious software, probing target networks from outside in an attempt to find vulnerabilities that allow data to be extracted from them, or by the capture and reverse-engineering of hardware that is running software using the encryption that is to be broken.

> **❛The problem with the internet is that it's meant for communication among non-friends.❜**
> **Whitfield Diffie**

China is widely believed to be the world's leading power in terms of its capacity for cyber-espionage, thanks to sustained investment in the field, skilled manpower and a willingness to use volunteer citizen forces for operations. Over 30 major US corporations have reportedly experienced digital infrastructure attacks originating in China – including, most famously, Google, which cited an attack on its corporate infrastructure in early 2010 as one of the reasons for pulling its operations out of mainland China. But the capacity for such actions is growing internationally, with the global cyberwar sector estimated to be worth over $12 billion by the end of 2011, making it the world's single fastest growing area of defence expenditure.

the condensed idea
The web is a war zone

26 Social networking

Social networking is the defining trend of the current phase of the internet's development, as the web moves steadily from being a tool for finding and sharing information into being a tool for finding and relating to other people. There has always been a social element to digital culture. But it is with the idea of tools dedicated to social relationships – and above all with the rise of Facebook – that this idea has taken its place at the heart of an increasing number of contemporary lives.

Early social networking services began to appear in the mid-1990s, and offered what were essentially enhanced chatroom services, modelled on the communities that had developed across pre-web bulletin boards and web forums. For example, theGlobe.com was founded in 1994 by two Cornell students. Inspired by the social appeal of chatrooms, the site essentially offered enhanced digital spaces for people to post public information about themselves and their interests.

This site, theGlobe.com, became a poster-child for the late 1990s internet boom, setting a record for a first-day gain in share price of 606 per cent when it went public in 1998. Within a year, though, its share price had collapsed. Other sites fared better: In 1995, a site called Beverly Hills Internet – later renamed GeoCities – began inviting users to create their own free home pages within different online 'cities' themed by topic.

By the end of the 1990s, several different types of social networks had been established. There were general interest communities like

timeline

1994	1995	2000
theGlobe.com is founded	Classmates.com is founded	Friends Reunited is founded

theGlobe.com, featuring increasingly advanced user profile pages and opportunities for creating and sharing content; and more specific networks, typified by the US Classmates.com, launched in 1995 as a way of helping people to reconnect with old contemporaries from school and college. Inspired by Classmates.com, British site Friends Reunited launched in 2000. Services like AOL Instant Messenger, meanwhile, which launched in 1997, were steadily moving into the mainstream the idea of instant messaging and using live contact lists of online friends.

> **❝Social Media is about sociology and psychology more than technology.❞**
> Brian Solis

From destination to hub By the end of 2000, millions of people had profiles on a variety of social networking sites – and might check in a couple of times a week or month to see how their networks had shifted. Social networks were a destination online. But they were not yet a dominant part of online experience.

The power of play

One of the most significant recent developments in social networking, and on Facebook above all, has been the increasing proliferation of applications developed by third-party companies for use within social networks. Of these applications, both the most popular and the most profitable category is games; the term 'social gaming' has even been coined to describe the immense popularity of playing simple games with friends via networks. Rather than involving simultaneous, time-consuming and immersive play – as most traditional video games have tended to do – social games emphasize the ability of players to perform limited, frequent actions at different times. These may involve answering quiz questions, making a move in a game like Scrabble or chess, or – most popular of all – performing a few actions within a virtual environment like a farm, city or restaurant, where the game is not so much about winning or losing as it is about building up more and more resources, and sharing and comparing these with friends' pet projects. One of the most infamous and popular of such games, FarmVille, boasted over 80 million players around the world at its peak.

2002	2003	2004	2006
Friendster is founded	Myspace is founded	Facebook is founded	Twitter is founded

This began to change in 2002 with the launch of a new style of social networking site called Friendster. Friendster was designed not simply to help people connect with old classmates or those with similar interests, but also to function as a far broader online destination within which visitors could browse profiles at will, make easy connections with real-life friends, and share media and messages.

Business social networking

Although most time spent on social networking sites is leisure time, the phenomenon is also having a profound effect on businesses. The world's best-known business social networking site, LinkedIn, was launched in 2003 and as of January 2011 connected over 90 million profiles across the world. The increasing universality of sites such as LinkedIn – which includes facilities for full career histories, online CVs, personal details, and most importantly the ability to connect to, find, contact and recommend other people in related fields – is now rapidly transforming the recruitment processes of many companies, and attitudes towards finding employment. Online self-presentation is becoming a core skill in many fields, today – as is ensuring that potentially unimpressive details of your life are not publicly available to any potential employer doing a quick sweep of other social networking sites.

Friendster had over a million users within a year, but was soon overtaken following the 2003 launch of a similar-looking site, Myspace. Myspace mimicked Friendster's features but pushed far harder for new users, and by 2006 was celebrating its 100 millionth account. It became the leading venue not just for communication with friends, but for exploring pop culture, discovering new bands, sharing music and video, and generally interfacing with the web via the most discerning of all search engines – other like-minded people.

Facebook Even as Myspace was celebrating its triumph – and its purchase in 2005 for $580 million by News Corporation – a rival, founded in 2004 as a way for college students to stay in touch, was gaining on its lead: Facebook.

Founded by Harvard student Mark Zuckerberg and launched as thefacebook.com in January 2004, Facebook opened out over its first year from Harvard-only membership to other US colleges, then high schools, and finally in 2006 to anyone aged 13 or over. Facebook hit its 100 millionth user in 2008, reaching 200 and 300 million users in 2009, and half a billion by the middle of 2010. As of January 2011, the total was 600 million and still growing.

Another milestone was passed at the end of 2010, when Facebook overtook Google for the first time as the most visited website in America. What explains Facebook's huge success? One reason is undoubtedly self-reinforcing: it is far more valuable for new users to join the world's largest social network than any other. Beyond this, though, Facebook has demonstrated an aggressive willingness to bring within the structure of a social network almost all of those things that make up the fabric of relationships online: an internal email and messaging system; image sharing; invitations, events, groups, societies and petitions; fan sites and detailed profile pages; and perhaps above all, games and applications, and the opportunity to connect these with a host of other sites and online activities.

> **'Being the first is old media, while being to the point is new media. And Twitter never forgets.'**
> **Mercedes Bunz**

Twitter and interconnected sites The only other social service to make a similar impact to Facebook in recent years is the micro-blogging site Twitter. Launched in 2006, it allows members to follow each other's 'tweets' of no more than 140 characters – and had by the start of 2011 almost 200 million user accounts. This transition towards experiencing the internet as a real-time stream of updates and links is perhaps the greatest transformation of all wrought by social networking. For it marks the emergence of a new default digital state for many people, where the online world is primarily encountered not as a limitless resource waiting to be searched, but as a real-time network of friends and contacts, sending and receiving messages and updates. This social web – which, thanks to smartphones and mobile devices, many people are now able to spend most of their time plugged into – represents one of the most profound shifts in the history of digital technology.

the condensed idea
The social web is the digital future

27 Games consoles

Games have always tended to be one of the most significant forces driving the popular use of technology. In 1972 many home users got their first ever taste of computing as something that could be experienced at home as well as at work or in academic institutions, thanks to the appearance of the first games console: a home machine dedicated entirely to playing video games. Today, the console market is worth tens of billions of dollars, with hundreds of millions of machines around the world.

The world of console games began in 1972, with the release of the Magnavox Odyssey. Its inventor, Ralph H. Baer, had the then-revolutionary idea that his simple machine could be connected directly to a TV set to produce an image rather than needing its own, expensive monitor. The machine boasted a variety of simple games but suffered from poor marketing and failed to make much of an impact compared to a product also released in 1972 – the new American company Atari's arcade game, Pong, which became the world's first commercially successful video game. It was played in public on an arcade machine rather than at home, but it had itself been inspired by a similar table tennis game on the Magnavox; Atari and Magnavox would later reach an out-of-court settlement over the fact that Atari's game had been based on Magnavox's. It was Pong, however, that would truly launch the home gaming market when in 1975 both companies released home consoles dedicated to playing Pong.

Atari soon grew into a position of dominance in the young console market, releasing the Atari 2600 console in 1977 (known at the time as the Atari VCS), which popularized the principle of buying games as cartridges that

timeline

1972	1977	1983
The first games console, Magnavox Odyssey, appears	Atari VCS (later 2600) is launched	Nintendo Entertainment System appears

Famously risky

Building and marketing a games console is a hugely expensive and risky business for a company, requiring an enormous investment in research and development and gambling on a notoriously fickle and cyclical kind of consumer interest. Inevitably then history is littered with failures and under-performing machines. The very first games console, the Magnavox Odyssey, itself performed poorly; while its conqueror, Atari, would in due course be overtaken by Nintendo and Sega. In 1993, Atari released a console called the Jaguar intended to reclaim gaming dominance from its rivals. Instead, the ill-fated machine proved to be the company's last cutting-edge gaming machine. A similar commercial fate befell Panasonic's attempt to enter the market in 1993 with a machine called the 3DO, while Sega itself dropped out of the console-manufacturing business after its 1998 machine the Dreamcast failed to win back lost ground from Nintendo and Sony.

could simply be inserted into the machine to play: a substantial advantage consoles had in ease of use in an era when home computers tended to be anything but simple for the non-initiated to use.

Backed by the growing craze for arcade gaming, the next milestone in the console market came in 1980 when Atari released a version of the new arcade hit Space Invaders for its home systems. The future seemed secure, and yet in 1983 a combination of overcrowding in the market and a lack of quality led to a crash in the North American games market and a rash of bankruptcies.

> **‘Man is a game playing animal and a computer is another way to play games.’**
> **Scott Adams**

The rise of Japan The 1983 crash left a hole in the market that the Japanese company Nintendo was perfectly placed to exploit with the release of its 'Family Computer' or Famicom, as it was known in Japan. Re-titled the Nintendo Entertainment System for global release, this squat grey box heralded a further revolution in home entertainment, thanks to

1994	**2001**	**2006**
Sony PlayStation is launched	Microsoft enters the market with Xbox	Nintendo Wii is launched

> **❝Games are made by highly intelligent and creative people, and . . . the best of them are sophisticated artworks in their own right.❞**
> **Steven Poole**

its sturdy combination of quality and usability – and the game that would popularize the world's greatest gaming icon, Super Mario Bros., a title that went on to sell over 40 million copies.

The late 1980s and 1990s soon became a period of intense rivalry between two Japanese companies – Nintendo and Sega – for dominance of the increasingly lucrative games console sector, with the Sega Mega Drive console locking horns with the Super Nintendo Entertainment System. The balance of power shifted once again, however, with the arrival of a new rival on the scene at the end of 1994: Sony. The Sony PlayStation became the first console to sell over 100 million units and helped to bring gaming to a new, more adult audience thanks to its CD-quality sounds, dazzling visuals and slick marketing.

Meanwhile, Nintendo increasingly rose to dominance in another vital market – the handheld console, a field its 1990 console the Game Boy went on to define, in part thanks to the iconic game Tetris. The 2004 release of the Nintendo DS system similarly revolutionized the market in a new decade.

New revolutions The console market has continued to grow in steady cycles or 'generations' of machine, to the present day. In 2001, another new player entered the scene – software giant Microsoft, with its Xbox console – and home games sales continued to soar, with console graphics and sounds offering ever more sophisticated experiences.

Perhaps the most significant innovation to come from the world of games consoles, however, arrived in 2006 with Nintendo's seventh-generation console, the Wii. Offering motion-sensitive controls as standard, the Wii had by the start of 2011 sold over 75 million units, and helped to change public perceptions both of games and interactions with digital technology in general, thanks to the unprecedented accessibility of its control method. Microsoft duly took this kind of interaction a further leap

Commercial heaven

Modern console games are staggeringly expensive – and potentially profitable – products to make. Retailing for up to £50, their production costs rival the biggest movies, approaching $100 million in the case of 2008's Grand Theft Auto IV. That game boasted half a billion dollars worth of sales in its first five days on sale, making it the most profitable entertainment release of any product in history at the time: a record broken the next year by Activision's game Modern Warfare 2. Given the many hundreds of people it takes to craft such game worlds from scratch, and the demand that such worlds be fully interactive and contain potentially hundreds of hours worth of content, it's arguable that such games are among the most complex digital products ever created.

forwards with the introduction of its Kinect system for the latest version of the Xbox in November 2010 – a motion-control system based not on moving a controller through the air, but on a camera able simply to track the motions of people's bodies in front of it.

This is the kind of field in which consoles in particular, and video games in general, have always led the digital world: in bringing revolutionary advances in graphics, sounds and interfaces to the general public, and in making technology at once more accessible and more compellingly appealing. The future of consoles increasingly lies not simply as games machines but as home media centres: streaming television and movies, hosting gaming and leisure communities of players, storing digital media and offering new kinds of interactive experience. But all this aligns with their most fundamental function: tapping into the basic human urge to play, and helping to place its stamp firmly on a digital age where the boundaries between work and leisure are growing every more permeable.

the condensed idea
Play drives digital revolutions

28 Mashups

One of the most central features of digital culture is the manipulation and recombination of existing media – video, images, sounds, words – to create new works: 'mashups'. Often comic or parodic, these pop cultural products range from modified images that are the result of a few minutes' work to elaborately re-cut movie parodies or tributes that can take days or even months of effort. At the same time, the principles behind mashups go well beyond media, spanning data, applications and the power of combining existing resources into something new.

The idea of recombining existing materials into new creative works is an ancient one. But 'mashing up' different elements into a new work also embodies one of the fundamental principles associated with a digital culture: that content exists to be shared and re-used, and should be made as inter-compatible as possible.

It is something that can fundamentally conflict with many established legal notions of copyright and intellectual property, but has also helped to fuel new notions of creativity and originality. And, as with so much else, it is an activity that the ease of digital reproduction and manipulation has put within the reach of almost everyone with a computer and an internet connection.

Mixed media Comic images have been a staple of the internet since the pre-web days of bulletin boards in the 1980s. But it is only with the increased bandwidth and numbers associated with the rise of the web that mashup culture has extended fully into other media – and reached its richest modern form in music and video.

timeline

2000	2001
Website machinima.com is launched	2 many DJs release the first mashup album

The musical tradition of sampling and mixing multiple songs is almost as old as the technology for recording music itself. Music mashups created using digital tools, however, allowed new levels of precision and complexity – and distribution and imitation. Tracks such as 'Destiny's Child v Nirvana', which first appeared in 2001, show off highly intricate musical and video mixing skills in their online form. They also demonstrate the increasing invisibility of the line between amateur tributes and commercial product, especially given the willingness of the commercial world to re-exploit the most popular memes and mashups.

Subversion combined with affection is a common theme of many mashups, some of the most striking of which are also called 'remixes'. These involve re-cutting film trailers and adding new soundtracks to give the impression of a switch of genres: *Forrest Gump* presented as if it were a horror movie, for example, or *Dumb and Dumber* as if it were a science fiction thriller. More elevated performance art based on video and sound mashups is also increasingly common at live events, overseen by a VJ – the video version of a DJ.

Lolcats and imageboards

One of the most famous – or infamous, depending on your perspective – products of the last five years of online culture is the 'lolcat': a cute photograph of a cat that has been repurposed for entertainment by the addition of a caption, usually mis-spelled ('I can has cheezburger?' is one of the most iconic captions). First seen on the imageboard website 4chan in 2005, lolcats are just one example of online 'image macros' – images on which text, usually humorous, is superimposed. Almost the simplest kind of mashup, the ease of creation and distribution of the most popular image macros has created a host of internet memes and, in the case of lolcats, an entire private language, 'lol-speak', which now boasts among other things an almost complete translation of the Bible (sample from John 1:1, 'In teh beginz is teh meow, and teh meow sez "Oh hai Ceiling Cat" and teh meow iz teh Ceiling Cat.').

2005

First lolcat appears on web

2005

Google Maps launches with its ability to integrate into other websites

Fan labour Interactive and online media have created increasingly vocal and creative groups of fans around most successful imaginative worlds, and the quality and quantity of fan productions based on the adaptation of original materials is acknowledged in the notion of 'fan labour'. The phrase is itself an acknowledgement of the blurring boundaries between the creation of original material and the subsequent re-use of that material by an audience, and many media companies and creative individuals are increasingly trying to maintain a productive balance between the two.

Mashups are only one aspect of this issue but present some of the most urgent questions for fans and producers alike, as they involve the use not simply of characters and ideas from creative works but the wholesale re-use of images, sounds and other elements of content. Among the most radical approaches is the possibility of deliberately making creative 'assets' available for re-use by fans – from scripts to graphical models, environments, samples and soundtracks. One notable example of this taking place was the British band Radiohead's release of its 2008 single 'House of Cards', which included a promotional video of lead singer Thom Yorke based entirely on three-

Machinima

The modern culture of mashups spans interactive as well as linear media – and one particular area of interest is the practice of using characters within video games to put together often complex recorded performances. The practice is known as 'machinima' after a website launched in 2000 whose name was a variant contraction of the phrase 'machine cinema'. Fans utilize the sophisticated graphical environments of games and their control over in-game characters as a kind of theatre – recording often carefully scripted performances and then processing them much like real films,

complete with soundtracks, cuts, fades and even online trailers. Both original, satirical and re-enactment works are popular; among the most watched projects of recent years include a 2006 episode of the TV comedy series *South Park*, 'Make Love, Not Warcraft', which incorporated footage 'acted' within the game World of Warcraft itself. The popularity of machinima productions has led game-makers to clarify the licensing conditions on which they can be made, most notably in a 'Letter to the Machinimators of the World' from the operators of World of Warcraft, permitting most non-commercial machinima.

dimensional data scanned in real time as he sang. This data was released openly online, allowing fans to construct their own visualizations of the song based on the raw, original data.

Mashup applications While media and entertainment may be the most familiar forms of mashup, the name is also applied to web applications that take information or functions from multiple sources and combine these into something new. By harvesting data from databases and combining it with other data and functions, such as mapping and analysis tools, mashup applications can offer some of the most powerful public Web 2.0 tools around, and are increasingly recognized as an important resource for everything from eGovernment to development economics.

A typical example might involve data visualization: in the UK, the government's release of public data ranging from crime statistics to the locations of local services has led to a wealth of mashup products plotting this data geographically, providing visualization and comparison tools, and using it to map social and economic trends across the country. The government has actively encouraged this approach by releasing data in formats suitable for re-use and recombination, aiming to encourage small digital companies to explore the possibilities of combining different data sets and tools. A similar approach in the USA has yielded powerful and popular applications based on official data from multiple sources: from an employment market explorer that displays regional unemployment trends overlaid on a Google map to a 'data masher' tool that allows its users to choose from a selection of data sets and then display them graphically and analyse them.

> **People have stories to tell and will utilize whatever means to do so.**
> Friedrich Kirschner

As with artistic mashups, the idea of combining different sets of data and resources is hardly a new one to the digital era: in the 19th century, for example, mapping disease outbreaks played a central role in first understanding the role of contaminated water in the spread of cholera.

the condensed idea
Digital media means perpetual remixing

29 Culture jamming

Culture jamming is 'jamming' in the same sense that one side might attempt to disrupt radio communications during a conflict: it aims to disrupt and subvert mainstream cultural messages, often for satirical or political ends. Given the ease with which digital media can be manipulated, culture jamming broadly describes whole swathes of online activity and an 'alternative' scene that has itself become sufficiently established to merit further satire and subversion.

The idea of culture jamming itself precedes the digital era, with origins in both ancient rituals of carnival and subversion and, more recently, 20th-century artistic movements like Situationism that sought to highlight the absurdity of many everyday conventions. Many anti-consumer movements like Adbusters, founded in 1989, have consistently attempted to 'jam' mainstream culture with various forms of satire on advertising, branding and mass consumption.

The suitability of such subversions for digital culture has led to an unprecedented diversification of the phenomenon online – in part thanks to the match between the ease of digital production and the fact that culture jamming neither creates nor distributes a commercial product. In its early days the internet itself was outside of and often opposed to the cultural mainstream, and this ethos continues today in the presence of many online spaces within which no form of satire or invective is considered too extreme and materials that might invite legal actions if published in other media can be aired in relative safety and anonymity.

timeline

1957

Situationist International
group is founded

Perhaps the most infamous of all early internet venues for deconstructing mainstream culture were a variety of comic imageboards and cult sites hosting content such as satirically manipulated photos, accounts of anti-establishment pranks and satirical reviews. One such site, Something Awful, was founded in 1999 and has since amassed a noted anarchic online following of subscribers – sometimes self-identified as 'goons' – to its forums.

In addition to the satirical demolition of many mainstream targets on the forums themselves, 'goons' are noted for organizing groups of players within popular online games and virtual worlds with the express intention of destroying the play experience for normal users – a form of virtual culture jamming that also serves as an acknowledgement that much digital culture has today become sufficiently mainstream for it to merit jamming in its own right.

Hardware jamming

For those serious about jamming the unwanted cultural signals in their lives, the internet is richly stocked with 'open source hardware' instructions for constructing devices to help. These range from remote controls able to turn off any unwanted televisions in public spaces to machines for jamming mobile phone signals, as well as low-tech items such as fake designer labels to attach to clothes. The ethos of such devices can be summarized as 'taking control of the information around you', and is allied to 'maker' culture and the art of mashups, all of which invite individuals not to consume contemporary culture passively but to probe and play with it – and reserve the right to reject elements of it outright.

Political culture jamming The sheer speed with which online communities can create and disseminate responses to events makes digital culture jamming especially suitable for rapidly shifting fields like politics – a trend fully in evidence during the 2010 British general election. Within hours of their release, a series of posters for the Conservative Party that used the phrase 'I've never voted Tory before, but . . .' were being doctored and posted online and linked to in their thousands, with variations ranging from 'I've never voted Tory before . . . because I'm 7 and like the Power Rangers' to 'I've never voted Tory before, but believe in scaremongering about society'.

1989	**2003**	**2010**
Adbusters magazine is founded	Santorum controversy rages	'Jamming' becomes an integral part of a British general election

Alternative vs mainstream

For some critics of the concept of culture jamming, the notion that a meaningful distinction can be established between alternative and mainstream culture is itself a suspect one. Both mainstream branded goods and independent 'open source' products, they argue, appeal to people through the same fundamental mechanisms: a particular image and idea is being sold, which in the case of anti-mainstream products is simply an anti-establishment image. Such criticisms treat the more extreme forms of culture jamming as meaningless, in that they argue that being against the 'system' is not a position that leads to meaningful change or improvement in the world – and that there are more effective forms of activism for those who do wish to change the world.

The activity quickly spawned a website, a Facebook group and a trending topic on Twitter – as well as controversy within the mainstream of the election campaign itself, as Labour MPs linked to and commented on the jamming of the poster campaign.

Jamming the messenger The potential for the near-instant widespread subversion of any message is both a source of delight to many people and a significant factor in much modern publicity and public debate. On the one hand, much online debate tends to be ephemeral, near-invisible amid the sheer quantity of information available, or to be of interest largely to particular constituencies already persuaded of a position. On the other hand, the rising importance of some websites as the world's primary form of reference means that the ability of online communities to 'jam' one message and replace it with another can prove significant.

One such example is the 'Santorum controversy', which arose in 2003 when the US Republican former Senator Rick Santorum commented during the course of an interview that he did not believe the constitution granted consenting adults a right to privacy in sexual acts, meaning that the state had a right to regulate homosexual acts in the same way as it regulates against acts such as incest and child molestation.

Santorum's comments provoked considerable criticism but perhaps the most enduring effect of the reaction against them was the hosting of a contest by the columnist Dan Savage to create an alternative meaning

> **❛My whole mindset is, there are terrible things on the internet: Can I write about them and transform them into something humorous?❜**
>
> **Rich Kyanka**

for the uncommon surname 'Santorum' and attempt to introduce this into common usage. The campaign, which provided the word with an unpleasant sexual definition, was such a success that any online search for the name 'Santorum' now produces it among the very top search results.

Google bombing Successful campaigns to 'jam' a particular word or message often attempt to exploit a technique known as Google bombing – an attempt to exploit the operation of search engine algorithms by establishing large numbers of connections to a particular page from other pages, all linking via the same phrase. Google's search engine is today extremely resistant to such efforts but some notable results remain, including the top link for the search 'French military victories' leading to a spoof Google search results page asking 'Did you mean: french military defeats'?

Serious as well as comic effects can also be achieved by such techniques. 'Googlewashing', for example, describes a kind of reverse culture jamming, where a corporate or mainstream interest aggressively tries to change the top results that appear when a term is searched for or to ensure that traffic is directed away from rivals and towards them. Online battles over perceptions can rage back and forth between different accounts, as many of the 'edit wars' within reference sites like Wikipedia testify – with 'jamming' unfavourable messages today being far more than an amateur art.

the condensed idea
Using digital tools to dismantle ideas

30 E-commerce

Commercial transactions are one of the most fundamental uses of the internet and can seem like one of the simplest. Services are bought and sold on a similar basis to physical transactions. And with retail goods, much as in many shops or catalogues, items are selected, paid for and then delivery is arranged – either by post, in the case of physical goods, or via download. Behind this, however, lies an administrative and logistical network of immense complexity, above all when it comes to processing financial transactions, ensuring data security and dealing with the proliferating forces of fraud and scamming.

Security is the single most important factor in the existence of online commerce. The world wide web was opened for commercial usage in 1991, the year after its birth, but it wasn't until 1995 that the most important initial step was taken in helping online sales to take off: the public release of an online protocol called Secure Sockets Layer (SSL) that could be used to encrypt traffic to and from a website.

Previously, information had travelled across the web in what was essentially an open form, potentially readable by anybody who intercepted it. SSL meant that a website could now be created with a secure 'layer' over its traffic, encrypting all information sent to and from the server so that, even if it were intercepted, it would not be possible to work out the actual details that were being entered on the site. SSL has continued to be improved since its release; in particular, 1999 saw the release of an upgrade called Transport Layer Security (TLS), offering additional protection on top of the latest version of SSL, and both protocols have continued to be developed since.

timeline

1992	1995
Book Stacks Unlimited is founded	Amazon and eBay launch online

Amazon and eBay Although they weren't the very first online shopping sites, two modern giants – Amazon and eBay – were the first to have a profound market impact and to begin accustoming the world to the idea that items could be bought as well as merely viewed online. Between them, the sites also embodied the two core types of business that the internet would excel at delivering: selling a greater range of new goods than could be fitted into any physical store, and offering a bigger consolidated marketplace for second-hand auctions and resales than any physical location. The overwhelming success of these companies is also a telling indicator of the dominance of e-commerce by large brands.

Amazon was founded in 1994 and launched online in 1995 as, initially, a bookstore. It wasn't the first internet-based bookseller (that was the company Book Stacks Unlimited, founded in 1992) but it gradually moved

How much – and who benefits?

In 2010, Amazon had around $25 billion worth of revenues while eBay had revenues of around $9 billion. But this is only a fraction of the money now spent in online retail. The world's biggest market, the USA, saw around $170 billion worth of online retail sales in 2010 – 7 per cent of its total retail market – while the global market is predicted to pass the one trillion dollars mark by 2014. The significance of e-commerce's growth is difficult to predict but two related trends suggest that traditional businesses located in the middle ground between vast and boutique firms may find the digital transition most difficult: very large businesses benefit most from the improved economies of scale and access to huge audiences that the internet offers, while highly specialist and boutique businesses are more easily able to find their very particular customers. For those in the middle, the online future may prove increasingly bleak.

1999	2002	2010
Transport Layer Security (TLS) is introduced	eBay buys PayPal	Amazon revenues hit $25 billion

to selling a huge range of products and services. Unlike many other early dotcom companies, Amazon planned from the beginning not to aim for profitability for several years – and didn't make its first annual profit until 2001, an index of the unusually slow-burning nature of online retail compared to other digital businesses.

eBay launched online in the same year as Amazon, 1995, under the name AuctionWeb, and by 1998 had half a million users. It went public that year and continued to grow rapidly, reaching revenues of over seven billion dollars by 2008. Its most important acquisition, however, came in 2002, when it became the sole owner of the e-commerce business PayPal – a company allowing people to make and receive payments and transfers of money online via an account with PayPal itself rather than a business bank account or credit card.

Payment systems Services like PayPal's have proved a central part of the growing online economy, as they make it far easier to purchase goods and services online for both customers and businesses (for many online businesses, processing credit card transactions securely across a spectrum

Going social

Like everything else online, the next stage of e-commerce is being influenced by social media. Leading multinationals such as Procter & Gamble have begun to experiment with selling brands directly through Facebook – with the sales platform powered by Amazon. And the online culture of individual recommendations and reviews, which Amazon and others did so much to fuel in the first place, is taking on a new level of complexity given the sophistication of recommendations systems on social platforms. Effective automated recommendation systems have for years been a priority for online retailers anxious to understand, predict and profit from their users' behaviour. Increasingly, though, the emphasis is falling on enlisting users themselves as informal ambassadors and consultants for brands – something that not all consumers, or indeed businesses, are entirely comfortable with.

❝There is no physical analog for what Amazon.com is becoming.❞

Jeff Bezos

of different national banking systems is one of the most expensive and resource-intensive aspects of their entire business). PayPal accounts also allow small businesses and individuals to make and receive payments securely when they would often be ineligible or unable to set up a payment system through conventional banking. The service operates today in over 190 markets, as well as via a text-message-based system on mobile phones, and has helped to define the model for many other online payment and currency systems – as well as making steady headway in being accepted alongside credit card payments as a truly mainstream way of paying for goods and services.

Major retailers In parallel to these booming internet-based businesses, almost every major retailer in the world now has a substantial online presence, with an increasing sophistication of goods and services available. Supermarkets have expanded heavily into online shopping and home deliveries, while many physical stores – and in particular those selling media, such as books, CDs and DVDs – have found their business shrinking or have been compelled to adapt to more of a 'destination' experience to differentiate physical shopping from online shopping. Accompanying this, too, has been a steady increase in the sophistication of delivery and logistics services – something exemplified by Amazon, whose strategically located distribution centres can each be larger than ten football pitches.

the condensed idea
The web is the world's biggest shop window

31 Online advertising

As digital products consume an increasing amount of human time and attention, online advertising is becoming an increasingly central part of many businesses – and is steadily changing the way advertising itself functions. Like other digital tools, the costs of entry for online advertising are far lower than in traditional media, and the data available is potentially far more precise. But new hazards also come with the territory, as well as a new and unprecedented degree of influence wielded by the biggest companies in the field.

The earliest online adverts began to appear in the mid-1990s and predictably enough were based on existing print models: 'banners' might appear on the top of a web page or 'towers' along its sides. Clicking on these adverts would take people directly to a company's website, marking both a newly immediate relationship between an advert and a company and a far more accurate, rapid way of measuring the effectiveness of an advert than had traditionally been possible.

By the late 1990s, animated and interactive adverts had become increasingly common on websites and, with investors rushing to put money into online companies, the market began to take off at an exponential rate – at least until the dotcom bubble burst in late 2000. By this stage, it was becoming clear that online businesses and advertising were not delivering everything that had been hoped: effectiveness tended to be low for web adverts, and companies' willingness to pay for them correspondingly reduced.

timeline

1994	1996	1998
First online adverts appear	First ad-serving companies arrive	Pay-per-click advertising is first demonstrated

Serving Advertising in all formats and media has always had its specialist providers – and online advertising proved no exception. Almost from the beginning, companies specializing in 'ad serving' found a welcoming market online of people wishing to profit from showing advertising on their websites but who were unable or unwilling to solicit it themselves.

The first dedicated online ad-serving company came into existence in 1996. Soon after, the practice of 'remote serving' was launched, allowing a specialist company to manage the advertising on any client website that installed its code. The appearance of appropriate adverts would be selected, uploaded, updated and managed by a serving company; statistics on performance would be measured; and specialized targeting based on content and user behaviour would usually be available.

The power of data The online world offered something advertising had never truly had before – real-time, precise statistics on the effectiveness of adverts. Early online advertising tended to work on the basis of how many times an advert was displayed to different users: the number of 'views' a page featuring it received. Billing according to this metric was known as a 'cost per impression' approach. In 2000, however, Google launched a system called AdWords that allowed customers to

Beware of click fraud

Online advertising is a rich arena for deceptions targeted both at consumers and at advertisers themselves. Perhaps the commonest way advertisers are targeted is click fraud, which exploits the popularity of pay-per-click advertising to generate a large number of clicks on a particular advertisement, potentially costing its operator a great deal. This is a criminal offence in many parts of the world but can be difficult to detect and prove. Techniques range from small-scale human fraud – someone simply clicking on links themselves, or paying other people to do so – to automated fraud on a large scale using programs to mimic customers.

2000
Google begins keyword advertising

2006
Facebook announces advertising deal with Microsoft

2008
Google purchases DoubleClick

When is an advert not an advert?

Today, the best advertisement for a company often has little to do with traditional advertising and more to do with social media and the effective enlisting of customers as advocates – even if many of them may not be aware of the service they're publicizing. The online hit 'megawoosh', for example, appeared in 2009 purporting to show a test run of 'the biggest waterslide on earth'. The clip showed a waterslide in an Alpine location that appeared to launch a man in a wetsuit over a hundred feet through the air into a small paddling pool, and included a link to the website of the supposed builder of the waterslide, Bruno Kammerl. Closer inspection showed that the entire setup was a 'viral advert' for Microsoft's Project Professional software and the clip itself a carefully faked stunt involving rope, editing and stuntmen. To date, the clip has had over five million views on YouTube, generated acres of comments, been viewed and discussed across the world, and even featured on an episode of the TV show Mythbusters in May 2010. Few advertisers could hope for more.

buy small text-only adverts that would show up next to particular search results. The company had begun a business model that would soon grow into its primary source of income. Initially, customers paid Google on a cost per impression basis. In 2002, however, the company moved to a new system that had first been deployed in 1998 by the startup GoTo.com. Known as 'pay per click', this meant advertisers were only charged for an advertisement when a user actually clicked on it.

With this, Google had not only become its own server – it had also tapped into a powerful new model for using a combination of data and the huge penetration of its search engine to transform the online advertising market. Google's 2010 advertising revenues were over $28 billion, thanks in large part to AdWords, but aided by an external ad-serving system launched in 2003. This system, AdSense, allows any website owner to sign up and use Google as their ad server. Google then provides advertising on their website, paying either on a per-impression or a per-click basis. Google's dominance of online advertising was further enhanced by its purchase in 2008 of the major ad-serving provider DoubleClick – an acquisition that left Google controlling almost 70 per cent of the world's ad-serving business.

Social, mobile and beyond With digital culture being transformed by the mobile internet, social networking and an increasingly diverse range of online services and activities, advertising is rapidly moving beyond established models of banners and keywords. In particular, the increasing amount of streamed media online has boosted a more traditional approach – embedding advertising in video and sound, much as on a television or radio station. Most web users are prepared to tolerate half a minute of advertising in exchange for free streamed audio or video. Music streaming service Spotify, for instance, offers free songs to users who are prepared to listen to regular adverts of 15 to 30 seconds. A similar approach is increasingly being applied to interactive media, such as video games, which boast a rapidly expanding and extremely attentive audience: adverts can be embedded in loading sequences or even within game worlds themselves, with the model of advertising-supported free play increasingly popular.

> **❛First we thought the PC was a calculator . . . Then we discovered graphics, and we thought it was a television. With the World Wide Web, we've realized it's a brochure.❜**
> **Douglas Adams**

Social media are also a growing focus of online attention and an area of innovation in sponsorship and advertising. Twitter, for example, allows advertisers to pay for a 'trending' topic to be featured at the top of the site's lists or to promote a corporate account or individual tweets in order to gain attention.

Facebook, meanwhile, is rapidly becoming one of the world's leading venues for advertising, offering enormously powerful targeting at particular types of customer – and basing its served advertising exclusively on Microsoft's adCenter system rather than Google. Already the world's fastest growing advertising market, digital advertising looks set to keep on expanding and evolving for many years, driven above all by social, mobile and play-orientated trends.

the condensed idea
As attention migrates online, so do adverts

32 Analytics

Digital culture revolves around an explosion in information – not just access to different sources of information about the world, but also information about people's own digital behaviours. From the websites you visit to the online purchases you make, and from the video games you play to exactly how long you play them for, almost everything done through digital devices is measurable. This has led to the development of a large and influential industry based around analysing such data. Traffic analytics – the analysis of the exact nature of web traffic to particular sites and pages within those sites – is the core of this process, but by no means the entire story.

The most important units in analytics relate to three things: how many people visit a particular page or website or service, how long they spend on it and what their routes of arrival and exit are. Related to this, and of increasing importance, is the secondary measure of how much 'buzz' surrounds something – and in particular how much it is being discussed and perhaps reproduced through social media.

The number of users is the most basic and oldest of these measures. Originally, someone operating a website might simply have counted the total number of times a site or page was accessed, by looking at this number on the server. This measure – the total number of times a page has been viewed or its 'pageviews' – can still be useful today, but has generally been superceded by the more advanced process of counting the number of different people using something. This is determined by looking at the unique IP addresses of users, making it possible to come up with a figure for

timeline

1993	1994
Web analysis company Webtrends is launched	First commercial web analytics tool appears

the number of unique users per day, week, month or even year – once a site has been accessed from a particular IP address, that address is not counted again during the period in question.

Monitoring tools A huge variety of companies provide tools for analysing web traffic, but there are at root just two ways in which such data is recorded. The first and oldest method is analysis of the log files on the server hosting a website, something that has been possible since the earliest days of the internet. The second and more popular method today means attaching a small amount of tagging code to a website, allowing it to be monitored by a specialized third-party site: one of the most popular such sites is Google's free Google Analytics service, which collects detailed information on how any website that has chosen to install its tracking code is used.

In addition to visitor numbers, the time each user spends using something is another key indicator, together with another related factor – how many different pages they view within a site, and how many actions they perform.

How many?

What level of traffic do the world's biggest websites get? The answer is an ever-changing and increasing one but, according to the web information company Alexa at the time of writing in early 2011, the top three sites were an unsurprising trio: Google's US homepage at number one, Facebook at number two and YouTube (which is owned by Google) at number three. Another information company, Compete.com, put the number of monthly unique visitors for Google.com at around 150 million at the end of 2010, compared to 142 million for Facebook and YouTube at 117 million. Outside of these web services, the top blogging service, Google's blogger, comes in as the world's seventh most visited site on Alexa, with Wikipedia the most popular information source at eighth, Amazon the most popular shopping site at 14th, the BBC the top news site at 44th, the *New York Times* the top newspaper at 93rd, and The Huffington Post the top blog at 123rd, corresponding to around 13 million unique monthly visitors at the end of 2010.

1997
Start of third-party analytics

2005
Google Analytics is launched

When someone arrives at a website and visits only a single page, this is known a bounce. The percentage of visits that are bounces or the 'bounce rate' is considered an important statistic for many websites, depending on the purpose of the site. For a newspaper or magazine, for example, as a bounce rate of over a third of visits might be considered an index of a poorly performing website; while a site aiming to provide one-off chunks of consumer information might expect three quarters or more of its visits to be bounces.

The number, duration and 'depth' of visits to a website – that is, how many different pages within it an average visitor uses – are important, among other things, for selling online advertising. Equally vital in this field is the 'click path' taken by users: what do they actually interact with once on a site, and when and where are they most likely to click on advertising.

Browsing paths More generally, the entrance and the exit paths of each visitor are important information for a website: how did they arrive in the first place, and where did they go afterwards. Sources of arrival

Ever finer refinements

The art of modifying digital services in response to data is one of the most central and sophisticated skills in many 21st-century businesses. For businesses and commentators alike, analysis of user data offers an unprecedented opportunity to understand patterns of usage and interest among consumers. The biggest games companies developing products for platforms like Facebook can use over a billion data points a day in exploring precisely which aspects of their software did or did not retain users' interest, as well as testing and comparing whether everything – from different levels of difficulty to different colours and locations of objects on screen – generates greater interest or not. This had led to innovations such as 'split testing', pioneered online by Amazon, where single alterations to a website are tested by displaying two different versions of the site to different visitors, and seeing how the one difference between them changes users' behaviour. In parallel to such techniques, ways of allowing users themselves to express their preferences and ideas are growing online, and the science and the art of analysing behavioural data is growing ever more refined.

> **The challenge for the industry is to spread knowledge and educate users about what to do with data.**
> **Brian Clifton**

are generally divided between direct visits (where someone typed in a web address and went directly to a site), referred visits (where someone followed a link from one site to another) and referrals via search engines (where someone clicked on the link to a website from among a number of search results). In the final case, website analytics usually show which search terms led someone to arrive at a site.

None of the statistics above are immune to manipulation; generally, however, things like unique visitor numbers are treated as a core measurement of a website's influence. Of growing importance, too, is a website or an individual page's prominence in social media – and numerous tools already exist to show how many times something has been shared or mentioned on Facebook, linked to via Twitter, and posted on a variety of other social and aggregation sites.

Analysing this kind of data can suggest powerful insights into trends and interests: analysis of positive mentions in social media has even been used to predict such results as a film's box office success. And no company with a digital presence today dares conduct its business without keeping a continual eye on how exactly its services are being used, discussed, shared and competed with.

the condensed idea
Data means nothing without analysis

33 Optical character recognition

Optical character recognition, or OCR, is the process by which a machine scans and recognizes printed words and numbers. A vital component of the effort to make all human knowledge available and searchable in digital form, it allows books and other printed documents to be automatically converted into digital formats, rather than needing to be laboriously entered by hand. The origins of OCR predate the internet but, like many other technologies, its full potential is tied in with online resources. Similarly, the field of teaching machines to 'read' handwritten text and other information not available in printed formats continues to progress.

The first patent for a form of OCR was filed as early as 1929 but early efforts to build machines proved cumbersome and expensive, and it was not until 1955 that the first commercial devices appeared – the very first being a machine installed at the Reader's Digest. The early machines were only able to recognize a limited range of characters and these had to be printed in a special font: the first of these fonts was known as OCR-A. The font was so simplified and standardized that it could be difficult for people themselves to read; in 1968, the font OCR-B appeared, using softer outlines and clearer characters for the human eye to read.

By the mid-1970s, these fonts had become dominant across the industry, and OCR was being widely used by companies for tasks such as processing banking and accounting details, sorting mail (the US postal service used a form of OCR from 1965) and bill payments (Britain was the first country

timeline

1955
First commercial OCR
machines appear

1965
US Postal Service
adopts OCR

in Europe to introduce an OCR system in banking, via the National Giro in 1968). From the mid-1960s, it was possible to connect OCR systems directly to computers, producing data as electronic files. But machines remained bulky and expensive through the first half of the 1970s, costing tens of thousands of dollars and featuring only in the offices of large businesses.

> **What happens when computers can start reading all the records of human civilization?**
> **Ben Vershbow**

In 1974, OCR advanced significantly with Ray Kurzweil's invention of an 'omni-font' system that could identify characters printed in a variety of fonts, rather than just fonts designed specifically for OCR machines – a development that for the first time allowed the wholesale automatic digitization of printed records, such as newspapers and magazines, into searchable databases. For tasks requiring an extremely high level of

Reading books

Digitizing the contents of books is one of the most important modern uses of OCR, but has also always presented a problem. Thanks to the binding, the pages of a book do not lie exactly flat when it is opened but curve slightly. This means that an image taken by a scanner of the pages of an open book slightly distorts the text, making it extremely difficult for software to process accurately. Until recently, the main ways of dealing with this entailed either unpicking the binding of a book – effectively destroying it – or pressing pages flat with a heavy glass plate, an inefficient method that was also

unsuitable for many books. After internet giants Google began to digitize the contents of hundreds of thousands of books for the Google Books project in 2004, however, they helped to perfect a new way of dealing with this problem. Google's technique involved infrared cameras, used to model the shape and curvature of the pages of a book in three dimensions within the scanner. The result is then transmitted to the OCR software, allowing it to compensate for the distorting effects of curvature and to recognize text accurately and rapidly without damaging books.

1974

Omni-font system is invented

1993

Intelligent Character Recognition (ICR) emerges as a commercial technology

> **❝The rush to digitize the written record is one of a number of critical moments in the long saga of our drive to accumulate, store, and retrieve information efficiently.❞**
>
> **Anthony Grafton**

accuracy, OCR-specific fonts still needed to be used. Even today, complete accuracy can only be guaranteed by human supervision, with mainstream commercial OCR products achieving recognition rates of anything from 70% to 99%, depending on fonts, print quality, paper, context and the content itself.

How it works Almost all forms of OCR work according to one of two methods. In each case, an image of a printed page is first scanned by an optical system – essentially taking a photographic image of it – and then this image is analysed by computer software. The oldest and simplest method of analysis is called matrix matching, which takes each number or letter on the page at a time, breaking it down into a number of dark and light points on a tiny grid: the matrix of its title. These points are then compared to a reference library of different characters – until a sufficient number of points match for the computer to judge that the character in the image matches a particular character from its memory.

The second method is a more complex process called feature extraction. Instead of attempting to match characters to fixed information stored in its memory, a program using this technique – also known as 'intelligent character recognition' or ICR – looks for general features on the printed page, much as people do when they are reading.

ICR is sufficiently advanced to be usable not only with a range of different fonts but also with handwriting, although a program has to be 'trained' to recognize the individual features of a user's handwriting. ICR programs often include learning processes that allow them to exhibit a degree of artificial intelligence, actively searching for and remembering patterns. When correctly trained to read an individual's handwriting, recognition rates can be over 90%, leading to potentially powerful innovations in the field of data entry and rapid writing on a machine.

Better data through CAPTCHA

Except when a font designed specifically for OCR is being used in good conditions, even the best OCR technologies make some mistakes, especially when it comes to older books, more complex or antiquated fonts, unusual words and spellings or damaged paper. This means that some element of human oversight is always required to ensure accuracy. With millions of texts being scanned, however, it simply isn't efficient to employ workers to look over every text or even over every problem area within a text. One elegant solution to this problem involves the use of CAPTCHAs: reading tests used by millions of websites to distinguish genuine human visitors wishing to post comments from pieces of software attempting to fill the internet with spam links. Such tests usually ask you to correctly retype a couple of words written in a disguised pattern. By making one of these words something that a piece of OCR software found it difficult to understand, it neatly becomes possible to use the reading skills of thousands of different people to resolve some of the trickiest problems facing OCR systems, one word at a time.

As the development of ICR suggests, OCR is an increasingly specialized field, within which programs tend to be used for one of two specific functions: text recognition, or the capture of large amounts of repetitive data. Today, OCR software is often integrated into a range of common applications – from Adobe's Acrobat Reader to Microsoft Office – as well as being available for free online. OCR is still most commonly applied to texts written in the Latin alphabet, but is steadily being improved for languages in other alphabets, from Greek and Russian to Chinese and Arabic, not to mention other written forms, including music. Perhaps most notably, OCR is also one of the central technologies in the ongoing digitization of millions of books and documents around the world, a process that is bringing centuries of the printed word into the digital realm.

the condensed idea
Machine reading is breaking down digital frontiers

34 Machine translation

Aside from censorship, the biggest single barrier to communication between many individuals online is language, and the world wide web can be thought of as a number of overlapping networks, cut off from each other by linguistic restrictions. Given this, computer software able to translate fast and accurately between languages is an important tool – and one with a long and distinguished digital history.

Although automated translation had been a source of speculation for centuries, the history of practical machine translation began in the 1950s with the first successful American experiments into the automatic translation of Russian. The difficulties of translating more than a small amount of text on early computers, however, were considerable, due to the complexities of vocabulary, grammar and sense.

The process of translating a language involves two key stages: determining exactly what is meant by a text, then rendering this meaning as accurately as possible in a different language. The simplicity of this explanation belies just how complex a problem determining the meaning of a text is – and it was not until the 1980s that computers began to become powerful and sufficiently widely distributed for significant progress to be made in teaching a machine to 'understand' text.

Two methods Machine translation systems tend to work via either rules or statistics – or a combination of these. Rule-based systems were among the earliest to be used, the most basic of which simply followed

timeline

1954	1968	1983
First fully automated translation	Founding of SYSTRAN machine translation company	First machine translation system on a micro-computer

Point and translate

Digital technologies are at their most powerful in combination, and translation is no exception. Alongside spoken translations, among the most impressive applications to emerge on smartphones in recent years are those that combine machine translation with phone cameras in order to offer an instant retranslation of the world. One of the first such programs, Word Lens, was released in 2010 for the iPhone. Initially operating only in English and Spanish, users simply point their phone camera at printed text in one language and the same scene appears on the phone's screen with the text translated. That, at least, is the idea: large amounts of text cause problems for the program, as do hand movement, unusual fonts, handwriting or complex grammar. Still, the program – like the similar Google Goggles app, which can be used to photograph foreign text and then have it rapidly translated by Google's online services – offers another tantalizing taste of a future where instant translation, from written or spoken words, is available in every pocket.

a dictionary approach, translating each word in turn as if by using a dictionary. Such rules have obvious limitations when it comes to multiple meanings, word order and ambiguity – something that can be partly compensated for by another rule-based technique called transfer-based translation. This approach attempts to transfer the underlying structure of a text into a basic intermediate form of that language, and then into a similarly basic intermediate form of the other language, in order finally to convert this structure into a full text in the new language. A third rule-based technique, rather than use basic intermediate forms of the two languages in question, actually deploys an entirely different intermediate language to encode the meaning of a text, known as 'interlingua'.

Statistics-based translation, meanwhile, rather than attempting to codify the meaning of a text is based on analysing large amounts of texts that exist in two languages. This approach began to gain popularity in the 1990s and

1997
Babel Fish launches SYSTRAN on the web

2007
Google Translate launches

2010
Word Lens launches

Web languages

The world's top language among internet users is, perhaps unsurprisingly, English, used by just over half a billion people online in 2010 – around a hundred million more than use the world's second most popular online language, Chinese. Next are Spanish, with 150 million, Japanese (100 million), Portuguese (83 million) and German (75 million). The rate at which these statistics are changing, however, suggests that the global picture will look very different in a decade's time and that the current dominance of English, which penetrates over 40% of the web at present, will be replaced by a far more fragmented digital world. The number of Chinese speakers online grew between 2000 and 2010 by over 1,200%, more than four times the rate at which English speakers increased. But Chinese pales in comparison to the rate of growth in Arabic (2,500%) and Russian (1,800%), with Portuguese also close to a 1,000% increase over the period. As the entire world arrives online, the great story will not simply be technological convergence but linguistic divergence and an ever-increasing demand for communication between resources in different languages.

is widely used today as it is able to harness the power of modern computers to process extremely large amounts of data. This is now the method Google uses for its online translation service, having decided to 'train' its machines in different languages by inputting some 200 billion words of documents in multiple languages taken from the United Nations. This approach is not so much about a machine 'understanding' text as it is about the study of patterns. Given enough words, however, it is extremely powerful.

Artificial intelligence is also an increasingly influential factor in progress in the field, with programs that are able to learn and to improve their own approach being a vital research tool. In all of this, the increasing volume of digital text available in multiple languages is itself both a great asset for research and a tremendous challenge.

Problems and potentials No such thing as perfect machine translation unaided by a human currently exists. Indeed, some would argue that no such thing as 'perfect' translation can ever exist, even when performed by a bilingual human, as the subtle differences in meaning between words and ideas in different languages can never entirely be

replicated. Despite this, basic accuracy rates of over 90% are not uncommon in modern software. What remain most problematic are the moments of ambiguity and complexity that all languages contain, where both rule-based and statistical analyses of a sentence come up against fundamental ambiguities relating to a unique reference, a linguistic quirk, something that has no direct linguistic equivalent and so on.

Native speakers of a language are generally able to resolve such ambiguities, although specialist knowledge or research may be required. Even the most advanced current artificial intelligence systems are not generally able to handle these ambiguities, although the frontier is being pushed back all the time, as are improvements in the field of computer guesswork: that is, teaching machines how to match 'fuzzy' terms with ones that do not exactly correspond.

> ‘**All translation is a compromise.**’
> **Benjamin Jowett**

Applications Free web-based software includes Google Translate and Babel Fish (launched in 1997, powered by the SYSTRAN translation system and named after the eponymous fish able to translate all languages in Douglas Adams's *The Hitchhiker's Guide to the Galaxy*), while paid software services also abound.

Another service just beginning to arrive is spoken translation applications, often designed for smartphones. iLingual, for example, effectively functions as a mobile audio phrasebook, speaking set phrases in multiple languages. More ambitiously, Google previewed a feature for its Android-based Translate app in early 2011 that offered a 'conversation mode', translating spoken conversation to and from English and German, allowing a basic spoken conversation between two people with no language in common. Given the steady progress being made in both mobile computing power and machine translation techniques, real-time bilingual conversations entirely mediated by machine may be a feature of the not-too-distant future.

the condensed idea
Technology can help to unite our divided languages

35 Location-based services

Geolocation means knowing someone or something's exact geographical location. It's a simple idea and one that technology like Global Positioning Systems (GPSs) has already made a reality for many millions of people. What remains in its infancy, however, is the idea of location-based services: a growing area of digital applications that tailor results to an individual's precise location but that also offer services based on their locations in relation to other people. It's an idea with large implications for privacy, communications, business and leisure alike – as well as representing an increasing use of digital and networked technologies not just when sitting at an office desk or a room at home but when on the move.

A form of location-based service has been available since the early days of the world wide web thanks to the ability to identify most web user's approximate location via their IP addresses – something that has allowed companies to customize websites based on user location, offer region-specific advertising and so on. True location-based services, however, have only gained ground since the turn of the century and in particular since the spread of smartphones and other devices with integrated GPS and internet connectivity.

LBS and GIS Many location-based services (or LBSs) take advantage of a considerable body of work that has been done over the last few decades in developing Geographical Information Systems (GISs).

timeline

1978	1995	2000
First GPS satellite is launched	First production of car GPS navigation system	Fully accurate GPS is made available to civilians

In the simplest terms, GISs represent a digital version of much of the detailed mapping and location data held by organizations ranging from national governments to emergency services, academic institutions and planning authorities.

GIS data has historically tended to be used in business and professional applications – for urban planning, emergency service work, infrastructure maintenance, regional administration and other activities reliant on a high quality of detailed data about locations and boundaries. But both the databases and the systems developed for GIS are digital tools that are increasingly being made available – either for free through government initiatives or as paid resources by private companies – to those developing applications based on location.

Going hyperlocal

A 'hyperlocal' service is one that goes beyond simply offering tailored content for different areas, focusing on offering content specifically tailored to a small, clearly defined local area. The term was first coined in the USA in the 1990s in reference to local news but has since been adopted online to describe the potential for digital resources aimed at – and often largely generated by – the needs of an area too local and specific to be covered in detail by a more general database or site. Perhaps the web's best known hyperlocal service was founded by the popular science writer Steven Johnson in 2006. Called

outside.in, it was based on the principle that much of what an average resident of a neighbourhood might wish to do or know – from school board meeting times to local news about services, shops, opening times, parking, law enforcement, events and so on – was either non-existent or extremely difficult to find online. The service now covers over 57,000 neighbourhoods and invites users to: 'stay up to date on what's going on, discover new things about where you live, do research, and contribute to the local conversation yourself. Or, if your neighborhood hasn't been entered yet, to start the conversation.'

2002
First TomTom navigator product is launched

2009
Foursquare is launched

2010
Facebook 'places' is launched

Foursquare

Founded in 2009, Foursquare is a social network service with a difference: it's based entirely on mobile devices and uses GPS tracking to allow users to post a regularly updated record of their location. These updates appear on Facebook or Twitter accounts and allow users to see where their network of friends are in relation to each other in real time. Beyond this, though, the service allows people to 'check in' when they are near particular locations, which in addition to updating their status earns them points, online awards in the form of 'badges', and boosts their status in an effort to become 'Mayor' of a particular check-in point – that is, the person who over the previous 60 days has checked into that location on more days than anyone else. This combination of game mechanics with social networking has proved enticing, especially as users can gain more power within the network as they participate more heavily: from being able at the first level of achievement to edit information about venues to, at the top level, being able to add and adjust venues themselves and monitor the global flow of suggestions and traffic.

General uses of LBSs The most self-evident use for an LBS is of course telling someone where they are, and supplying detailed information about what is around them. Satellite Navigation systems in cars are the most widely used commercial example of this technology, with services like Google Maps for mobile devices an increasingly close second. Detailed local mapping information is enhanced by lists of everything from businesses and facilities to reviews, images and web links.

Specifically, a user's typical needs can be broken down into five categories: location tools, for determining exactly where they are in relation to local geography; navigational tools, helping them to plan a route towards an intended destination; geographical search tools, helping them to find particular facilities or types of service; other data search tools, helping them to find out information about everything from public transport timetables to event timings; and social tools, linking them to the locations and activities of other people in as close to real time as possible.

Particular uses of LBSs The potential applications of the above are almost limitless but have had a particular impact on only a limited number of fields so far. Navigation aids for vehicles are the most obvious case and have already helped to transform the experience of driving for many people (as well as promoting concerns that their use may reduce some drivers' attention on the road and undermine general navigational skills). But more specialized uses of similar services have equal potential, especially in the emergency services, where locating people who do not know or may not be able to communicate their own locations is a vital skill. In

these cases, an LBS can automatically transmit a precise location, as well as potentially alerting any other people in the immediate area who may be able to assist.

A powerful everyday use of such automatic location checking is embodied in the 2010 app Neer, which allows people to give others in their immediate social network permission to receive automatic updates on their own location – allowing parents to check, for example, that children have arrived safely at school or where they are in a shopping mall. For wider social networking, Facebook's 'places' functionality, also launched in 2010, allows users with smartphones to share their location with friends and enables other applications that integrate with Facebook to make use of this functionality too.

❛The business models that circle the intersection of people and their favourite places are endless.❜
Josh Williams

Trends At the start of 2011, Microsoft released the results of recently commissioned research into trends within the young LBS sector. The top uses for LBS systems were firmly orientated towards more 'traditional' travel and information topics: GPS navigation was the most used, followed by weather reports, traffic updates, restaurant information and facilities location. New trends that seem set to grow, however, included gaming, the 'geo-tagging' of images and videos within information about where they were taken, and social networking.

A number of concerns were also expressed about privacy on LBS systems – an understandable fear given that information about a person's physical location represents a new kind of immediacy and exposure within digital culture, which has historically allowed people relative anonymity and freedom from physical constraints or obligations. The increasingly close integration of physical space and networked technology is, in this sense, one of the more profound digital transitions of recent years, and one that may for this reason not gain the penetration of other services.

the condensed idea
Technology that knows exactly where you are

36 Virtual goods

Virtual goods are items that exist only in a digital form, and that – unlike digitally purchased music, films or books – have no intrinsic value or existence beyond a virtual environment. This means that they tend to exist within virtual worlds and especially within online video games, where purchasing and owning virtual items is valued by players thanks to the status and benefits they confer. An increasing number of online games and virtual worlds are funded wholly or in part through virtual items sales, while the trade in virtual items has rapidly become a multi-billion dollar global economy.

Virtual goods came into existence in parallel with the first shared virtual worlds – the text-only Multi-User Dungeons of the 1980s. Items such as weapons, armour and potions conferred benefits on characters in these game worlds, and players soon began informally to trade these, agreeing to exchange them in return for other goods.

Such transactions were a 'grey' economic activity, conducted outside the official rules and environment of most games but not explicitly against their spirit or rules. By the time that more sophisticated three-dimensional multiplayer online games began to involve a significant number of players in the late 1990s, however – and in particular after the launch of Ultima Online in 1997 – this independent activity by players had begun to become more sophisticated and, to the surprise of many, had also begun to involve real-world money as well as exchanges, thanks to online auction sites like eBay that allowed players to offer each other virtual goods for real cash. Money would change hands, then players would meet within the virtual world in order to exchange the actual goods in question.

timeline

1997

Ultima Online launches

Trading in virtual items between players was not seen as desirable by the companies running most online games: it potentially threatens a game because it allows players to leverage real-world resources (that is, their wealth) rather than rewarding in-game skill and effort, as well as draining potential revenues from game operators themselves. Nevertheless, it remained popular, with levels of player demand allowing some traders to earn thousands and even tens of thousands of real dollars in a year through selling virtual items, often via third-party auction sites. In some cases, individual virtual items could be worth substantial sums, thanks to the considerable effort required to obtain them: a single character within World of Warcraft was, for example, reportedly traded in 2007 for around $9,500.

Official models Given the level of demand among players for purchasing virtual items, many games companies have over time begun to introduce models for officially permitting their sale. The most basic model here is known as 'free to play', where a game or virtual world costs nothing

Farming for gold

In countries like China, amassing then selling virtual assets on the international market has become a significant digital industry. 'Gold farming' is so-called because it historically tended to involve workers playing long, repetitive shifts within a game – World of Warcraft being the most popular – to gain as much in-game currency or 'gold' as possible. Successful gold-farming businesses tended to involve teams of workers using computers in warehouses for ten or more hours a day in shifts, often sleeping on site, with the resulting gold being sold online by an entrepreneur running the 'farm' and paying workers on the basis of their ability to gain in-game gold. Games companies have cracked down on such businesses but it is thought that the global market is worth hundreds of millions of dollars and increasingly includes more sophisticated services, like 'power-levelling' in-game characters by doing the hard work of advancing a character towards the end of a game on behalf of western players prepared to pay not to have to work hard at playing.

2003	2005	2007
Second Life launches	Sony Entertainment opens virtual goods marketplace	World of Warcraft character is sold for almost $10,000

to access but virtual items are then bought through official channels, granting players access to new abilities, areas, faster progression or simply different kinds of character appearance. This has become a dominant model in online gaming in Asia, where the value of official virtual item sales within games and virtual worlds is estimated at over five billion dollars a year.

Virtual item sales rely on large numbers of low-value transactions, known as 'micro-transactions', often made using an in-game currency that has itself been purchased in bulk with real money via the company operating a virtual world or game. As in other areas of digital culture, one of the most important trends of the last few years has been the rising importance of social networking and of virtual item sales within the more casual games played by tens of millions of people across social networks. Such games often take advantage not only of virtual item sales but of what is known as a 'freemium' product model: a basic version is free to play, then a small amount of money is required to access the premium features of the full version.

Learning real lessons

The economics of trading virtual goods is thought by some economists to offer a potentially powerful way of exploring real-world economic trends and in particular the notoriously difficult-to-analyse field of human motivations and interests. Perhaps the most noted economist active in this field is American Professor Edward Castronova, whose work has demonstrated that players in virtual worlds act in extremely similar ways economically to people in real-life economic situations. Given the ability to manipulate and record every detail of a virtual environment precisely, this suggests that virtual environments may become powerful experimental arenas for exploring – and testing – economic ideas, from taxation and redistribution to pricing structures, structuring economic incentives and individual perceptions of value and fairness.

As the global value of trade in virtual items has increased, other such models have been increasingly widely adopted too, ranging from running a direct exchange rate between real and virtual companies – something Second Life has offered since 2003, with its Linden dollar (L$) trading in early 2011 at a rate of around L$200 to one US dollar – to 'trade-supported' business models, in which companies allow official platforms to trade virtual goods. Many players prefer the security and reliability of these official platforms to the more shadowy realm of the grey secondary market. Sony Entertainment has, for example, created an official marketplace where players of some of its games are able officially to trade and purchase virtual items, with a small commission paid on each

> **The games we choose for our amusement are becoming so complex, so involving, that the line between gameplay and career, between gameworld and society, begins to blur.**
> Julian Dibbell

transaction. Sony's marketplaces are themselves operated by the company Live Gamer, which specializes in operating official marketplaces for trading virtual in-game goods.

Global markets One of the most notable features of the market for virtual goods is the relatively low barriers to obtaining virtual items. If someone has a computer and access to the internet, very little education or specialist ability is required to play most games in order to obtain items: the most substantial investment is simply time. This has led to an unusual global economic opportunity, where those with fewer earning opportunities can spend their time earning virtual goods or gaining virtual currencies, which can then be sold on to wealthier people who are willing to spend money on such things rather than investing the necessary amount of time themselves.

Many of these developments present serious difficulties not only to those operating games and virtual worlds but to governments and regulatory authorities, not to mention both those using virtual worlds for leisure and those using them for 'playbour' – playing games for financial gain. The official declaration and taxation of revenues from virtual goods sales are one such problem, as are virtual property rights, given that items have no existence outside of computers run by games companies, and as such can be confiscated by these companies whenever they wish. Other legal issues concern the ability of players to seek reparation or redress if virtual items are stolen or removed; not to mention the ethical issues surrounding the working conditions and rights, if any, of the many thousands of people making a living through virtual item sales outside of official channels.

the condensed idea
Value has little to do with physical reality

37 eGovernment

eGovernment simply stands for electronic government and covers all forms of digital interaction between a government and its citizens. It is mostly used to describe advances in the way in which government services, information and opportunities for participation are being broadened by online services. More radically, however, it also involves using such digital arenas to explore how many governmental processes themselves might be open to transformation.

eGovernment strategies can be divided into three areas: using digital technologies to improve the processes of government itself; improving the quality, quantity and ease of interactions between citizens and government; and improving interactions between citizens in a way that is of benefit to the country. In simple terms, this can be described as improving administration, improving access to and provision of services, and boosting the functions of civil society. A fourth field covers the relationship between governments and business – one that, in the technology sector in particular, tends to run in both directions, with most examples of best digital practice having evolved first within private companies or online communities.

Access and provision Potentially the most problematic issue with all forms of eGovernment is access. While most citizens in developed countries now have access to computers and internet connections, a significant minority – mostly from more deprived or isolated backgrounds – do not. This can mean not only that such a minority fails to benefit from digital services but that digital service provision can simply widen the gap between deprived groups and the rest of society.

timeline

1994

South Korean Ministry of Information and Communication is launched

1999

First US Memorandum on eGovernment

For this reason, successful eGovernment strategies have a strong emphasis on access, which can mean the provision of digital facilities in public places such as libraries and town halls, but which can also involve the innovative use of far simpler technologies. In Britain, for example, some companies have focused both on developing efficient ways of determining the locations of local services and on rapid and cost-effective ways of printing these out as instant information sheets to be used by anyone.

Often, lower tech options are more powerful democratic tools than more complex devices. For example, text messages on mobile phones are a means of contacting almost every adult member of most countries in the world – making them an extremely effective digital means of contact for public messages ranging from reminders about voting to information on local services, with services currently being trialled around the world to allow voting itself to take place via text message.

Community activism

Action does not require advanced technologies, and over-complicated digital thinking can sometimes get in the way of getting things done. This is part of the message embodied in the work of William Perrin, a community activist based in the Kings Cross area of London. In 2006, Perrin was driven by vandalism in his area to start a community activist movement based on combining offline activism with a simple website – www.kingscrossenvironment. com – with a message for local people: 'Help us make our neighbourhood a better place. Share your Kings Cross news, views, events and grumbles.' A grass-roots initiative, its philosophy was that effective local civic action required effective information and communication, and this was best served not by complex technologies but by an online destination gathering local news, views, photographs backing up complaints, minutes from meetings, documents – everything that is not usually featured as 'news' but can provide a focus for community action. The site has won notable victories for planning, improvements and getting local issues heard, and has formed a template for other such sites around Britain.

2007	**2009**	**2010**
EU launches eParticipation initiative	USA launches data. gov website	UK launches data. gov.uk website

> **❝We want government to be more agile, more transparent, more open and accountable. That's the kind of transformation this government is about.❞**
>
> David Cameron, 2011

Text messages are also an increasingly flexible method of payment for goods and services. Given the fact that mobile phones are fast becoming a universal and highly personalized technology, it's not unlikely that they may come to be used as core governmental technologies in everything from personal identification to tax payments.

Administration As with any business, one of the greatest benefits technology can bring to government is improved communication and compatibility between departments, with a common code of best practice covering everything from the efficient formatting and tagging of data to the use of digital project management tools. In the case of government, cost and efficiency savings potentially go hand in hand with the devolution of more services to local authorities.

Security and privacy are, however, more of an issue with government technology than almost any other field, with everything from wireless networks to email systems needing to be secure, and levels of access to sensitive data carefully vetted. Governments are less able than most corporations, for example, to make use of cloud computing facilities or proprietary services. However, one of the most fertile areas for innovation is in the increasing adoption by governments like the US and UK of international open standards of best practice for document and data storage, information tagging and the public release of non-classified materials in formats that facilitate re-use and innovation.

Civil society In addition to increased transparency and access to government services, civil society can potentially benefit greatly from the digital availability of government resources. For example, in early 2011 government data in Britain relating to the incidence of crime was put online by the Home Office in the form of a free-to-use 'crime map' allowing anyone to search for details of crime on an interactive map covering England and Wales. With more than 18 million visitors in its first few hours online, the service was judged a tremendous success, although

State surveillance

One potentially darker side of eGovernment is the use of surveillance technologies by governments. State surveillance can range from traffic enforcement cameras to CCTV, electronic eavesdropping and identity checks, potentially involving the use of biometric identification (via a database of details such as fingerprints and retinal scans). Such surveillance is usually justified in terms of security, and the prevention of offences ranging from vandalism and car crime to terrorism. Civil liberties campaigners have raised increasing concerns in some countries about the degree of power accumulating in a 'surveillance state', as well as the effectiveness of its techniques. Controversy also surrounds governments' right to access or scan internet traffic, with Internet Service Providers being made increasingly liable through legislation to police the traffic of their users for activities such as copyright infringements via file sharing, as well as being potentially compelled by law enforcement authorities to hand over records of email and phone data relating to investigations.

it has also been reported to have fuelled anxiety over incorrect reporting, potential damage to house prices and increased fear of crime, illustrating the double-edged nature of data.

Other examples of social eGovernment include the ability to report back on government service performance, express preferences, submit petitions and vote on local issues, although the sheer volume of material generated by such schemes can create large administrative burdens. As ever with information, utility depends on the ability to analyse and combine rather than simply gather data – something that makes the encouragement of a third-party ecosystem of developers working with government data a vital part of the future of eGovernment.

the condensed idea
Technology is an increasingly vital political tool

38 Crowdsourcing

Historically, difficult practical and intellectual tasks have tended to be dealt with by small groups of experts. But the interconnection of hundreds of millions of people via the internet has increasingly allowed an opposite approach: presenting a problem as an open call to the digital world and letting the digital 'crowd' itself – that undefined, amorphous and self-selecting group of people who decide to take an interest – attempt to find a solution. An idea so simple as to be almost self-evident, crowdsourcing is also one of the defining and most powerful aspects of digital culture.

Like much else in digital culture, crowdsourcing has its origins in the collective efforts of the internet's first pioneers, specifically in the open-source software movement that began in 1983 with a mass collaboration effort called the GNU Project. The GNU Project set out through the combined efforts of the academic community to develop a body of free and freely available computer software that would enable anyone who wished to, to use a computer system without needing to buy any programs for it.

A utopian proposition, the GNU Project was launched by a manifesto written by the American programmer and activist Richard Stallman. In 1992, nine years after it was first announced, the project finally delivered a complete operating system called Linux. Today, versions of the Linux operating system are used on around a quarter of the world's server computers – and over 90 per cent of the world's supercomputers – while other open-source systems, such as the Apache server software and Firefox web browser, dominate their markets.

timeline

1992	1997
Linux is released	SETI@home is launched

Unpaid, passion-driven collaboration had proved itself to lie at the very root of digital culture: a basic truth awaiting a formal definition. Mass collaboration is, of course, a far older idea than any digital technology: from physical 'suggestion boxes' to research projects calling upon members of the public to send in queries or suggestions. Crucially, though, digital media exponentially increased the potential scale, the ease and the speed of such collaborations. Thanks to the internet and the continuing development of web technologies with the Web 2.0 movement, mass interaction is now simply a fact of daily global life.

Crowdsourcing proper One of the first people to use the term 'crowdsourcing' itself was the author Jeff Howe, who combined the words 'crowd' and 'outsourcing' in a 2006 article for *Wired* magazine. At the heart of Howe's formulation was the idea that it was becoming possible to outsource work not to selected experts but to self-selecting volunteers from the digital world at large.

An early example of this process is the Search for Extra-Terrestrial Intelligence (SETI) programme at Berkeley, California, which was based on analysing vast amounts of data from radio-telescopes in search for patterns. The analysis was a far larger task than even supercomputers could manage. And so in 1999 a project was launched called SETI@home, asking people across the world to lend their computers' power to the effort of analysis by downloading a simple program that worked as a screensaver – analysing data and transmitting the results to Berkeley whenever a computer was idle for a certain amount of time.

Crowdsourced censorship

Like most digital ideas, tapping into the wisdom of crowds is powerful – but isn't an inherently positive thing for a society. In China, for example, the government is adept at using 'human flesh search engines' – that is, thousands of human volunteers – to enhance its propaganda and censorship efforts. Similarly, the state's efforts to censor internet content in countries like Saudi Arabia are helped by crowdsourcing initiatives, with groups of conservative-minded citizens trawling the web and flagging up any content that they think might be damaging to the state or is against its policies about what should and should not be available to the public.

2001	2009
Wikipedia launches	Kickstarter is launched

Do crowds have rights?

Mass collaboration is a far older phenomenon than digital technology but the ease and scale that digital crowdsourcing bring also highlight a number of problems. In general, those taking part in a crowdsourced project have no formal contracts and are receiving no payment for their efforts. The open and anonymous nature of many projects also makes them vulnerable to highly motivated minorities who may wish to introduce bias into results or simply ruin things for the sake of it. Wikipedia, for example, suffers tens of thousands of acts of 'vandalism' a year, and members of its community spend thousands of hours correcting these. Then there's the simple fact that, because a crowd doesn't work for anyone in particular, it can be hard to coordinate efforts or complete an open project where there aren't many rights or responsibilities involved.

Within six years, over five million people had downloaded the program. It cost them almost nothing in terms of time, effort or electricity, and yet the result was thousands of times more powerful than a single supercomputer.

What can crowds do? SETI@home was a project directed centrally by an elite academic institution. But far more ambitious and decentralized collaborative works were yet to come. Among the most famous of these was founded in 2001 with the modest aim of establishing a free, web-based encyclopedia of human knowledge that anyone could use or edit. Called Wikipedia, by the end of 2010 the encyclopedia had logged over 100 million human hours of labour, in the process becoming the world's most exhaustive general source of information – and one of a quality many times higher than even the most optimistic might have dared to predict at its founding.

Digital crowds, then, can develop astonishing results when it comes to information. Perhaps more surprisingly, however, the same can also be true of action – at least of a kind. One of the more recent developments in the crowdsourcing movement is crowd funding, an idea epitomized by the website Kickstarter, which launched in 2009 as a venue for anyone to appeal for funding to start a project. Volunteers can chip in as little or as much money as they wish towards the stated total, in exchange for a stake in the project as defined by the project's originator – as opposed to a conventional investment and equity arrangement. Successfully funded projects have

ranged from music albums to games companies to a film with a budget of over $300,000.

Even this barely scratches the surface of what collective intelligence can do online. Tapping into the collective knowledge and capacities of the web has become an increasingly standard tactic for businesses, artists and governments alike. In 2009, the *Guardian* newspaper used a network of over 20,000 volunteers to sift through the controversial expenses claims of British MPs; in 2010, the Library of Congress turned to photo-sharing site Flickr to appeal to the public to identify people in a newly acquired archive of Civil War photographs. The list is a constantly expanding one, covering almost anything it is possible to persuade people is worth a few moments of their online attention.

> ‘Open source efforts haven't merely equalled the best efforts of some of the largest corporations in the world, they have exceeded them.’
>
> **Jeff Howe**

What can't crowds do? Jimmy Wales, co-founder of Wikipedia, is one notable opponent of the term crowdsourcing to describe what his site does, arguing the idea fails to take into account the amount of work it takes to create and maintain a system within which users can collaborate to good effect. More generally, crowdsourcing schemes can run into problems with quality control, ownership of the results, legal liability and simple feasibility – the notion that simply inviting contributions to a massive project online will yield a solution has ended in disaster for many companies, in part because of the difficulty of achieving collaboration around tasks that people are not intrinsically motivated to perform.

This criticism spills over into the political and activist arena, where the term 'slacktivism' has been coined to describe those who prefer the almost effort-free ease of signing mass petitions and joining Facebook groups to taking more meaningful or risky action. As analysts of 'the wisdom of crowds' have long noted, the many can indeed prove smarter than the few – but history itself is more often made by a highly motivated few than by committee.

the condensed idea
Ease of mass collaboration is changing the world

39 Free software movement

The free software movement is closely linked both to the ideas behind crowdsourcing and to many other open, collaborative movements that have characterized the internet since its beginnings. Its importance lies not simply in the idea that software or other creative products should be given away for free but in the ways in which the online community has sought to formalize and perpetuate the principles of free use, free re-use, adaptation and collaboration in perpetuity.

Simply making something freely available for use or re-use by anyone – known as releasing work into the public domain – is not a guarantee that this freedom will continue. Someone else may try to profit by selling a copy of it or by slightly modifying it and declaring this new product their own creative property. The free software movement is a formal attempt to prevent this. To this end, it makes selective use of copyright legislation by releasing products under a variety of licenses, which legally limit the ways in which something can be used. Usually, these licences explicitly state that every future copy, modified version or derivative work must itself be both freely available and released under the same licensing conditions. This means that legal action can be taken against anyone attempting to profit from a work released under a free licence, compelling them either to destroy their own version or release it publicly under a free licence. Free software is a movement in the loosest sense of the word and a variety of different licences and approaches exist, offering a number of different levels of protection – and representing different perspectives on what can be a controversial topic of digital debate.

timeline

1984	1989
Term 'shareware' is coined	First GNU General Public License

Copyleft The oldest form of free digital licence is called 'copyleft', a play on the word copyright. Its symbol is a mirror image of the © copyright symbol, and although it was first used in the mid-1970s perhaps its most famous and influential formulation is the GNU General Public License (often known as the GPL). The GPL was written by Richard Stallman for the development of the Linux operating system – a process described in the previous chapter that culminated, in 1992, with the public release of the world's first entirely free-to-use computer operating system.

> ❛When we speak of free software, we are referring to freedom, not price.❜
> **Free Software Foundation**

The latest version of the GPL, its third, was finalized in 2007. The licence itself is designed to be used by anyone and is today applied to over half the free software packages in the world, but its own wording is not permitted to be modified in any way. Its stated aim is to ensure 'to guarantee your freedom to share and change all versions of a program', a principle that Richard Stallman describes as 'pragmatic idealism' in its resistance to

Open source

The phrase 'open source' is often used in conjunction with 'free' when talking about software, although it describes a larger and more nebulous idea than that of simply constructing a free licence for software distribution. The term refers originally to the 'source code' of software – the core code of a program that shows exactly what a programmer has done to construct it – which for commercial products is never usually revealed. Opening up the source code allows others to replicate and build on software. For some people, the phrase 'open source' has grown from these roots to describe a larger philosophy of opening up the workings of any process to public scrutiny and collaboration, from government to art or activism. Open-source materials are not necessarily subject to the terms of any particular licence. What is central to the approach, however, is an open and collaborative process of development whose key elements will always be open to public and expert scrutiny alike – a trend that is gaining support across many fields, from medical science to the workings of government policy.

2001	2004	2007
Creative Commons is founded	Lawrence Lessig publishes *Free Culture*	Latest version of the GNU GPL is published

permitting any proprietary re-use of copyleft-licensed software, even if this offered the tempting possibility of such software reaching a huge audience.

Today, numerous types of Copyleft licence are available for different kinds of product, ranging from licences for specific software uses to documentation licences. Copyleft does not itself maintain that artistic and creative works ought to be free but recommends a similar Free Art Licence for those who do wish their creative work to be distributed freely in perpetuity.

Creative Commons Copyleft is not the only form of licence used to define the terms on which a work can be distributed for free. The best known and most influential of other such licences are those of the Creative Commons organization, founded in 2001 by the American activist and legal academic Lawrence Lessig who helped to coin the idea of 'free culture' in his 2004 book of the same name. Today, the Creative Commons organization is headed by Japanese activist and entrepreneur Joichi Ito.

'Free culture' opposes restrictive copyright laws in favour of the use of media – and digital media above all – to distribute and modify works freely. The movement has attracted criticism from those who argue that this damages the ability of creative individuals to both profit from and safeguard the integrity of their work. Its proponents, including Lessig, argue that properly licensed free distribution enhances creativity and cannot be blamed for the decline of many old media business models.

Creative Commons licences are widely used in connection with creative digital products of all kinds, from photographs to written words – although not software, which is generally better served by Copyleft. The licences all permit the basic right of free copying and distribution but with four potential qualifications attached. An 'attribution'

Shareware

Another important species of 'free' software in digital history is shareware, which embodies a very different notion of freedom to Copyleft or Creative Commons licensed material. Shareware is proprietary software that has been released in a free, trial version, either with limited features or time-limited use. First used in 1984, the term usefully described the way that such free programs were shared across the early internet and became an important new distribution and marketing channel for software companies. Some of the most successful early video games and utilities succeeded partly on the basis of their distribution as shareware, including the 1993 video game Doom. Shareware enabled smaller companies to reach a large potential audience, but it is not to be confused with free or open-source software, which inherently has no commercial application.

> **The unintended consequence of all this democratization . . . is cultural "flattening". No more Hitchcocks, Bonos or Sebalds. Just the flat noise of opinion.**
> **Andrew Keen**

licence simply stipulates that a work can be displayed, copied, modified and distributed provided its creator is attributed. A 'non-commercial' licence adds the further restriction that uses of a work can only be for non-profit purposes, while a 'no derivative works' licence stipulates that a work can only be reproduced exactly and not modified in any way. Finally, a 'share alike' licence insists that work can only be reproduced with an identical licence attached to it. These conditions are usually applied in one of six combinations, all of which include attribution as standard and which do not contradict the application of basic copyright law.

Applications and controversy Copyleft and Creative Commons are the most used but there are dozens of free licences in use around the world, ranging from those targeted at specific subsets of software to those that wish to impose more restrictions on usage – or fewer. Millions of works and web pages use such licences, ranging from the works of activist authors such as Cory Doctorow and Lawrence Lessig to albums, films, art, photographs and programs. Perhaps most famously, the entire Wikipedia project is issued under a Creative Commons licence.

These undertakings have received criticism, above all from those who feel that important and hard-won principles enshrined in copyright are being fundamentally undermined by much online activity, and that abuses of copyright are too easily dignified by the arguments of the more radical proponents of 'free culture'.

the condensed idea
Genuinely free work is free forever in every form

40 Digital distribution

During the early years of digital technology, data storage was awkward and expensive, and transferring information between different systems meant copying information onto disks and moving these physically between machines. Today, the internet and the increasing interconnection of all digital devices means that information can be distributed largely without any need for disks. What could not have been foreseen, however, is just how profound and universal the consequences are proving.

It was obvious from almost the beginnings of the internet that print media – books, magazines, newspapers – would begin to appear in digital formats, and that new forms of digital writing would in turn come to challenge them. As the power of computers and the speed of digital connections increased, however, it also became increasingly easy for far larger music and video files to be transmitted online, rather than needing to be stored on physical media like CDs and DVDs and then distributed.

This was a process that went hand in hand with steady advances in digital file formats. July 1994 was an important milestone, marking the official release of a format called MP3, able efficiently to encode music at high quality in a relatively small amount of data. The next year, software able to play back MP3 files in real time on a computer was released.

MP3 files were small enough to store, download and upload easily via the early internet, and soon hundreds of thousands of files were being shared online, often via systems known as peer-to-peer networks, which made it

timeline

1994	1999
MP3 format is invented	Napster is founded

easy for people to locate and share files between their personal collections (see Chapter 15 on File sharing). Networks such as Napster (founded in 1999, shut down in 2001) helped to transform the face of the music business forever, as well as foregrounding issues of copyright violation that continue to dominate many discussions about digital media.

> **❛Books are no more threatened by Kindle than stairs by elevators.❜**
>
> **Stephen Fry**

Enter iTunes By the time Napster closed, what would become one of the world's most significant industry-approved channels for digital distribution had launched: Apple's iTunes service, which started in January 2001 as an application which allowed Mac users to play and manage digital music on their computers.

With the launch of the iTunes store in April 2003 and the launch of iTunes that year for Microsoft Windows-based computers as well as Macs, it became possible for users to pay a small amount to buy individual songs online and download them directly to their computers and portable MP3 players. It was a field in which Apple already had a significant

A world without paper?

The newspaper and magazine industries have been hit heavily by the transition to digital technologies, and many believe increasingly that their future survival relies upon finding viable online business models, something publications have tried with mixed success. The rapid growth of tablet computers since Apple's launch of the iPad in 2010 has fuelled hope that applications for such devices may provide a profitable substitute for paper-based newspapers. In February 2011, Rupert Murdoch launched *The Daily*, the world's first newspaper to be available exclusively via iPad purchases. Without either a print edition or any kind of presence on the web, *The Daily* hints at what a paperless world might look like for newspapers and magazines, much as Amazon's Kindle and other e-readers have already begun to demonstrate the possibility of a world without printed books.

2003
iTunes store launched

2007
Amazon launches Kindle

2011
World's first iPad-only newspaper launches

presence thanks to the release in 2001 of the iPod, one of the world's first commercially successful portable MP3 players.

The iTunes store soon became an iconic example of digital distribution's ability to disrupt traditional business models through entirely legal and official models. Within seven years, iTunes was responsible for almost three-quarters of all digital music sales in the world, making it the biggest seller of music on the planet. In February 2010, Apple announced that over 10 billion songs had been purchased through the store since its launch – and that over 55,000 TV episodes and 8,500 movies could also be bought through it online.

The end of ownership?

In many cases, buying the digital version of a product does not grant ownership of it in the same sense that buying a physical version does. It is impossible to lend or give a file as you might do a physical object, and it can be almost as difficult actually to have the file in your own possession rather than merely be allowed to access it through a particular service. This transition from buying and owning media physically to merely accessing media as the user of a service is powerful and convenient, but also restrictive. A service can theoretically be withdrawn at any time or cease to operate for business reasons; high-quality internet access may not always be possible; and the absence of personal ownership makes consumers potentially vulnerable to censorship, hacking or accusations of misuse. This isn't true of all forms of digital distribution, but it has led to an impassioned debate about the rights and responsibilities associated with digital consumption

Across all media The growth of iTunes has been just one part of a key global transition over the last decade: where digital distribution has shifted from being a novelty to, today, the sole method of distribution for an increasing number of products. Digital books are perhaps the simplest example of this. An increasing number of books exist only in electronic formats. Amazon's Kindle, launched in 2007, is just one of an increasing number of e-reading devices now on the market. But its seamless integration with the world's largest bookseller offers a glimpse of just how profoundly digital distribution could disrupt existing publishing models – as does the fact that Amazon now offers authors the opportunity to publish directly onto Kindle, without either going through a traditional publisher or going anywhere near physical print.

Kindle, moreover, is not just a physical device for reading electronic texts; it is also a software platform for reading digital texts across a variety of devices. All that's required is an account with Amazon –

just as, in the case of Apple, an iTunes account allows people to download and consume digital media across a range of devices.

Digital distribution is becoming the normal method of purchase for much software, too, with increasing broadband access speeds removing many of the barriers that once made it easier to buy a physical disk with files on rather than spend many hours downloading. On computers, the digital distribution platform Steam is now a leading marketplace for video games, while software giants from Microsoft to Adobe offer downloadable versions of all their major products.

The world is becoming increasingly customized, altered to individual specifications.
Don DeLillo

Never-ending media Perhaps the greatest advantage of digital distribution, besides convenience, is its lack of finality: it is always possible to download a further update or a new copy. Moreover, digital platforms offer the opportunity to use a product not in isolation but as a member of a community – something that's especially important with entertainment, when streamed and downloaded games tend to offer users the opportunity to share comments, register and compare scores online, and play or watch alongside others.

Such a culture can also be a disadvantage, for those who wish to have finished, self-contained products that are designed to be used in isolation and that do not rely on a broadband connection for some functions or even, in the case of streamed media, an active broadband connection for the entire usage. Issues of quality control, copyright and ownership also complicate people's relationships with many digital-only products – with some arguing that distribution platforms open to anyone will come to mean a culture that may offer unprecedented customization and flexibility but that will also mean ever lower quality.

the condensed idea
As distribution transforms, so does content

41 Cloud computing

During the early days of computing, computers were huge, expensive machines and it was assumed that a small number of them would be used by many people. As computers have become smaller and cheaper, we have learned to take it for granted that everyone has access to their own computers. Yet with the growth of the internet, a version of the older idea has gained traction once again: there are many advantages to performing tasks and storing data not on a machine that you physically own but in the 'cloud', on a powerful remote system that you simply connect to from wherever you are in the world.

Rather than being processed by an individual machine, cloud computing takes place across a variety of different servers distributed across the internet. Neither users nor service providers necessarily know the exact physical location of the machines on which data is being processed. The phrase 'cloud computing' itself was first used in 1997, and specifically referred to the idea of a remote computing service taking place not in a single, known location – as was the case from the beginnings of the web with server computers hosting particular websites – but as something loosely distributed across a 'cloud' that the customers themselves had little knowledge of.

Why use the cloud? Cloud computing is a simple idea with extremely wide applications, but the core reasons that many are increasingly turning to it are clear enough. They also apply equally to both individuals and businesses, although it is in business that the biggest

timeline

1997	1999	2002
Term cloud computing is coined	Salesforce.com offers first web apps service	Amazon Web Services launches

changes are already starting to be felt. Cloud services offer mobility: as long as you have a computing device and an internet connection, you can connect to a service, whether this is simply personal email and documents or an entire company's project-management and database apparatus. They are also scalable: the companies providing cloud-based services tend to operate thousands or tens of thousands of computers, meaning that almost no matter how far or fast your needs grow, they can easily be matched.

Perhaps most important of all, though, are speed and expense. Cloud systems are maintained externally, so there are almost no costs associated with keeping everything up to date or setting up networks and software. Moreover, there are no capital costs associated with buying physical machinery: you simply pay for the level of service you need, which can be

Amazon Web Services

The world's largest public provider of cloud computing power is Amazon, via its web services platform. Launched in 2002, the service today is typical of cloud services in that it offers a vast range of options based on need, ranging from simply providing online storage or the capacity for sending large amounts of emails to hosting extremely popular websites or even providing raw computing power for those performing experiments or conducting computing-intensive processes such as detailed three-dimensional animation. Amazon's crucial innovation, however, came in 2006, when it began offering a service known as the Elastic Compute Cloud (EC2), which allowed companies or individuals to rent as much computing power as they needed in order to run fully functional applications. Economies of scale make this an extremely efficient and powerful way to compute. The cost of hiring time on Amazon's most powerful computing service at the end of 2010 was, for example, just over $2 per hour, with no expenditure on hardware or further commitment required. The processing power of this service is similar to that of the fastest supercomputers in the world in the late 1990s, theoretically approaching one teraflop – that is, around a thousand billion floating point operations per second.

2006
Amazon's Elastic Compute Cloud is launched

2007
Google Docs is fully launched

2010
Microsoft launches Web Apps for Office

> **For the first time, developers across the globe can access unlimited computing power. With a browser and a web connection, anyone can build applications and deploy them.**
>
> **Marc Benioff**

measured down to the hour. For this reason, cloud computing's business model is sometimes referred to as 'utility computing' because it turns computer systems into a utility much like gas or electricity.

Personal clouds While individuals are unlikely to cite cost savings as an advantage of cloud computing, an increasing amount and complexity of personal information is being stored online via services ranging from Google to Facebook.

Google's approach is typical, as it increasingly offers users of its services the opportunity to put more and more parts of their digital lives into the online cloud. Google's documents program stores spreadsheets and written records online and allows them to be edited anywhere in the world through a web-based word processing package; its calendar service integrates with other online apps; its photo service, Picasa, offers online image storage and management, as does the still more popular online photo-sharing site Flickr.

Similarly, social networking sites like Facebook and Myspace increasingly allow the main repository of images, words and messages in people's lives to be an online account accessible from anywhere in the world rather than the hard drive of a device they actually own. Indeed, social networking – which offers an increasingly all-in-one online experience – may be an instrumental factor in shifting an entire generation of internet users towards cloud-based thinking.

Looking ahead Today, powerful remote computing services are proliferating, together with suites of utilities encouraging businesses to outsource everything from email to data storage. Both hardware platforms and software services can be provided remotely, while the integration of

cloud limitations

Cloud computing is not without its critics, many of whom point to the security implications of individuals and companies storing increasing amounts of data remotely on machines they do not physically own. Cloud providers argue that data is better protected and more securely backed up in cloud systems than almost anywhere else. But legal concerns remain, in particular that cloud companies could be compelled to hand over data in circumstances that would not apply to data on personally owned machines in people's homes. Other issues include the difficulty of customizing cloud systems compared to local software; the technical and logistical demands of changing to new business models; and the possibility of interrupted connections. It seems unlikely that any of these will prove sufficient to stall the advance of the cloud for long; something that could in the long run mean an unprecedented accumulation of power in the hands of the relatively small number of companies who actually own and operate the software that runs most other companies.

cloud-based services into other software is becoming common, as in the case of Microsoft's Office suite, which in 2010 introduced online functions into all its major services.

One question for the future is balance: how much of a business or service will be web based, and how much of its technology will remain local. For advocates of free and open-source software, web-based technologies put a dangerous amount of power into large corporations running cloud systems, and potentially limit the kind of innovations and collaborations that have come from an open internet based on many thousands of different services and approaches. Meanwhile, research into improving the functionality of cloud computing continues across the world, with access from mobile devices, increased flexibility and enhanced security being major fields.

the condensed idea
Computing power is becoming a universal utility

42 Going viral

A virus is a primitive form of life able to produce huge numbers of copies of itself in a short time: something that has made it the perfect metaphor for the way in which ideas, words, sounds and images can spread in a digital age, where the cost of reproduction is almost nothing and the rest of the world is only a click away from infection.

The idea of viral spread via computers was initially a negative one: pieces of malicious software were designed to deceive computer users and spread themselves automatically from machine to machine much like a biological infection. Such programs are still a major problem for modern computing but the idea of viral spread itself has increasingly been applied to a more positive, active cultural process, where striking or amusing cultural nuggets are noticed and distributed online by a rapidly increasing number of people.

> **All your base are belong to us.**
> **Zero Wing meme, 1991**

This is a process that has much in common with scientist Richard Dawkins' notion of 'memes': ideas that behave within human society in a similar way to genes in the human body, effectively replicating copies of themselves thanks to their spread from person to person. The internet has greatly facilitated this process. But it has also helped it to develop from a matter of simple repetition and reproduction to one of extremely rapid mutation. From a subculture on early image boards, memes have grown into the most mainstream of digital phenomena and a self-perpetuating region of baroque self-reference that is now regularly co-opted into every context from commercials to concept art.

Pre-web memes Before the world wide web, certain phrases became popular on the early internet, one of which is thought by some to qualify as the first internet meme. This is the phrase 'Garbage In: Garbage Out' –

timeline

1976	1982
Richard Dawkins coins idea of 'memes'	First emoticon in use

often abbreviated to the acronym GIGO – which is credited either to the programmer and journalist Wilf Hey or the early IBM programmer George Fuechsel. Intended to highlight the fact that a computer's output is only as good as the quality of input it receives, GIGO became an unofficial motto among early programmers.

Another contender for first digital meme may be the first emoticon – the use of punctuation to depict a human face in outline – which in the case of :-) dates back to around 1982 and has been in repeated use ever since. One of the few confirmed memes to have existed on Usenet – a global internet-based discussion system first launched in 1980 – dates to 1991, when a discussion about martial arts styles led one user to make up a fictional 'ancient Celtic martial art called Greenoch', earning the word 'Greenoch' almost instant fame and a place in internet history in the process as a shorthand for absurd claims.

Rickrolling

Of all the viral phenomena the internet has thrown up, few are more delightfully odd than Rickrolling. The principle is simple enough: in an online situation, someone pretends to be sharing a useful link to a relevant resource but their link in fact takes any unsuspecting victim to a video of Rick Astley's 1987 hit song 'Never Gonna Give You Up'. This bizarre practice began, like many other memes, in 2007 on the notorious imageboard website 4chan as a variant on a previous meme with a similar trick to it 'duckrolling'. By 2008, the phenomenon had spread to the web at large, where it gained astonishing momentum, claiming tens of millions of victims and culminating in November 2008 with Astley himself performing a surprise 'Rickroll' at the Macy's Thanksgiving parade in New York. Combining whimsy with a schoolboy-style prank, Rickrolling exemplifies viral culture not just in its spread but in the endless variations it continues to exhibit, from elaborate re-edits of Barack Obama's speeches that make him appear to speak the song's lyrics to the mass online movement that saw Astley voted MTV's Best Act Ever in 2008. It makes no sense at all – and has no need to, beyond the momentum of a phenomenon fuelled not so much by collective belief as by a collective relish of absurdity.

1996
First web memes appear

2004
Viral marketing term 'alpha users' is coined

Echo chambers

One of the most telling criticisms of online culture and virality made in recent years has come from American legal scholar Cass Sunstein. He has argued that the rapid and seamless flow of ideas between like-minded individuals online risks turning much of popular culture into a series of 'echo chambers': spaces that allow people simply to confirm their own established views and tastes, encountering and passing on nothing that does not immediately appeal to their particular sensibilities. It is a phenomenon that, if true, poses equal dangers to culture and politics, being likely to entrench people in extreme positions, and allow those at the far ends of the spectrum to reinforce and sustain their extreme tastes, no matter how antisocial or objectionable to the minority. For some, of course, this inclusiveness is one of the great assets of digital culture, alongside its limitless ability to spread ideas and images along receptive channels. But this does not negate the hazards and limitations Sunstein, among others, warns against.

Vitality and the web Almost every modern digital meme dates to after the launch of the web. The web also signalled the arrival of what would soon prove to be a sufficiently wide network of users for truly 'viral' spread of links, ideas, images and words – the main criterion for a viral phenomenon being its spontaneous, decentralized nature.

For this reason, viral digital phenomena have tended to be things that provoke a rapid, strong emotional response from their audience – shock, delight, amusement, but usually something avowedly non-useful, and with a visual component. Some of the first web memes to spread virally included a series of crude images of famous figures speaking the phrase 'ate my balls' (1996), a three-dimensional computer animation of a dancing baby (1996) and a collage of a screen full of cartoon hamsters dancing to a speeded-up song sample (1998). Between them they were, in other words, slightly rude, crude, cute, surprising, linked to celebrity and easily understood. They were also considerably harder to spread than modern memes, given the absence not only of social networks and file sharing sites but also Google.

Viral services Viral spread is the default mechanism by which many online services succeed: through links and recommendations and the reinforcing process of search engines picking up on this momentum and directing fresh traffic towards them. Services like Google and Yahoo!

themselves gained much of their early success through networks of recommendation and links, as did later social services like Myspace and Facebook.

Virality is generally a method of spread for younger or smaller companies, which, once established, will increasingly resort to conventional marketing tactics in order to bolster their position and advantages. But it can become a double-edged sword, given the ease with which dissatisfaction, rumours and negative publicity also spread.

> ❛No matter how smart we get, there is always this deep irrational part that makes us potential hosts for self-replicating information.❜
>
> **Neal Stephenson**

Virality goes mainstream As the consumption of media online has increasingly become normalized, the web has seen the most successful viral spread of materials increasingly reflecting mainstream concerns. The most followed people on social networks are actors, musicians and celebrities; in January 2011, the three most watched videos on YouTube were all big-budget accompaniments to hit singles by Justin Bieber (425 million views), Lady Gaga (327 million views) and Shakira (270 million views).

This reflects not so much the loss of internet subculture as the loss of the internet as a subculture; instead, almost the entire cultural mainstream is rapidly heading online and in the process becoming subject to the viral structure that is intrinsic to the web. Companies and individuals alike are highly aware of this, giving rise to the paradoxical situation that what businesses, advertisers and creative individuals all most wish to engineer is a self-perpetuating groundswell of online interest in their work – a sign that they have 'gone viral'.

In these cases, the biological metaphor is especially apt, as much of the art of engineering viral spread lies in attempting to identify individuals susceptible to the appeal of particular ideas and likely to spread them – sometimes referred to by marketing companies as 'alpha users' – as well as trying to make the ideas in question as virulent as possible.

the condensed idea
Viral transmission is digital culture's default state

43 Virtual worlds

Virtual worlds are one of the purest embodiments of the new possibilities presented by digital culture: self-contained unreal places that people can 'visit', interact within and use to experiment with different ways of being. The idea of such worlds long predates computing technology. In the last few decades, however, they have moved with remarkable speed from being mere imaginative experiments to both powerful artistic and experimental arenas and, in the form of massively-multiplayer online games, some of the most profitable and dynamic of all 21st-century digital businesses.

In 1974, an early video game called Maze War appeared, allowing multiple players to navigate a crude 3D maze shooting at each other, perhaps the first example of a shared graphical world being created on computers. The first true virtual world, however, was one based entirely on words. Released in 1978, it was dubbed a Multi-User Dungeon or MUD. Consisting of a series of descriptions of interconnected rooms and locations, multiple users on different computer terminals could move via simple geographical commands, talking to each other and interacting with the world. MUD1, as it came to be known, was created by programmer Roy Trubshaw at Essex University in Britain in collaboration with fellow student Richard Bartle, who continued to develop it after Trubshaw left the university. Remarkably, a version of MUD1 can still be played online today.

MUD's great innovation was twofold: allowing multiple players to occupy the same virtual space at the same time, but also allowing them to inhabit it not simply as themselves, as in the case of a chatroom, but by playing the roles of characters engaged in exploring a sometimes perilous alternate

timeline

1974	1978	1991
First three-dimensional game	First multiply inhabited virtual world	Neverwinter Nights is released

world. From the beginning, the relationship between virtual worlds and play was a close one.

By the 1980s, graphical elements were beginning to feature. One of the first networked graphical virtual worlds appeared in 1986. Called Air Warrior, it allowed players to engage in simulated air combat against each other via an early computer networking system called the General Electric Network for Information Exchange, or GEnie for short. GEnie also provided a home for some of the earliest experiments with more complex shared worlds, such as the 1988 fantasy-themed game GemStone, based on text. The first such game to incorporate graphics, Neverwinter Nights, appeared in 1991 on the America Online network.

Open worlds As the internet began to become the world's dominant form of computer networking, other, more open forms of virtual worlds began to appear alongside games. These were typified by creations such as 1995's The Palace, which allowed users to create their own two-dimensional

> **'We're not playing with toys but with people. We need to use what we already have and make a difference.'**
> **Raph Koster**

Virtual lessons for real lives

One of the most intriguing areas of study to emerge from virtual worlds is their potential impact on the study of human behaviour. From psychology to economics and politics, the ability precisely to measure and compare human behaviours within complex three-dimensional environments is something unprecedented. Although the characters within virtual worlds are not real, the people behind them are, and they often exhibit a far more 'realistic' range of behaviours than can be achieved in experimental conditions – and on a far, far larger scale. Economics, in particular, is a close match to many virtual worlds, where systems of barter, monopoly, auction and complex player collaboration take place. More directly, virtual training environments are increasingly used to train everyone from pilots and soldiers to surgeons, triage workers and train drivers, with billions being spent each year by the US military among others on simulation-based programs and tools.

1999	2003	2004
EverQuest is released	Second Life is released	World of Warcraft is released

> **❝Anyone who is worried about the effects of virtual worlds on social interaction should direct their concern at television long, long before they look at virtual worlds.❞**
>
> **Richard Bartle**

graphical 'palaces' within which they could talk to each other and customize individual avatars. Open, unrestricted virtual worlds like The Palace offered important new kinds of social space and experience. But it was within games – where participants were driven to achieve particular objectives, and forced to collaborate – that virtual worlds began to demonstrate their full potential as engines for human engagement. The first three-dimensional massively-multiplayer online game (usually abbreviated simply to MMO), Meridian 59, appeared on commercial release in 1996, followed in 1997 by one of history's most influential virtual worlds: Ultima Online.

MMO gaming Ultima Online was the first three-dimensional virtual world to gain a population of over 100,000. Its success helped to pave the way for a newly complex type of online environment: one sufficiently engaging to lead to the development of an entire grey economy of real-world money, based on the manufacture and sale of virtual items and property (see Chapter 36).

Since Ultima, complex MMOs have continued to be a booming industry, with major releases ranging from EverQuest in 1999 to EVE Online in 2003 and, perhaps most famously of all, World of Warcraft in 2004, which today boasts over 12 million players. But simpler shared virtual spaces have increasingly become common, too, in styles ranging from driving to first-person combat, management and real-time strategy.

Beyond play Outside games, virtual worlds have continued to grow in influence. In 2003, American company Linden Lab launched Second Life, an online space in which players were given an unprecedented degree of freedom to live out virtual lives through their avatars, buying virtual land and consuming virtual goods from a variety of real-world companies with a virtual presence within Second Life.

Dangerous games

The migration of attention towards virtual worlds brings with it many concerns, some of which centre on the neglect of real life. Cautionary tales are told about 'Warcraft widows' who leave their husbands because of their online gaming habit, or in the most extreme cases a couple whose child died of neglect while they were playing an online game. Given the tens of millions of people now participating in virtual worlds, exceptional cases will always exist. But studies do suggest that those predisposed to addictive behaviour should exercise caution around the extraordinarily compelling experiences some game worlds can offer – and that companies could do more to promote the balanced use of their products. However, there is also hope in the most fundamental properties of virtual worlds – that they are highly interactive and involve many players, unlike linear media such as television broadcasts. For virtual worlds are not inevitably isolating or a simple matter of 'unreality'. They can also be a path towards action and re-engagement with the world.

Second Life is primarily a social space, and one for indulging in the fantastical delights of building everything from virtual palaces to factories, but it has featured as a virtual venue for everything from business meetings to artistic collaborations and teaching. Increasingly, too, specialist virtual worlds have developed to target these varied demands, ranging from education simulations like Whyville – founded in 1999 and now used by over five million people – to environments for business, medical or military training.

Entertainment remains the dominant force in the field but, with steady developments in the application of virtual environments within fields ranging from education to training and simulation, what some people refer to as the 'three dimensional internet' seems set to escape these early boundaries into an increasingly diverse range of other realms.

the condensed idea
Building virtual worlds helps to build other ways of being

44 Avatars

The word 'avatar' is derived from the Sanskrit word describing the incarnation of a god in the form of another being. In technology, it describes the form in which a person is represented within a digital environment – whether this is in the form of a character within a virtual world or simply an icon or name within a chatroom or an online forum. This notion of digital incarnation is central to much online culture and to understanding behaviours within the digital realm.

There are essentially two different classes of avatar. First, and earliest chronologically, there are static avatars that simply represent people in online arenas ranging from discussion forums to blogs or some social networks. Second, there are actual digital characters that people can control within virtual worlds, games or digital environments, and that can in turn have virtual possessions, properties and often be customized in detail.

As James Cameron's 2009 film *Avatar* – in which human characters are able through technology to inhabit and control artificial alien bodies – suggests, avatars do not have to be human figures. Indeed, they do not even have to be animals or living things. To some extent, any virtual object controlled by a human can be thought of as an avatar, although a degree of embodiment and identification is usually implied by the term.

Early avatars The term avatar was first used in the technological sense in 1985, meaning simply crude icons placed next to people's names in early internet discussion forums. It wasn't until Neal Stephenson's 1992 novel *Snow Crash*, however, that the term came into wider usage. Avatars

timeline

1985	**1992**	**1995**
First use of the word avatar in digital sense	Neal Stephenson popularizes the term avatar	First three-dimensional chat avatars

in early forums were generally 'hacks' put together by advanced users rather than standard features – in many cases functioning as enhanced digital signatures, with faces or icons drawn in ASCII symbols.

The kind of personalization that avatars offered had a universal appeal, and by the mid-1990s many discussion forums were offering avatars as standard features, usually in the form of small slots for a pixellated image to occupy. The early internet chatroom Virtual Places Chat was, in 1994, one of the first to offer its users avatars in the form of small two-dimensional images, followed the next year by other services offering crude three-dimensional avatars as part of the chat experience.

Inhabiting an avatar Once the idea of an avatar began to move beyond a simple two-dimensional icon into something with three dimensions, a natural synergy existed between the established field of video games and the emerging fields of three-dimensional graphics and online chat as an experience more immersive than that simply offered by chatrooms.

Tall dark strangers

How does the way someone looks in the virtual world change the way they and others behave? Perhaps unsurprisingly, experiments using different kinds of avatars have found that people tend to be more confident and willing to engage others when they are using more attractive and more appealing-looking avatars. More interestingly, though, research suggests that these effects can cross over in a limited way into the real world, and that after using attractive avatars and behaving confidently online, people may for a short period of time be more confident in the real world. The implications of this may be hard to pin down precisely but it suggests that the processes of identity and identification associated with taking on a secondary digital presence are not distinct from one's sense of personal identity – and that the future of identity may in part entail a dialogue between the different ways in which people interact with it, and the different forms that constitute various versions of 'them'.

2006
Nintendo introduces 'miis'

2010
Launch of Microsoft Kinect

Three-dimensional massively multiplayer games were beginning to be developed online from 1996 (*see* Chapter 43), and it soon became obvious that the avatars people used within these represented a new order of immersion in online experience. As games and virtual worlds rapidly gained a large audience, the sophistication of avatar customization increased rapidly, together with the possibilities of action. Learning from online games, customized avatar creation soon became a staple of most forms of big-budget gaming, with characters adjusting everything from weight and height to skin colour, clothing and accessories.

The degree of user investment in such avatars can be gauged by the considerable market in purchasing virtual accessories for them – a major stream of revenue in particular for online games in Asia, which are often free to play and then supported by micro-payments for extra features. An increasing number of games and virtual worlds, too, involve players maintaining elaborate environments for their avatars to inhabit and interact within – and even games-within-games for them to play.

Embodiment

With the emergence of the first generation of mass-produced, affordable motion-tracking technology – epitomized by the success of Microsoft's Kinect peripheral for its Xbox 360 console – another possibility has appeared: the direct, real-time mapping of someone's body and actions into a virtual environment. Kinect functions through stereoscopic motion-tracking cameras that can follow two people's movements within a room and use these to control avatars on screen with great accuracy, based on modelling of the joints and skeleton. With Kinect also boasting voice and face recognition through its cameras and microphones, this signifies the arrival of digital embodiment in avatars in a newly intimate sense: someone's body, face and voice translating without any mediation into live actions on a screen and live interactions with other similarly controlled avatars.

Getting personal Within the latest generation of games consoles, a further leap forwards was made in virtual embodiment. Launched in 2006, Nintendo's Wii console asked every user to create a cartoonish version of themselves – known as a 'mii' – for use not within a single game, but across every game bought for the system.

Different players' miis, moreover, are used together to populate games, with each console able to store up to 100 different miis – and bring them together with miis from other consoles over the internet. This notion of universal graphical avatars spanning a whole range of services was introduced in 2008 by Microsoft to its Xbox 360 console, allowing players to create a customized character for use across a variety of games.

❝It scares me in one way, and fascinates me in another, in wondering where it will take people. What impact does having a false identity have on your real identity?❞

Susan Greenfield

The system was sufficiently successful that in 2009 Microsoft introduced an Avatar Marketplace, selling clothes and accessories for its avatars, including virtual goods with mainstream branding. Microsoft is not unique in this – the virtual world Second Life has a successful market for real-world branded virtual goods.

Emerging technology The future of avatars is rapidly being defined by a combination of new interface technology (see box opposite) and a newly realistic level of computer modelling. The research division of one games studio in Britain, Blitz Games Studios, has for example demonstrated next-generation avatar technology that builds ultra-realistic human heads according to a series of sliding scales that a user can modify in real time to define any range or combination of gender, skin tones, race, feature sizes and styles, weight, age, build, hair and accessories.

Given the near-cinematic quality of modern three-dimensional modelling and motion capture, the prospect of customizable virtual selves almost indistinguishable on screen from film footage of actual people is not too far away – something already demonstrated by the increasingly photorealistic versions of people, ranging from famous footballers to actors, found within the biggest budget commercial video games.

the condensed idea
The digital world is full of other selves

45 Net neutrality

The principle of 'net neutrality' asserts that neither Internet Service Providers nor governments should be able to impose restrictions on the use of the internet: customers paying a certain amount for internet access should all receive the same level of service and be free to use whatever devices, sites and services they choose.

Since the mid-2000s, the topic has been one of the most heated sources of debate about the internet's future, with many influential figures advocating net neutrality as a vital principle. Against this, critics have argued that the ability to discriminate between different kinds of internet traffic and to allow customers to pay for an internet 'fast line' is part of open competition and the maximization of limited resources.

The neutrality of communications networks had been a subject for debate and legislation since the birth of the telegraph in the 1860s but net neutrality itself is a relatively recent development. The current debate was anticipated in a June 2003 paper by professor Tim Wu of Columbia Law School entitled 'Network neutrality, Broadband Discrimination', examining the concept of network neutrality in telecommunications policy and its relationship to Darwinian theories of innovation. At its heart is a simple question: should Internet Service Providers have the right to offer companies a premium rate internet service that would allow their content to be delivered faster online than other, 'ordinary' traffic?

The debate thus far has largely been played out in America but it poses questions that the world at large needs to answer and that will have a profound effect on the future nature of the internet and businesses that operate online. An 'open' internet is almost universally regarded

timeline

2003	2005
First paper on broadband network neutrality	FCC Broadband Policy Statement

How is traffic shaped

Internet Service Providers handle vast quantities of data in order to provide many millions of people with internet access, and this means that one of the most vital questions for their industry is how to make their networks as efficient and effective as possible. 'Traffic shaping' takes many forms, but at root it always comes down to the same thing: delaying particular packets of data, in order to control the volume of traffic at any one time. It can involve simply holding back data based on the level of traffic, or it can use more complex ways of classifying different kinds of data. In the increasingly complex networks run by many businesses, traffic shaping is a vital tool. As the net neutrality debate shows, however, many people feel that when it comes to the basic provision of internet service, it is not acceptable for service providers to differentiate between data of different levels of priority. Naturally, many service providers themselves disagree, and see sophisticated traffic shaping as an integral part of their business.

as desirable in principle but the increasingly vast amounts of traffic transmitted across it and its increasing centrality to much of the commercial world mean that in some eyes it is not meaningful to attempt to protect complete equality in all aspects of access and service.

An open internet In 2005, America's Federal Communications Commission (FCC) set out the basic tenets of an open internet in the four guidelines of its Broadband Policy Statement, asserting consumers' right to access any content they chose via any internet provider through any devices and using any applications, so long as all of these were legal. These four principles do not explicitly cover the principle of discrimination between different internet services – something that led in 2009 to the chairman of the FCC proposing two further guidelines be added to its Policy Statement, banning Internet Service Providers from discriminating in any way between the level of internet service made available for different applications and types of content, and ensuring that full disclosure of all policy details always be made to customers.

2010

Comcast wins case
against FCC

The innovation question

One of the central points in the net neutrality debate is innovation – and the capacity of the internet to bring a brilliant individual idea to a huge audience without the need to raise a huge amount of investment first. As the campaigning group Save The Internet puts it, 'Net Neutrality ensures that innovators can start small and dream big about being the next eBay or Google without facing insurmountable hurdles.' If, they argue, established companies are allowed to pay in order to boost their own accessibility online, or young companies need to pay premium rates in order to maintain a competitive digital presence, much of the innovative dynamism of the net as we know it will come under threat. As far as many established Internet Service Providers and others are concerned, however, the reverse is true, and unless flexible funding models allow significant investment in internet infrastructure, it will cease to be an innovative arena due to a gradual lowering of quality of access, the rise of overwhelming levels of traffic, junk sites and over-protective legislation.

Despite these changes, the FCC has found it difficult legally to prevent service providers from varying the speeds at which different kinds of content can be accessed. In a 2010 court case, US provider Comcast won a court ruling against the FCC, defending its right to slow down peer-to-peer traffic between internet users – a move aimed at restricting the amount of file sharing taking place between them – in the name of 'network management'.

As well as demonstrating the limits of regulatory powers like the FCC's, the 2010 case highlighted differences within the notion of what exactly net neutrality ought to signify: should limited discrimination be permitted, as long as no special payments are associated with higher quality service? Or should data be transmitted entirely on the basis of timing, with users' data requests constrained only by the order in which they were made? As of early 2011, while the USA and many other countries have laws protecting some aspects of an open internet, there is almost no binding legislation preventing service providers from restricting or filtering users' access to different sites and services.

Pro-neutrality An influential and prominent group of companies and individuals have spoken out in favour of such a formal legal protection in recent years, including the world wide web's creator Tim Berners-Lee,

> **❝As the web becomes a vehicle for the transport of richer and richer content, the question of whether all content from all providers is treated equally by the networks becomes ever sharper.❞**

Mark Thompson, BBC Director-General

Google, Microsoft, Yahoo! and Barack Obama. What they are opposed to is not every single form of discrimination between different types of data online but between different people's abilities to access the same kinds of data. The argument is that it should not be possible for 'gatekeepers' – as Internet Service Providers are often termed – to make, for example, music or video or products from one source less accessible than exactly the same kind of content from another source. This does not include, however, the right to prioritize different kinds of online traffic: giving file transfers a lower priority than voice interactions, for example.

In Britain, the BBC's Director-General Mark Thompson argued in early 2011 that it was vital to the BBC's public service mission that Internet Service Providers were not able to charge companies for offering improved access to their websites. The European Union at the time of writing was in the process of drawing up new regulatory legislation for internet provision, as current legislation seems unlikely to be able to prevent companies from offering a tiered service if they wish.

Meanwhile, many global internet and cable companies, among others, have been vocal in their criticisms of the arguments in favour of net neutrality, suggesting that the enhanced revenue opportunities that tiered service provision offers are important for future investment in the internet, and that in the rapidly evolving world of digital law and technology, any legislation passed is likely to be both ineffective and rapidly outdated.

the condensed idea
Can all online activity remain equal?

46 Semantic web

In the view of the creator of the world wide web, Tim Berners-Lee, the future of his creation lies in a project he has termed the 'semantic web'. A new way of thinking about the way in which online information is 'marked up', the semantic web proposes to replace the simple system of interlinked pages used by the current web with a far richer system for describing the exact nature and content of all the information on a web page. These 'semantic' descriptions would have the potential to locate and integrate all related information automatically. The system may just represent a revolution as great as the first incarnation of the web all over again.

Tim Berners-Lee first set out his vision of the semantic web in his 1999 book *Weaving the Web*, arguing that 'I have a dream for the Web . . . and it has two parts. In the first part, the Web becomes a much more powerful means for collaboration between people . . . In the second part of the dream, collaborations extend to computers. Machines become capable of analysing all the data on the Web – the content, links, and transactions between people and computers. A 'Semantic Web', which should make this possible, has yet to emerge, but when it does, the day-to-day mechanisms of trade, bureaucracy, and our daily lives will be handled by machines talking to machines, leaving humans to provide the inspiration and intuition.'

The word 'semantic' itself means something that relates to meaning, or from distinctions between the meanings of different words and symbols. Berners-Lee's 'semantic web' has no concise formal definition but is based on the use of a set of online technologies to add a rich new layer to the world wide web, interlinking the meanings and significance of information

timeline

1999

Tim Berners-Lee outlines
the semantic web

as well as the simple content of that data. Central to this is the idea that web applications will eventually be able to analyse the context in which words and information are being used, and then automatically connect this to other contexts containing similar concepts and data – a far more intelligent and powerful model for web software than is currently possible.

Beyond HTML HTML, the markup language used as the basis of the current world wide web, would in a semantic web be replaced by a combination of more advanced technologies, such as XML, embedding a huge amount of metadata – an additional layer of information describing the nature of all the information on a page – within the structure of web pages. The structure this metadata should take first began to be set out by Berners-Lee's World Wide Web Corporation in 2002, proposing a Web Ontology Language (for which the acronym, slightly confusing, is OWL) that would 'provide a language that can be used for applications that need to understand the content of information instead of just understanding the human-readable presentation of content'.

An impossible dream?

Despite its promise, for some critics there are fundamental flaws in the idea of a semantic web, relating to the size and the imprecision of the information that the web at large represents. Tens of billions of pages mean that a full semantic system would have to be able successfully to reconcile and categorize potentially hundreds of millions of terms, many of them redundant or duplicated. On top of this, many concepts and definitions are 'fuzzy' enough to be extremely difficult to pin down in a sense that can be 'understood' by an application running on a machine, especially when there are direct contradictions between different versions of particular information or arguments, thanks to one or more occurrences being faulty or inaccurate. These problems are well known to those trying to build the semantic web, who nevertheless believe that in time it will be possible to overcome them thanks to the ongoing development of techniques for dealing with vague ideas, probabilities and uncertainties within machine logic.

2002
First proposed Web
Ontology Language begins

2008
Second Web Ontology
Language starts development

The fundamental problem that OWL addresses is applying a sufficiently powerful and rigorous system of classification to data to allow machines automatically to 'understand' the meaning of different data in different contexts. This means identifying particular 'properties' about each piece of information to be classified, including its class (a horse, for example, would belong to such classes as 'mammal', 'animal' and 'quadruped'), its properties in relation to other objects (so a father would have the property 'hasChild' in relation to his daughter), its position within a hierarchy of classes (indicating that 'mammal' is a subset of 'animal') and so on.

For this to work, it is important that reference is made to central sources of data, rather than attempting to define everything individually on a page. So the class indicator that a person or a horse is a 'mammal' would automatically refer to a central data point which exhaustively defined the class 'mammal'. Eventually, it may be possible to define every single attribute of a web page using this kind of reference to central data points

Web 3.0

Just as Web 2.0 is a shorthand for the current developments taking place on the world wide web, Web 3.0 looks ahead to its next great shift – something that the semantic web is seen by many as central to. If something like the semantic web is achieved, what related changes can we expect in digital and online culture? Given that a working semantic web will entail machines and applications 'understanding' data in a way far closer to human understanding than currently, some analysts see this as part of a steady convergence between the physical and the digital worlds: a state often referred to as the 'metaverse', meaning an enhanced melding of virtual and real experiences beyond our current conception of the physical universe as all there is. Other key themes are the ongoing integration of personalized services into larger networks, and the potential for customized access to the internet based on applications understanding an individual's personality and preferences to a far greater degree than anything possible in the present.

> **❝The Semantic Web is not a separate Web but an extension of the current one, in which information is given well-defined meaning.❞**
>
> Tim Berners-Lee

so that, for example, even something as simple as deciding to put a line of text in bold type could be achieved by referring to a central, shared definition of what it means for text to be bold.

Semantic web today The semantic web is already operating in a limited sense beneath the surface of the present web. With Creative Commons copyright licences, for example, a central database stores all licence details, and individual documents simply contain links to this central resource rather than needing to reproduce the details in full themselves. Moreover, the way these links are embedded in pages contains a large amount of metadata designed to help search engines and other web applications automatically understand what a particular licence means and how it is being used. Semantic thinking also has many digital applications outside of the web, and in particular in the field of database and information management, where Berners-Lee has also been influential in leading an 'open data' movement designed to institute as standard the recording of public and government data in semantically tagged, open databases, enabling it to be used and analysed by powerful third-party applications.

There is a considerable way to go before such principles can be applied across the web at large, but for many in the digital sector, the logic of the semantic web is compelling and it is one that can already start to be applied incrementally to digital information, as additional layers of information begin to be encoded in everything from mapping and geographical programs to product specifications.

the condensed idea
Teaching machines to understand us

47 Augmented reality

Digital technology is increasingly able to conjure complex, immersive virtual environments within which thousands and even millions of people can interact. But this is not the only way in which technology is shifting the human experience of what 'real' actions and interactions mean. Another burgeoning field is the use of technology not to replace real experiences with virtual ones but to enhance our everyday experience of the world by overlaying it with context-sensitive information, images, possibilities of action and more. This is the realm of 'augmented reality'.

In the most fundamental sense, almost all technology augments people's ability to act within the world: clothes protect us; vehicles transport us; the written word translates our knowledge and experiences through time and space; telecommunications allow us to see and hear others from great distances.

What the increasing power of digital technology offers in particular, however, is the possibility that computer-generated sounds, images and feedback can be overlaid in real time over someone's perception of the world, and in direct response to what is happening in the world.

Augmented reality, as the name suggests, could theoretically entail augmenting any aspect of our experience of reality: smell, taste, touch, sight, sounds. In practice, however, it tends to work through sounds, visuals and perhaps 'haptic' feedback – that is, physical movements as feedback. And it tends to be delivered either through mobile devices or through customized technology.

timeline

1966	1989
First head-mounted display	Phrase 'virtual reality' is coined

❛It is my firm belief that Augmented Reality will be the next web revolution.❜
Rouli Nir

Early glimpses Augmented reality is a young idea but we're already fairly used to something close to it: the augmentation of real, live images being shown to us on screen. On television broadcasts of live sporting events, for example, it's now fairly ordinary to see diagrams or symbols being superimposed onto the sporting arena to highlight aspects of the event.

Similarly, television advertising at some sporting events is increasingly experimenting with digitally making different advertisements appear within stadiums depending on which part of the world the television audience is in. Such technology relies on tracking the locations for adverts in real time, then generating digital images that blend seamlessly with the real images around them, meaning that what viewers see at home may be entirely different to what they would see if they were actually present.

The technologies underpinning these processes are closely related to those that are used actually to augment our experience of something we are

My virtual pet

In 2009, the release of the game EyePet for the PlayStation 3 and PlayStation Portable introduced a wider public to the potentials of augmented reality. Via a camera attachment, the game makes a monkey-like virtual pet appear within real environments on screen: the camera is pointed and the virtual animal can then be seen through the console, apparently interacting with people and objects. The process of interaction operates in two directions, with the virtual creature moving to avoid obstacles in the real world, while also being able to be given virtual objects which it will then appear to use within the real landscape. The technology was not perfect but it was one of the first popular demonstrations of what might be possible with augmented reality devices and the increasingly seamless overlaying of virtual layers upon real experience.

1992	**2003**	**2009**
Phrase 'augmented reality' is coined	BMW starts making Head-up Displays for its cars	Layar, first augmented reality browser, is launched

experiencing in person, rather than through a television or computer at home. In fact, most modern augmentation relies on replicating the same kind of effects on the move, via the screen of a mobile device – but one that, crucially, is able to take into account its own location and movement at any point.

Mobile power It is a combination of hardware and software that today makes augmented reality a widespread possibility: visual displays, motion-tracking capabilities and sensors, GPSs, fast processors, cameras for visual input and sophisticated software able to integrate these. These technologies have only become sufficiently powerful and affordable in the last few years to be widely used but almost all new smartphones now have all of them, making them ideal platforms for the widespread use of augmented reality technologies.

> **The ultimate display would, of course, be a room within which the computer can control the existence of matter.**
>
> **Ivan Sutherland**

One example that combines many of these functions is a smartphone application billed as the world's first 'augmented reality browser' called Layar, which requires users simply to point their phone's camera at a street and then information about restaurants, directions, sights and other historical or tourist information is automatically overlaid on the image on screen, guided by GPS, motion-tracking and visual recognition software.

Other interfaces Mobile screens are by far the most widely owned possibility for augmented reality in the short term but two other kinds of interface also show great potential. The first is head-mounted displays, often in the form of glasses or goggles able to track the user's motion and superimpose information on their view of the world. This offers a far more immersive experience than a handheld screen and, although more expensive and cumbersome at the moment, it is already being widely applied in the operation of specialist vehicles such as military equipment.

The other major interface option uses a projector to reverse the process of augmentation: instead of a user seeing data overlaid on reality by a display, an augmented layer is projected onto objects in the real world. This technology can be applied to particular locations and groups of people rather than carried by individual users.

Heads up

'Head-up displays' or HUDs began as a military technology designed to enable pilots to look at instrument readings without looking away from where they were going: sighting and speed information might, for instance, be projected onto the windscreen of an aircraft, eliminating the need to glance down at instruments during high-pressure situations. Such technologies were regularly being built into military vehicles by the 1960s, and spread to commercial vehicles by the 1970s. But it was not until the age of video games that ordinary citizens began to see such technology, with games necessarily tending to show detailed information about a virtual character overlaid on screen on top of a view of the game world. Today, thanks in part to innovations driven by the games industry, the art of constructing effective HUDs has become extremely refined, with sophisticated augmented reality displays overlaying complex real-time information about the world on everything from ski and scuba masks to windscreens and, experimentally, contact lenses, and potentially direct projections into the retinas of people's eyes.

Making an environment responsive to people's actions within it through augmented reality projection is, among other things, a technique with powerful potential for constructing simulations and truly immersive multi-user experiences. The commercial potential of such techniques for advertising and displays within shops and businesses is huge, as is the combination of such augmentations with 'smart' technology able to identify individuals and where they are looking, adapting the augmented material displayed to each viewer passing by.

Meanwhile, in scientific research, architecture and much else besides, the opportunity for teams of people to explore three-dimensional projections of projects in real spaces offers a tantalizing new tool for analysis – with a similar potential to transform the possibilities of entertainment and public performance. *Star Trek*'s holodeck remains some way away but it is no longer entirely a matter of science fiction.

the condensed idea
Layering digital reality over the physical world

48 Convergence

Convergence occurs when the functions of several different technologies begin to overlap. It describes a process of increasingly dense interlinking between technologies and networks as an increasingly large number of social, commercial, cultural and administrative actions begin to take place in digital spaces.

Convergence tends to occur in technology where there is an advantage to consumers in having multiple functions available to them through a single device or application. Modern mobile phones are a good example, as they have increasingly taken on the functions not only of a telephone but also of a portable computer, a music and video player, an internet browser, a compass and GPS, a games console, a camera and video recorder, and much else besides. Similarly, modern games consoles are no longer simply machines for playing games on but also integrate many of the functions of a computer and domestic media player.

Convergence has been a feature of technology since well before the digital age, together with the counterbalancing trend of divergence, where some devices tend to grow more highly specialized over time. Where, for instance, in the early days of the car there were very few different types of vehicle available for purchase, there are now many thousands, catering for specialist needs and tastes. Digital technology is, however, a unique case, in that the existence of mass interactive media distributed via the internet has fuelled a participatory culture within which consumers increasingly expect to be able to consume all and any different types of media on the same devices. Moreover, it is becoming increasingly important for almost all of the services that citizens use – for business, for pleasure and for participation in civil life – to have a presence in this same online space.

timeline

1994	1997
First online television is broadcast	First camera-phone appears

The value of groups One of the more powerful pressures towards convergence in digital media is the capacity of communities to generate value. The community represented by the members of the social networking site Facebook, for example, is over 600 million members strong and still growing – and this represents a tremendous incentive for those launching other goods and services to allow easy integration with Facebook's services.

> **❝There's a time and place for everything, and I believe it's called "fan fiction".❞**
> **Joss Whedon**

Similarly, for most people designing either new software or hardware, the pressure to ensure compatibility with dominant digital communities like social networks is considerable. People expect to be able to use Facebook and Twitter on any smartphone, tablet or computer, just as they increasingly expect not to be limited to a single format for media purchases: books are available in physical form but also on Kindle, via iBooks and other digital formats; television series can be bought on DVDs or Blu-Ray but also downloaded from iTunes, streamed online from subscription media services, or recorded from live television and then stored on a hard drive.

Transmedia tales

'Transmedia storytelling' means the use of many different media to tell a particular story or create a particular experience. But it also represents a step beyond the 'multimedia' notion of simply presenting different media in parallel. Instead, it tries to create an immersive experience in which the audience are active participants rather than passive spectators, piecing together the story of a parallel or alternative world from elements embedded in different media. The television show *Lost* used transmedia techniques to create a rich fictional universe around the show, involving the websites of fictional organizations, a published novel credited to one of the show's characters, the limited release of a brand of chocolate bars from the show, and the live appearance of a fictional character at the Comic-Con conference. Such techniques can be seen as part of a convergence culture, in which not only media but also the roles of audiences and creators are steadily being blurred.

2005	**2006**	**2008**
Founding of the online *Star Wars* encyclopedia Wookieepedia	The Lost Experience launched	BBC iPlayer made available on games consoles

The power of fan fiction

From *Star Wars* to *Buffy the Vampire Slayer*, the most popular modern media involve fan communities as never before. Digital technology means that producing creative responses to films, books, television shows and fictional characters is within the reach of almost any sufficiently dedicated audience member, with a range of options at their disposal from creating original material to remixing existing content. Then, too, there is the power of indexing and annotating fictional works and universes, with the collective online 'lore' surrounding something like *Star Wars* running to many millions of words, including transcripts and frame-by-frame analyses of every film and official product. Such culture increasingly exists not as a separate entity to original productions but as a collaborative extension of it, generating and testing ideas for new extensions of imaginative universes, and with many current creations being seen from the beginning as a central aspect of taking full pleasure in a work of fiction.

This effect can be seen in services as well as physical products. Where organizations like cable television providers originally did little more than provide television channels, the process of 'bundling' today means that they are likely to offer extensive service packages in order to try to win customers: from broadband and phone line rental services to mobile phone subscriptions. Similarly, broadcasters like the BBC are now generally expected to offer content across all formats: radio, television, on-demand internet services, live streams, podcasts and so on.

Companies like supermarkets have taken this process still further, offering in some cases everything from banking and insurance to travel and phone contracts. They also to provide a one-stop shopping experience both digitally and physically.

Convergence problems As hardware, software and service-providing companies take on a wider range of functions, this can lead to a decline in quality: the replacement of dedicated digital cameras with smartphones meaning potentially lower quality pictures, for example. It can also lead to a decline in consumers' ability to differentiate meaningfully between different goods and services.

> **❝Cult has become the normal way of enjoying movies.❞**
> **Umberto Eco**

A larger issue connected to this second point is the use of convergence by manufacturers to generate demand for successive generations of new products that may offer new features but that have little actual improvement to offer in terms of quality over older, more specialized technology. This pressure towards rapid cycles of replacement can create a false impression of redundancy in order to fuel further sales – making a technology appear outdated by adding features to a new model that do not actually improve a user's experience.

There are, however, forces resisting this. The convergence of much of the mass media and mass-produced technology dominates the bulk of the modern digital marketplace and, through a combination of economies of scale and ease of access to markets, has driven many medium-sized players out of business. However, at the specialist end of the spectrum, the demand remains stronger than ever for niche products and boutique specialists, who can make a virtue of resisting convergence by producing products tailored to very particular tasks and to individual consumers.

Moreover, the increasingly participatory nature of fan and consumer culture means that modern manufacturers often struggle to distance themselves from poor service or products, and digital facilities for comparison, review and discussion put a great deal of information into the hands of consumers. In this sense, the most successful uses of convergence involve not simply combining goods and services but combining customer and audience responses with the process of creation itself. Within new media, the boundaries between creators, producers, critics, consumers, professionals and amateurs are all increasingly blurred, and this makes for new relationships that are above all dynamic, and defined more by the particular roles played at any one moment than by permanently fixed positions.

the condensed idea
Old barriers are breaking down fast

49 The internet of things

At the moment, the internet consists of connections between dedicated computers and computing devices. The idea of the 'internet of things', however, speculates as to what might be possible if smart, networked computer chips were incorporated in an increasing number of manufactured objects and places – from electrical systems to domestic appliances, streets, buildings, even items of clothing. Such a move would bring with it the possibility of precise, interconnected knowledge about all areas of life, and of enormously powerful tools for understanding and fine-tuning our use of resources.

The phrase 'the internet of things' was itself first coined around 1999 but has only more recently become a concrete possibility. The declining cost of powerful computer chips and networks has been matched by improvements in the kind of networking necessary for this new notion of an internet – one formed of sensors able to configure themselves on an ad hoc basis.Today, a combination of technologies has begun to allow the commercial deployment of such ideas on a limited scale. These technologies include electronic tags that can be read over short distances by wireless signals, short range wireless communications between devices, networks of sensors within structures, and real-time localization techniques that can use wireless tags to determine the location of objects within a space at any particular moment.

Wireless tagging is an especially important recent development in this field. In the last few years, radio-frequency identification (RFID) has

timeline

1997	1999
Hong Kong metro introduces wireless smartcards	Term 'internet of things' coined

Remote control

Once a home or business is equipped with a sufficient number of sensors – monitoring everything from temperature to light levels in real time – it becomes possible to create a highly accurate virtual model of it. Technologies already in development are now experimenting with the use of these virtual models to allow people to monitor and control remotely conditions within homes, offices and even public places. This could in future make monitoring and adjusting the status of almost every appliance in a home or office a matter simply of accessing an online model of the building from anywhere in the world, and seeing in real time the results of shifting the systems within it – as well as setting notifications for any variables shifting out of pre-established parameters.

advanced considerably, leading to affordable and extremely reliable chips that can simply be glued to everyday objects in order to identify them individually – much as individual computers are identified by their IP addresses – and track their movements. The largest current application of such tags is on shipping containers, millions of which can now be identified and tracked by the tags attached to them.

Travel and cities One of the most obvious applications of such technology is in transport. Detailed real-time information about the relative locations of vehicles could have a profound impact on everything from timetabling and management of public transport to providing local contextual information within individual vehicles – from cars to bicycles.

As with the current internet, the power of such networks potentially increases exponentially as more objects are interlinked. Tagging buildings and facilities in cities so that they are able to identify themselves and their locations to anyone in those spaces offers the possibility of 'smart' urban networks sharing information about everything from the nature and opening hours of commercial facilities to the relative costs and availability of commercial services, free parking spaces, seats in public transport and goods stocked by particular shops.

2001
Some Dutch libraries start using wireless tagging

2005
Las Vegas casinos begin wireless-tagging chips

2010
RFID chip manufacture increases hugely

Away from the city, such technologies have equal potential in industrial and commercial activities. Farmers, for instance, already make extensive use of GPS systems for ploughing, maintaining and harvesting land effectively. Armed with the next generation of precision sensors, this process could become far more accurate and responsive to the exact geography of a location.

Changing behaviours Another powerful possibility for bringing smart networks to an increasing number of everyday objects and activities is to help people to change their behaviours, in the light of both real-time information about the effects of what they are doing and comparative information about how others behave.

> **The future has already arrived. It's just not evenly distributed yet.**
>
> **William Gibson**

In areas such as energy consumption, for example, it is already well established that showing power consumption in real time for a household or business tends to make people both more aware and more willing to fine-tune energy usage – registering the instant drop in consumption and minute-by-minute expenditure when a device is switched off or replaced with something more efficient.

Smart networking between objects in a household, and the use of comparative information about different households, can allow both people and smart networks themselves to 'learn' from each other about effective

Personalization

Many people are ambivalent towards one aspect of introducing 'smart' technologies into an increasing range of objects: the potential for personalized responses from items that identify the individual using them and give a user-specific response. This might range from billboards and shops displaying personalized adverts and offers to museums and libraries automatically displaying information linked to someone's listed interests or reading history. For some people, this personalization is to be welcomed as the sign of cities becoming truly 'intelligent' in the way they adapt to those within them; to others, the loss of anonymity and potential infringement of liberty that tracking and identification technologies suggest is something to be resisted or approached with extreme caution.

> **It'll be really interesting . . . when we manage to link up data from other living things into the web.**
>
> **Tom Freeman**

tactics and devices for saving energy. Similarly, on a regional level, smart power grids can respond in real time to demand, with large potential increases in efficiency and a greatly reduced chance of outages.

Automation The transformative potentials of the internet of things resemble much that has already made the global computing internet so powerful – the collection and analysis of vast amounts of data. Where the future may differ from the present, however, is in the increasing automation of this process of analysis, allowing rapid analyses and responses to complex systems involving little direct human input.

It may be possible, for example, for the power and heating systems within a house automatically to adjust themselves depending on the number of people in each room. A more radical development would be the automation of many aspects of industrial and commercial tasks, with smart-chipped vehicles, objects and buildings 'knowing' where they are in relation to each other, what their status is and what the most efficient sequence of operations should be.

As the development of the internet and the web have shown already, the power of a network grows exponentially with its size, and the electronic interconnection of objects could eventually go far beyond simple automation towards new ways of modelling the functioning of entire national economies and systems of trade. Such interconnection seems distant at present but with sufficiently rigorous and scalable protocols, and sufficiently affordable and reliable technology, much of the infrastructure could even be in place within years rather than decades.

the condensed idea
Giving every piece of the world a digital presence

50 Distraction

What effect do the suffusion and multiplicity of digital media have on our minds? As more of each day is spent using media in some form – and in particular digital and online media, with their potential for rapid and constantly varying messages – people are looking with increasing concern to the long-term effects of this on the mind. Does digital culture mean the inevitable spread of distraction among its users: the shortening of attention spans, the loss of the ability to follow single trains of sustained thought. There are no definitive answers here – but many vital questions.

The amount of media consumed by people in the developed world has steadily increased over the last few decades. Young people in America are a group close to the cutting edge of digital culture, and since 1999 an organization called the Kaiser Family Foundation has regularly reported on patterns of media use among Americans aged from 8 to 18. In 1999, total daily media use for this group was estimated at the considerable figure of 6 hours and 19 minutes each day. The most recent report, released at the start of 2010, showed an increase that the authors of the report themselves admitted to finding surprising: average media usage of 7 hours and 38 minutes each day, rising to a total exposure of 10 hours and 45 minutes once multitasking was taken into account.

The increase was attributed in large part to 'an explosion in mobile and online media', with around 20% of all media consumption occurring through mobile devices – a number that is certain to increase. What this signifies for society as a whole is extremely difficult to determine, but many thinkers and critics have speculated as to both its positive and negative effects.

timeline

2001	2004
Term 'digital natives' is coined	Term 'life hacking' is coined

The shallows *The Shallows* is the title of a 2010 book by American author Nicholas Carr, arguing that older 'linear' ways of thinking are being radically altered by the use of interactive digital media and by the web in particular, leading to 'a new kind of mind that wants and needs to take in and dole out information in short, disjointed, often overlapping bursts – the faster the better'.

> **For tribal man space was the uncontrollable mystery. For technological man it is time that occupies the same role.**
> **Marshall McLuhan**

This argument embodies many concerns articulated elsewhere across fields ranging from education to neuroscience, suggesting that digital media may encourage patterns of thought and engagement that are shallow and fleeting rather than deep and empathetic. The British scientist Susan Greenfield has, for example, expressed concerns that the ways in which activities such as web browsing reward the brain may over time lead to diminished emotional development and an infantile mindset preoccupied with seeking short-term rewards.

The pomodoro technique

Created in the 1980s, the pomodoro technique is one popular example of a method of time-management that has proved a popular antidote to issues of distraction in fields such as software development. The technique is named after the Italian word for tomato, *pomodoro*, which is also the name of a popular range of tomato-shaped egg timers. Using the technique means deciding on a single task to be performed, setting the timer for 25 minutes, then working uninterrupted for that time, followed by a five-minute break and then the repeat of the cycle three more times. Given the potentials for distraction in digital media, learning such approaches to time-management and focus is emerging as an important 21st-century discipline – a set of skills sometimes called 'life hacking' by programmers, for whom information overload is a perennial problem.

2008
Idea of 'peak attention' is first invoked

2010
The Shallows is published

> **❝As we come to rely on computers to mediate our understanding of the world, it is our own intelligence that flattens into artificial intelligence.❞**
> Nicholas Carr

Determinism Many of the arguments expressing concerns over 'distraction' can be thought of as technologically deterministic – meaning they assume that technology has the capacity to determine the cultural, social and even intellectual values of a society. By contrast, there are those who argue that characterizing digital interactions as shallow and distracted is often a misunderstanding, and that they are often better thought of in terms of interaction with increasingly complex systems.

This argument was made in a 2005 book by the American science writer Steven Johnson. Entitled *Everything Bad is Good for You*, it argued that 'popular culture is actually making us smarter' – as the subtitle put it – and that much of contemporary mass culture, from video games to search engines and TV series, exhibited an increasing complexity and required far more concentration and engagement from its audience than the mass culture of the pre-digital era.

Johnson's thesis echoes those who see in the increasingly pervasive and overlapping use of digital media not an end to structured thought but an increasingly sophisticated new set of 'systems thinking' and multitasking skills. Users are accustomed to multi-stranded narratives, puzzling out the dynamics of systems from disparate clues and interacting in a non-linear way that is more akin to a scientific process of experimentation and learning than it is a passive process involving reduced concentration.

Platform agnostics One notable feature of digital media habits is the increasing degree to which people are becoming 'platform agnostic', that is not wedded to any particular device or media 'platform' for accessing particular content. Television programmes and films, for example, are watched not just on television screens but on mobile phones, games consoles, desktop computers, laptops and indeed any device that is convenient at a particular moment.

Unplugging

With the spread of the internet across not only wired but also wireless and mobile devices, being 'plugged in' to a digital network is becoming the default state for an increasing number of people – more of life is spent in some kind of online state than not. In response to this, many organizations and individuals are beginning to focus on building 'unplugged' time into work: mornings where the use of email is banned, for example, or conference events at which the use of mobile devices or social media like Twitter and Facebook is forbidden, in order to ensure full attention on what is actually happening in the moment. As digital culture continues to develop, it is likely that the art of selectively unplugging will as well, with ease of communications and multitasking paradoxically putting more of a premium than ever on live, personal encounters and unrecorded events occurring 'off grid'.

Among other things, this means that all media can increasingly be seen as in competition with each other for attention in digital formats: electronic books may be read on the same screen that someone uses for web browsing, watching DVDs, sending and receiving email, using social networking sites and working on office projects. In this sense, distraction is easy to understand, as is the pressure for media to attempt to grab users' attention instantly rather than taking concentration for granted.

Peak attention Given the sheer quantity of time spent using media during the average day for many people, it is obvious that the limiting factor in operation is no longer expense or the difficulty of obtaining content, but time. The theory of 'peak attention' takes this a stage further, observing that for people such as the average American teen described in the Kaiser Family Foundation, almost no spare time is now left in the day for media usage to expand into: attention is approaching a 'peak' point, beyond which there is no more to give.

the condensed idea
is Google making us stupid?

Glossary

AJAX (Asynchronous JavaScript and XML)
A group of technologies for developing rich, interactive web content

botnet A network of 'zombie' computers under the control of a hacker

browser A piece of software for using the world wide web

client A computer or piece of software that is receiving software from a central 'server' computer

cookies Small chunks of data stored on a computer by a web browser to allow a website to perform some functions

Denial of Service (DoS) attack A brute force attack on a website by hackers, over-loading it with requests for data and thus stopping it from working

domain A particular subdivision of the internet belonging to a company or person

Domain Name System (DNS) The basic system that translates web addresses from their familiar form in words into numerical Internet Protocol addresses

ethernet The most common standard for local networking

Extensible Markup Language (XML) An extension to HTML that allows a website to display content more easily across a variety of different kinds of hardware

firewall Something that protects computers from being attacked by hackers

File Transfer Protocol (FTP) One of the most basic ways of downloading files over the internet

HyperText Markup Language (HTML) The markup language that the world wide web is based on, which tells web browsers how web pages should look and function

HyperText Transfer Protocol (HTTP) The basic protocol that defines how web servers and browsers communicate with each other

hyperlink A web link that can be clicked on to take a computer user to a different location on the web

hypertext Text on the web that contains hyperlinks

Internet Service Provider (ISP) A company that provides the general public with access to the internet for a fee

Internet Protocol The basic protocol that defines the allocation of unique addresses on the internet to different resources: the most recent version is version six

Internet Protocol (IP) address The basic numerical form of four numbers separated by dots that defines the location of different resources on the internet

Java A programming language that can create programs which run inside web browsers

JavaScript A technology unrelated to Java that makes it easier to create interactive features within websites

name server A server whose role is to translate the words of internet addresses into the numbers of IP addresses

packet A tiny piece of information into which data is broken for transfer across the internet

peer-to-peer Description of a direct connection between two computers, rather than a connection that is mediated by a central service

plug-in A small piece of software that 'plugs in' to a web browser in order to allow it to perform additional functions, such as playing music or particular games

Really Simple Syndication (RSS) A syndication technology that makes it easy for web users to receive an update every time new content appears on a blog or website

search engine A website that allows users to search that engine's directory of the content of the web

server A computer that performs tasks such as hosting a website and which is accessed by remote 'client' computers wishing to use the service it provides

Secure Sockets Layer (SSL) Technology that encrypts information sent across the internet so that it cannot easily be snooped on by hackers

Transmission Control Protocol/Internet Protocol (TCP/IP) The core communications protocol combination that underlies the internet as we know it

Index

Quercus Publishing Plc
21 Bloomsbury Square
London
WC1A 2NS

First published in 2011

A catalogue record of this book is available from the British Library

UK and associated territories: ISBN 978 0 85738 546 8
US and associated territories: ISBN 978 1 84866 133 2

Printed and bound in China

10 9 8 7 6 5 4 3 2 1